THE EIGHT

THE REALIST REVOLT
IN AMERICAN PAINTING

THE
EIGHT

MAHONRI
SHARP YOUNG

WATSON-GUPTILL PUBLICATIONS, NEW YORK

First published 1973 in New York by Watson-Guptill Publications,
a division of Billboard Publications, Inc.,
One Astor Plaza, New York, N.Y. 10036

Manufactured in Japan

Library of Congress Cataloging in Publication Data
Young, Mahonri Sharp, 1911–
 The eight.
 Bibliography: p.
 1. Painters, American. 2. Painting, American—
History. 3. Painting, Modern—19th century—United
States—History. 4. Painting, Modern—20th century—
United States—History. 5. Realism in art.
I. Title.
ND236.Y67 759.13 73-6865
ISBN 0-8230-1607-2

First Printing, 1973

Acknowledgments

Anyone who works with The Eight works with Antoinette Kraushaar. Her father handled the work of many of The Eight, and was my father's dealer for many years. The fact that I have known her all my life does not excuse my exorbitant demands on her for facts, for photographs, for leads, for ideas. She is the only encyclopedia on The Eight and on all the other artists of the age in which we grew up. She knows everything about them and she knows where everything is. She is indispensable.

Mrs. John Sloan has been vastly helpful with memories and conversations and connections. She is single-handedly responsible for a great deal of the interest in and publication about The Eight today. Among many other favors, I must thank her for the loan of the splendid photographs of The Eight by Gertrude Käsebier.

Robert Chapellier, who handles the Henri estate, has been extremely generous and helpful in every way. Arthur Altschul, a leading collector of The Eight, has always been enthusiastic and interested in everything going on in this field. I would like to thank Mr. Jonathan M. Wainwright for the loan of his remarkable unpublished Yale thesis on Shinn. Charles T. Henry, who was Shinn's friend and dealer during the last year of Shinn's life, supplied useful material and wrote some wonderful letters.

Donald Holden, Watson-Guptill Editorial Director, is responsible for the whole project. I would also like to thank my editor, Jennifer Place, for her forbearance and courtesy. My indispensable secretary Carolyn Newpoff performed far beyond the line of duty, as always.

And finally, a special thanks to the collectors, dealers, and museums who have allowed their pictures to be reproduced.

Color Plates

Chronology

	
1859	Maurice Prendergast born in St. John's, Newfoundland.
1861	Prendergast's family moved to Boston.
1862	Arthur B. Davies born in Utica, New York.
1865	Robert Henri born as Robert Henry Cozad in Cincinnati.
1867	George Luks born in Williamsport, Pennsylvania.
1870	William Glackens born in Philadelphia.
1871	John Sloan born Lock Haven, Pennsylvania.
1873	Ernest Lawson born in Halifax, Nova Scotia. Henri's family moved to Cozad, Nebraska, named after his father, who founded the town.
1876	Everett Shinn born Woodstown, New Jersey. Sloan's family moved to Philadelphia.
1878	Davies' family moved to Chicago, where he studied at the Art Institute.
1880	Davies went to Mexico to work as a draughtsman.
1881	Robert Henri's family moved to Denver after his father killed a man in Cozad.
1883	Henri's family moved to Atlantic City.
1884	Glackens and Sloan entered Central High School in Philadelphia.
1885	Luks went to Europe on a long trip to study art.
1886	Prendergast made his first trip to Europe, visiting England and possibly Paris. Henri attended Pennsylvania Academy.
1888	Davies had his first show in New York. Sloan left high school to go to work. Henri studied at Julian's in Paris.
1891	Henri returned to Philadelphia.
1892	Luks, Sloan, Shinn, and Glackens all worked on the *Philadelphia Press*.
1893	Lawson lived and worked in Paris. Davies worked in Europe with the backing of William Macbeth, his dealer. Prendergast still working in France; both Prendergast and Lawson were friends of Morrice, the Canadian painter. Under Henri's inspiration the "Philadelphia Four" took up painting.
1895	Henri and Glackens in Paris.
1896	Luks in Cuba as a war correspondent, then drew comics for the New York *World*. Glackens in Cuba as correspondent for McClure's.
1897	Prendergast worked in a frame shop in Boston. Lawson in New York. Shinn working as illustrator in New York. Henri had a one-man show at the Pennsylvania Academy.
1898	Prendergast back in Europe. Henri married Linda Craig in Philadelphia and moved to Paris.
1900	Henri moved to New York.

1901	Sloan married Dolly Wall in Philadelphia.
1902	Along with Glackens and Shinn, Sloan made illustrations for deluxe edition of the dashing French novelist Paul de Kock. Henri had first one-man show in New York.
1903	Shinn in Paris and London.
1904	Sloan moved to New York, the last of the Philadelphia Four. Glackens married Edith Dimock in Hartford.
1905	Davies in California. Henri's wife, Linda, died.
1906	Henri a member of the National Academy of Design. Henri married Marjorie Organ.
1907	Lawson had one-man show at the Pennsylvania Academy of Fine Arts.
1908	The great exhibition of The Eight at the Macbeth Galleries. Sloan met J. B. Yeats. Lawson elected an associate of the National Academy.
1909	Henri established the Henri School of Art. Became acquainted with Hardesty Maratta's color theory, and introduced Sloan to the theory. Prendergast living in France.
1910	Exhibition of Independent Artists in New York, dominated by Henri and his friends.
1911	Shinn executed murals for Trenton City Hall. Lawson exhibited with the Canadian Art Club in Toronto.
1912	Sloan became Acting Art Editor of the socialist magazine *The Masses*, of which Max Eastman was editor. Glackens bought pictures in Paris for Dr. Albert Barnes.
1913	The Armory Show, of which Davies was the primary organizer.
1914	Prendergast took last trip to Europe and moved to New York, where he saw a lot of Glackens. This is the first time that all The Eight were in New York at the same time. Sloan spent the first of several summers in Gloucester.
1916	Lawson painted in Spain. Henri "discovered" Santa Fe. Sloan had his first one-man show at the Whitney Studio.
1917	First exhibition of the Society of Independent Artists.
1918	Glackens spent the summer in New London. Luks received the Temple Gold Medal at the Pennsylvania Academy.
1919	Sloan spent summer in Santa Fe, as he did almost every summer for the rest of his life.
1921	Lawson won first prize at the Carnegie International. Sloan sold his first painting to a museum (*Dust Storm*, Metropolitan).
1922	Davies developed his theory of "inhalation" from the study of Greek art.

1923	Prendergast awarded Corcoran Gold Medal.
1924	Glackens received the Temple Gold Medal at the Pennsylvania Academy. Henri spent the summer in Ireland, as he did each summer until his death. Davies went to Europe to convalesce after heart trouble. Prendergast died in New York.
1925	Glackens took his family to France.
1927	Luks won Corcoran Gold Medal.
1928	Davies died at Florence.
1929	Henri died in New York.
1930	Davies Memorial Exhibition at the Metropolitan.
1931	Henri Memorial Exhibition at the Metropolitan.
1933	Luks died in New York.
1938	Glackens died in New York.
1939	Lawson died in Miami Beach.
1943	Death of Dolly Sloan.
1944	Sloan married Helen Farr.
1950	Sloan awarded Gold Medal for Painting of the American Academy of Arts and Letters.
1951	Sloan died in Hanover, New Hampshire.
1953	Shinn died in New York.

Preface

When The Eight closed their famous show at Macbeth's in 1908, they thought they had made a revolution, for "The Black Gang" had triumphed over the Academicians and the Impressionists. It was the victory of Realism, of the gray city streets, with horses steaming and locomotives puffing in the snow, drunks and derelicts and kids broken by life. The critics agreed, either reluctantly or exultantly.

The real explosion came from the pictures by Henri and his followers, the Philadelphia Four: Sloan, Glackens, Luks, and Shinn. Against gentility, they set up the bars, the cheap theaters, the street cars, Central Park, and they revelled in the spectacle, the intensity, and the surrounding swirl. Davies, Prendergast, and Lawson, friends of theirs, came along for the ride and to flesh out the exhibition; Davies' Arcadian dreams, Prendergast's starched nursemaids, and Davies' calm cathedrals on the Harlem River had nothing to do with the dark clatter of the streets.

This was Henri's show. He had been an Impressionist once. He had seen Post-Impressionists in Paris, and he knew art could not go that way. A determined man with a doctrine, he had found his way. Art *was* life, and it was the artist's task to see and to transfer directly what he saw; then the viewer would see just what the artist saw. Henri was tremendously persuasive, and he had convinced Sloan and Luks and Glackens and Shinn. They were newspaper artists in Philadelphia who had never cared much about painting until they met Henri, but who knew about life, fires, dead on arrival, and the mine disasters that were a Pennsylvania specialty. Because of Henri, they'd all come to New York, which was the artistic center then just as it is now.

They had a lot on their side. People who believed in Henry James would not believe in Henri, but it was a very real world The Eight painted, with more miles of slums than nests of gentlefolk. Their pictures showed kids swimming off the piers and the red sun behind the Catholic church—what they saw when they looked out the window. They saw straight Zola, straight Dreiser. The artist was always looking, always taking notes; the life you see comes out in your work. Henri said that it's easier to express than to see. You must see it first, and then what you see will be in your work. It's a great way to write novels and a great way to paint pictures, and while you're doing it you're convinced, as Henri was, that it's the only way.

The show of The Eight was just a starter. In 1910 they organized the enormous Independent Exhibition, which anybody could get into as long as he was a friend of Henri. Then, in 1913, his friends put on the immense Armory Show. When the other side, the abstract side, won, they could not believe it; they could not believe it all their lives. They all went on doing good work but they did not conquer. The realist revolution did not take place, but the abstract revolution did.

It was a colorful movement, and they had a wonderful time; they were all interesting men and good painters. And if they lost, why, artists rarely win. And perhaps they weren't so wrong after all.

THE EIGHT

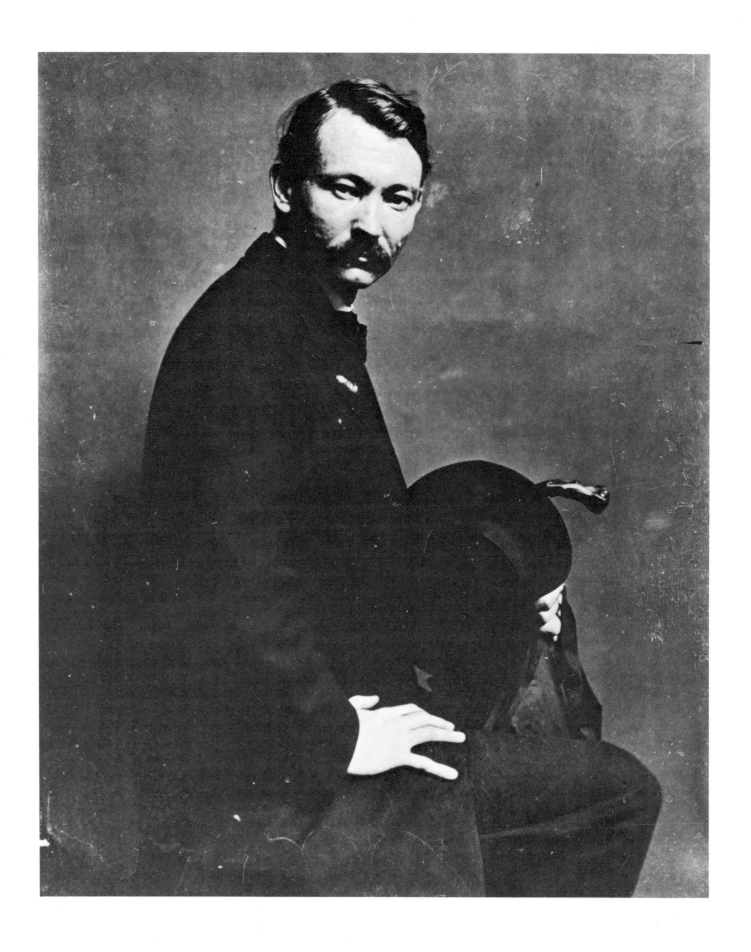

ROBERT HENRI 1865–1928

The Leader of the Band

Robert Henri was born in Cincinnati on June 24, 1865, as Robert Henry Cozad. His father came from Allensville, Ohio; the name Cozad was originally French. Henri's grandfather founded Allensville and named it after a prominent Democratic politician. The main road from Athens to Chillicothe, the first capitol of the state, runs through the place, but it has only a few houses, none of them old. This beautiful rolling country had the earliest ironworks beyond the Alleghenies, but it has been pretty quiet ever since John Jackson Cozad, Henri's father, ran away from home at the age of twelve to work as a cabin boy on the Mississippi and then as a river boat gambler. In those flush times, Cincinnati was the largest city in the Middle West and New Orleans the nation's fourth city. John Sloan romantically said that in the Sixties and Seventies gambling was an honorable profession, but in reality it was dangerous and dirty work. Cozad, "The King of Faro," was banned from many of the best casinos, but he worked steamers, railroads, and hotels all over the country.

John Sloan said that Henri's father looked like an El Greco. He had princely manners, tremendous courage and arrogance, and he dressed in black, as a gambler should, with expensive jewelry. His part of Ohio was settled by Virginians, and his son could even summon up a Southern accent. Cozad was wonderful to his wife when he was home, and idolized by his boys. On the road he had his jaw broken in a fight over another woman, and people who had lost money came looking for him to kill him. He had the grand manner, a great contempt for people, and a driving need to lead them.

Cozad married the hotel keeper's daughter at Malden, in West Virginia near Charleston, and the young couple set up housekeeping in downtown Cincinnati. Like his father, Cozad had always wanted to found a city, and he may already have tried his hand at a settlement for Confederate veterans in South America. After his sons Robert and Frank were born, he set up a town named Cozaddale—the accent is firmly on the second syllable—northeast of Cincinnati not far from the Outerbelt. The town is still there, much as he left it. Cozad's big red brick house is a quarter of a mile out of town, with white pillars and French windows and old apple trees. There are a few other brick buildings, a schoolhouse, and a wooden church that doesn't look old enough. Cozad hoped his town would rival Saratoga, but Cozaddale is right where he left it a hundred years ago. His son spent a wonderful American boyhood, killing snakes and catching

mud turtles when he was not attending the Chickering Classical and Scientific Institute in Cincinnati.

In 1872 Cozad took an option from the Union Pacific Railroad on 50,000 acres in Nebraska, where the 100th meridian crosses the Platte, about fifty miles from Kearney and three hundred miles this side of Denver. Hoping it would become the capitol of the state and maybe even the country, Cozad advertised for settlers in Cincinnati as Lord Selkirk had advertised in Switzerland for the Red River colony in Manitoba in 1821. The colonists came in 1874, and soon the town of Cozad had a hotel, a stop on the Union Pacific, and a newspaper called "The Hundredth Meridian." It also had drought, floods, and crop failures to an unimaginable extent.

From Cozad, where his father was grand potentate, pouring his gambling money into the town, Robert went back in the winter to the Chickering Institute, which was pretty dull. As he wrote about Nebraska at age eleven in "The Hundredth Meridian": "Some of the hunters wear pretty suits of buckskin with fringe all around. I saw one who had rows of gold dollars on his suit for buttons. They wear their hair very long and a belt around the waist filled with pistols and great spurs on their boots. They raise fine crops here, but the hoppers do most of the harvesting once in a while the wind blows a *little hard*." (William Inness Homer, *Robert Henri and His Circle:* Ithaca, New York, 1969, p. 12). What's more, his father had very serious trouble with the surrounding ranchers: the farmers and the cowboys can't be friends. By 1881 business had expanded so fast that Cozad set up another home in Denver. Robert wrote in his diary that they expected to settle permanently in Denver and build up a fortune there. His father traveled back and forth to Cozad and Cincinnati and played cards when he needed more cash.

This whole project blew up in 1882, when Cozad got into a fight with a local cattleman named Alfred Pearson. When Pearson drew a knife Cozad shot him. Cozad got out of town in a hurry to avoid being lynched. Two months later, Pearson died from the wound and Cozad was charged with murder. Mrs. Cozad sold everything they owned and joined him in Denver.

When Cozad turned up in the real estate business in Atlantic City he was a new man named Richard H. Lee; his son John was called Frank L. Southrn, and Robert became Robert Earl Henri. The boys were passed off as adopted sons and foster brothers. Any resemblance to the Cozad family was extinguished, and all four members of the family maintained their new identities all their lives, though the murder charge was eventually dropped. Henri covered up the story even from his closest friends. Certainly the murder was the most important event in his life, and it may have accounted for his faintly sinister air.

In Atlantic City, Mr. Lee bought a strip of land on the beach at Texas Avenue where he built houses. Robert helped his father build and paint them. His new name was pronounced Hen-rye, like buckeye, and Henri never let you forget it. Left-handed, like

so many men of talent, he began to draw at an early age, writing his own stories and illustrating them. One of his friends had gone to the Pennsylvania Academy of Art, and when his brother Frank registered at Jefferson Medical in 1886 Robert went to Philadelphia with him and enrolled at the Academy.

The Academy was then by far the leading art school in the country, and it occupied the same wonderful and dusty building that it does today. Henri just missed studying with Thomas Eakins, who left in a huff after a fight over the way he posed the models. Eakins was not an easy man, and he was capable of being pretty crude; he thought he was a martyr to art, and he considered his opponents fools. His absent figure still dominated the Academy, and he was in the back of Henri's mind all through his life. Henri said that "it was an excitement to hear his pupils tell of him. They believed in him as a great master, and there were stories of his power, his will in the pursuit of study, his unswerving adherence to his ideals, his great willingness to give, to help, and the pleasure he had in seeing the original and worthy crop out in a student's work." (Robert Henri, *The Art Spirit:* Philadelphia, 1960, p.92). This statement is partly true of Eakins, but absolutely true of Henri. Eakins' mantle fell on Thomas Anshutz, an excellent painter but not of the same caliber: Eakins had a rough tongue, but Anshutz was called "a file dipped in acid." It's a method of teaching that Henri never used.

When Henri began drawing from a cast of the Medici Venus he was delighted to find that he was as good as the other students, but he was not a rapid learner. He never liked drawing from the cast, and when he became a teacher he dropped the antique. In his great days, Henri gave his students the idea that they were bursting with talent. Even loyal John Sloan spoke of having to show a student how to draw after she had been hailed as a genius by Henri. But Henri felt that the world bears down enough on us all. He felt that encouragement gives confidence and that the teacher's task is to free what is already there. There are very few tricks in painting; the flaw of the Beaux-Arts method that Eakins used was the belief that painting could be taught. Henri taught his students to be themselves, but a great teacher can use any method; it's the man that counts, and what his students get from him.

Henri came a long way in this first year at the Academy and he had reason to be pleased. In Atlantic City for the summer vacation, he painted clam shells for the tourist trade, and in the fall he was glad to go back to school. He was popular among the students, tall, good looking, and a leader. He made many friends, and he kept them all his life. He had extraordinary personal charm and attractiveness, with a pleasingly disturbing hint of strangeness.

There was an epidemic of Paris fever at the Academy his second year, and Henri caught it. After another long summer in Atlantic City he took off for Paris with the sculptor Charles Grafly and three painter friends and enrolled at the Académie Julian, which had been popular with Americans since the days of Will Low and Sargent. There was no entrance exam as there was at the Beaux-Arts, and all the world flocked there,

including many Americans. Under Bouguereau, who was an outstandingly good teacher, it was the most progressive art school in the world: ". . . they work eight hours a day on one model there, with no antique nonsense. Besides, they have their atmosphere and their great masterpieces." (Homer, p.36). For Henri it was a giant step from Cozaddale and Atlantic City.

The Philadelphia friends lived for the first year on the Avenue Richerand, which runs between the Canal St. Martin and the Hôpital St. Louis, very far indeed from the Latin Quarter of their dreams. But Henri was in ecstasy. As he said, who would not be an art student in Paris? He would like to live in this beautiful city forever. At the Musée du Luxembourg he was tremendously impressed by Vereshchagin, who painted the wild tribes of Russian Turkestan, and like many excellent judges he thought the greatest picture at the International Exhibition of 1889 was Bastien-Lepage's *Joan of Arc*.

At the end of the season the five Philadelphians broke up and Henri moved with his roommate to the Rue Mazarine, behind the squat dome of the Institute, where they should have lived in the first place. He spent the summer of '89 at Concarneau, which was already a flourishing artist colony. The old walled city and the women with their lace headdresses are picturesque now, but in those days the men wore baggy pants and wide berets and so, you can be sure, did the artists. The artists chose Brittany because it was inexpensive and backward, but Atlantic City has better beaches, and Montauk more beautiful moors. In Brittany, Henri was under the wing of Alexander Harrison, an American who painted excellent pictures along the roads to Concarneau. Henri worked outdoors a lot, experimenting with Impressionism, which was very much in the air, and this most pragmatic man even had a moment of almost mystical vision when he seemed to see the solution of all his painting problems.

Back in Paris, he worked hard, as always. He still saw his Philadelphia friends, but he also joined a new group for dinner at the Hôtel de Nice so he would have more conversation: he loved to talk. He was also very good at keeping his mouth shut, and there are no surviving stories about his connections with women; many men fell in love with their models and some married them, to the discomfort of their friends.

Doing his own work in the summer became increasingly important. In the spring of 1890 he painted at Brolles, seven miles from Fontainebleau, not far from Grez, where Robert Louis Stevenson met his American bride. At the Salon des Indépendents in 1890 he was repelled by what he saw. The Douanier Rousseau, Van Gogh, and Gauguin were too much for him, then and later. He financed his first trip to Italy by his winnings at Monte Carlo. He was remarkably good at gambling all his life, and he later paid for many trips across the Atlantic by winning at bridge.

On his return to Paris he had a room by himself in a tiny street behind St. Germain des Près. He had never felt more content in his life. He was like a lord in his castle, very content to be all by himself. "I lived once in the top of a house, in a little room, in Paris. I was a student. My place was a romance. It was a mansard room and it had a small

square window that looked out over the housetops with their pink chimney pots. I could see l'Institut, the Pantheon and the Tour St.-Jacques. The tiles of the floor were red, and some of them were broken and got out of place. There was a little stove, a wash basin, a pitcher, piles of my studies. Some hung on the wall, others accumulated dust on their backs. My bed was a cot. It was a wonderful place. I cooked two meals and ate dinner outside. I used to keep the cheese out of the window on the mansard roof between meals, and I made fine coffee, and made much of eggs and macaroni. I studied and thought, made compositions, wrote letters home full of hope of some day being an artist. It was wonderful." (Henri, p.40). He had lots of friends, all the old set and a lot of new ones, including Ernest Seton Thompson, whose Canadian nature stories enchanted our boyhoods.

At the Académie Julian, Bouguereau thought Henri was carrying his admiration for Monet too far, with all those purples, but Henri's real favorites were Puvis de Chavannes and Albert Besnard. Before coming home, he spent a summer in Venice with a group of friends, including William Gedney Bunce, an old painter of sunsets who had been one of Duveneck's boys back in the Seventies.

When Henri got back to Philadelphia in 1891, people made much of him because he had been in Paris, which was a state of grace. He was very active in Academy affairs because he liked to run organizations, and to run them his way. At the Academy Annual, an exceedingly important exhibition, he was hung next to Monet, to the consternation of the conservatives. Always a bit of a scrapper, Henri rather enjoyed the fuss.

Henri had his homecoming problems, and he found things very different, for the students in Philadelphia didn't include the naked model in the class photographs as they did at the Académie Julian. In Paris, the artist was the Great Man, which was what he wanted to be. If it were not for the nudes to get shocked at, Philadelphia people would never know an art exhibition was on.

His father, who still went to Saratoga when he needed money the way other people go to the banks, was always extremely generous, but when Henri was offered a job at the Philadelphia School of Design for Women he took it even though it meant putting off his return to Paris. He was a born teacher, and the girls adored him, so that Henri developed a taste, which eventually became a need, for both the audience and the adulation. He worked very hard at his teaching, just as he had at his painting. He taught all the classes and he taught all day long; until the end of his life it was a toss-up between his painting and his teaching. After school closed in the spring he had outdoor classes in landscape painting as Alden Weir did in Branchville, Connecticut, and Chase did in the Shinnecock Hills near Southampton.

At night he gave criticisms at the Charcoal Club, which met several nights a week in his studio to draw from the model. There was no formal teaching; Henri was president, and John Sloan, who was secretary, substituted when Henri was away. The Club only ran through the summer, but the great Philadelphia gang was formed at this time, with

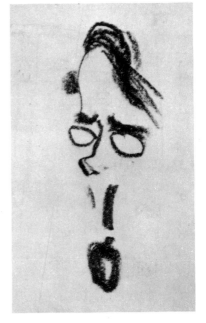

Portrait of John Sloan, *charcoal, 7" x 4". Collection of Robert Chapellier, New York, New York.*

Henri at the head, Sloan at the shoulder, and Glackens, Luks, and Shinn right behind. This was the start of The Eight. Henri loved to have the studio crowded with learners and listeners. Despite his devotion to painting, a surprising amount of his life was spent teaching in the daytime and holding forth to his friends at night. He wasn't a man you argued with; he was the boss, so either you agreed with Henri or you spent your evenings elsewhere. No other American painter except Frank Duveneck had such a loyal following, and those who are left are loyal still. He was at his best in these sessions, and there has been no one like him since.

There was never any doubt that Henri was the leader of the band. He was a little older, but not enough to matter. He was a lean and striking figure with his faintly Mongolian features, his dark skin, and his long lope when he came striding into class. He was his father's son, and bore no more resemblance than a foster brother to Frank Southrn, whose good square face came straight out of southern Ohio.

It's surprising that the Philadelphia gang accepted his ascendancy for so long. John Sloan was a remarkably stiff-necked individual, Shinn was irrepressible, and Glackens in his quiet way did exactly what he wanted, but they all listened to Henri. Sloan said that without Henri it would never have occurred to him to be an artist; he not only had no interest in art, he did not know what it was. Glackens would have been perfectly happy to be a newspaper artist all his life. The obstreperous George Luks was the only one who was not completely respectful, but Luks had given up painting long before Henri came on the scene, and without Henri it's extremely doubtful whether he would ever have painted again.

The Philadelphia gang were not kids, and they were all working as newspapermen, a profession which believed in being hard-boiled. They smelled of printer's ink, and they lived in a harsh, cocky and self-sufficient world, like the hospitals that Eakins loved. Henri's humorous drawings were just right for the newspapers, but he was the only one of the bunch who did not have to work for a living. Instead, he brought them word of a higher life. They didn't know what an artist was, while for Henri, the artist was different from other men; he sees and he knows. That was Henri's religion, and he converted them.

Living in Philadelphia from 1891 to 1895, Henri taught all day and talked all night, which did not leave him much time for his own work. He did not find his own personal style until his second trip to Paris in 1895, when he went back with Glackens and Grafly and three other Philadelphians. He always traveled with a group and he always had a wonderful time; so did the people who were with him. He taught Glackens to love France: even the coffee and rolls were far superior, while lunch and dinner were divine. In those days the French people were tremendously kind and helpful to American artists, treating them like sons of the house.

The bicycle trip through Belgium and France with Schofield and Glackens was far more than a lark for Henri, for he discovered Frans Hals, and Frans Hals completely dominated his painting for the rest of his life. It was the *coup de foudre*, and the road to

Haarlem was Henri's road to Damascus. Hals darkened Henri's Impressionist sky and placed the dazzling white highlights on his figures, so that he painted very much the way Duveneck had painted in Munich twenty-five years before. From this time on, everything Henri painted had Frans Hals' brushwork, his black tonality, the red spot on the cheeks, the face caught in a flash. What is more, Henri imposed the Hals manner on his Philadelphia followers. Luks never got over it and Sloan, Glackens, and Shinn did their best work in this style.

Henri had a studio on the Boulevard Montparnasse near the railroad station and the Restaurant Lavenue where all the artists ate for fifty years. He and Glackens and a new Canadian friend, James Wilson Morrice, went sketching in the forest of Fontainebleau, and Henri organized his own class in Paris with the aid of a devoted student named Emilia Cimino, who later transferred her devotion to Rodin. As in Duveneck's famous classes in Florence, Henri's pupils were Americans and English with a peppering of foreign ladies. He took them to the Louvre and they were spellbound. He brought them meaning and they brought him self-realization. He was not a dramatic performer; he spoke directly to you. He gave his criticisms the same way. He stood in front of one student's picture, and pitched his voice so the others could hear, and the conversation stopped. He had unusual gifts, and the students understood him completely.

Meanwhile, Henri was also picking up his astonishing speed. By the time he hit his stride, a portrait took two hours and a head, five minutes. When he came back to Philadelphia in 1897 the Academy gave him a one-man show, which was a tremendous honor. He was 32 years old and had reason to be proud. The exhibition was a howling success, and the enthusiastic critics noted the new dark manner, which seemed a return to sanity. It was much more than that. In a startling reversal of styles, he forced a return to realistic painting, which after the sunny triumph of Impressionism was like reversing abstraction today. He was a great man, in his way, and he was very sure of himself.

Half the pictures in the Philadelphia show were landscapes and city scenes, for Henri had not yet decided to be a figure painter. These landscapes and city scenes produced the Ash Can School. Without them, Bellows would never have painted his best pictures and Sloan would never have painted at all; Henri's figures inspired Luks and gave Glackens his start. The exhibition made Henri as an artist. William Merritt Chase borrowed pictures to show in New York, but not a thing was sold. Recognition is wonderful and all very well, but a man wants financial success too. For Henri, this never really happened. He had the standing and the prestige all his life, but it was lucky for him that he had money behind him, for without his father he would have been trapped in the treadmill of teaching, which he pretty much was anyway.

He blamed the failure to sell on his lack of tangible honors, believing that he needed a name won in Paris and "a stroke of fame from over there." In the meantime, he moved into his old quarters on Walnut Street with John Sloan and went back to teaching, which

practically made him a Sunday painter. Because of the Academy show, he made a connection with William Macbeth, the New York dealer who was so important for all these men. His paintings were accepted at the Society of American Artists, and he felt the pull of New York. "New York is so different from here—one feels alive over there." But he was not ready for New York. Paris was waiting for him, and he felt that he needed the chance to get to work and try to reap the harvest that he had been so long preparing. Paris was the only place where he could paint full time.

Just before he sailed, he was married to an attractive and talented pupil, Linda Craig, whose family came from West Philadelphia. This trip, which lasted two years, rounded out the seven years that this most American of artists spent in Paris. He moved into the studio at 49 Boulevard du Montparnasse where he had lived before, and the delicious life took up again. Henri did no teaching, perhaps because he could not compete with Whistler's highly popular class, and he and Linda led an absorbingly quiet life, painting, seeing friends and reading aloud. The Paris scenes are among the best things he ever painted. You could not say, now or later, that Henri was the follower of any man. Once he found Frans Hals, the only school he belonged to was the one he founded. In

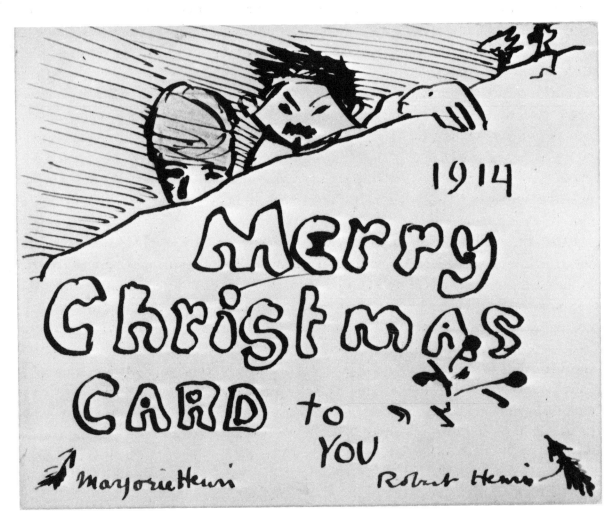

*Christmas Card, 1914, 3½" x 5".
Collection of Robert Chapellier,
New York, New York.*

Brittany, according to Walter Pach, he failed to see why the young Frenchmen made so much of Gauguin. He never joined the American Artists Club. When Miss Cimino asked him to meet Rodin he said that going to court makes you a courtier and that those who want to do something themselves can't give up much time to bask in other people's sunshine. He did not hang out with Whistler, who was holding forth just down the Rue du Bac. A man must flock by himself.

He took his wife for long walks through the Paris streets that he loved, and on Sunday they went to Saint-Cloud. He took her to Montigny, most charming of Fontainebleau towns, on its little river. It was enchanting for him, but a painter's life is sometimes lonely for his wife. Linda's health was not very good, and this was Henri's life she was leading. She had a miscarriage, which is always shattering. But he was very much in love with her, from all accounts, and despite his roughness he had a real streak of tenderness, particularly for women.

He had a passion for the Louvre and knew a tremendous amount about paintings, far more than most art historians. He was a genuine and original thinker about art, and there are very few. A great deal of his truth and perception he found in the creaking galleries of the Louvre. All morning he painted, and in the evening he read and talked about what he read to his wife. He was a wonderful reader, and with his wife he did not need a crowd. He admired Maupassant and Zola, whose stories were all around him, but this American who spent so many great years in Europe remained remarkably true to Walt Whitman, whom he had never met, though the poet lived across the river from Philadelphia in Camden, and to Emerson, who said that it was the strong personal prejudice that made the individual artist. Henri sent eight pictures to the Salon of 1899, of which four were accepted. We think of the Salon as a monster, but when *La Neige*, a dark day in the Paris streets, was bought by the French Government for the Luxembourg, this was success, and the recognition he had been working for.

Things were going his way, and when Linda's grandmother left them a thousand dollars, they decided to stay on. They now had lots of friends, the Redfields, Morrice, and the dashing Alfy Maurer, already established on the Marne with a girl or two. Besides, Henri's astonishing and violent father had been up to his old tricks again. When Atlantic City wanted to push the Boardwalk over his land he stood off City Hall with a shotgun, but this time nobody got killed. He won the "Battle of Fort Lee," as everybody called it, and the city officials paid him his own high asking price. What's more, a Philadelphia speculator bought twelve of Henri's paintings. Things were looking up, and the young couple took off for Madrid.

The Prado had been a mind-dazzling experience for Thomas Eakins, who managed to spend four years in Paris without seeing the Louvre, but what must it have been for Henri, whose other god was Velásquez? He copied five of his paintings and fell in love with Spain, like Mary Cassatt before him and shoals of Americans since. He loved the people, from bullfighters to gypsies, with their sober courtesy and their ferocious color.

When the Henris headed back to the States, they felt certain that almost anywhere was a better place to live than Philadelphia. With Glackens' help they found a house in New York, a brownstone at the end of 57th Street, the ideal place, as Linda called it, right on the banks of the East River with busy little boats hurrying by and big white river steamers. It's one of the great locations. To pay for it, Henri took a teaching job at a girl's school. Painting New York streets as though they were Paris, he invented the Central Park picture, with the children playing, which Glackens also did so charmingly.

By 1901, when they moved into the Sherwood Studios on Seventh Avenue, near Carnegie Hall, the pattern of his life was set. He painted and taught, and in the evening held forth to old friends and new converts. For a good stretch of years, up to the Armory Show in 1913, he probably was the most influential artist in the country.

Despite his eminence, Henri was unusually attached to his family, and the portraits of his father, his mother and his doctor brother Frank Southrn are completely convincing. He admired and idolized his father, though the old man must have been a handful, and got along well with his brother, who looked like the kind of doctor you can trust. He painted his friends, too, Glackens and his wife, and George Luks. This is painting in the great tradition. His work was as good as anything that was being done at the time.

For Henri and his friends New York was a good combination of Philadelphia and Paris, with the old gang and Morrice and Maurer from Paris, and new friends like Sada-kichi Hartman, the amazing German-Japanese philosopher and drunk, and the great trio of critics from *The Sun*, Gregg, Fitzgerald, and Huneker. Arthur B. Davies, who had a studio over the Macbeth Gallery, was a frequent visitor; Glackens brought around the Canadian Ernest Lawson, and Prendergast, who was an old Paris friend of Morrice, came down from Boston. As Henri wrote his parents, Prendergast was a very personal and original painter, quite unlike anyone else.

The Sherwood Studios were full of their friends, and there was a lot of visiting back and forth. Edith Dimock lived there until she married Glackens, and then Jimmy Preston, an illustrator who belonged to the Philadelphia gang, married her roommate and moved into the apartment. It was a perfect life for Henri, except that Linda's health was not good. Sometimes the doctor ordered her home to West Philadelphia, and Henri hated to be alone.

When the Allan Gallery asked him to organize a group show, he jumped at the chance to invite Glackens and Maurer and Van Deering Perrine. He loved to organize, had very definite ideas about how things should be done, and he was genuinely interested in getting a showing for his friends. His own work was doing very well—he had been invited to Chicago and the Carnegie International, but he wanted his friends to succeed and he liked to have his own group. He had no trouble with the National Academy, which showed and admitted him early, but the Academy was less than kind to his friends, and he wasn't able to dominate it. In 1902 he wrote, "I really do believe the big fight is on and I look for a great change in the attitude towards the kind of art I have been doing in the

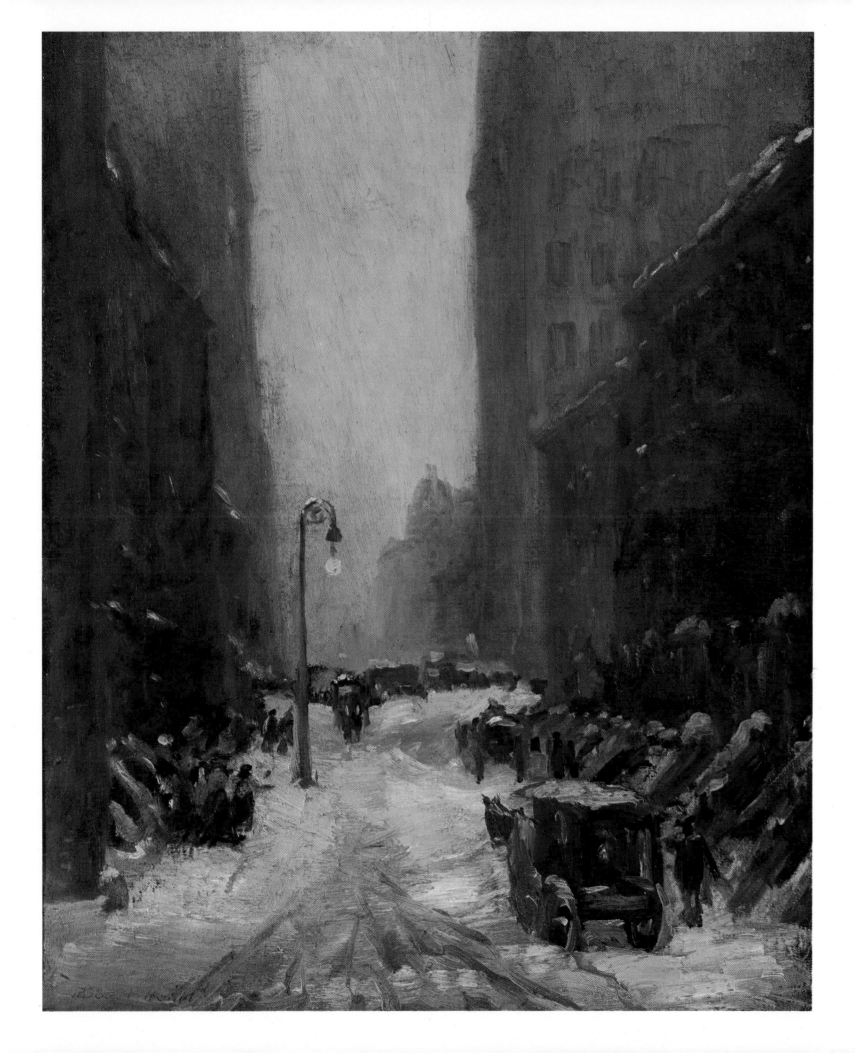

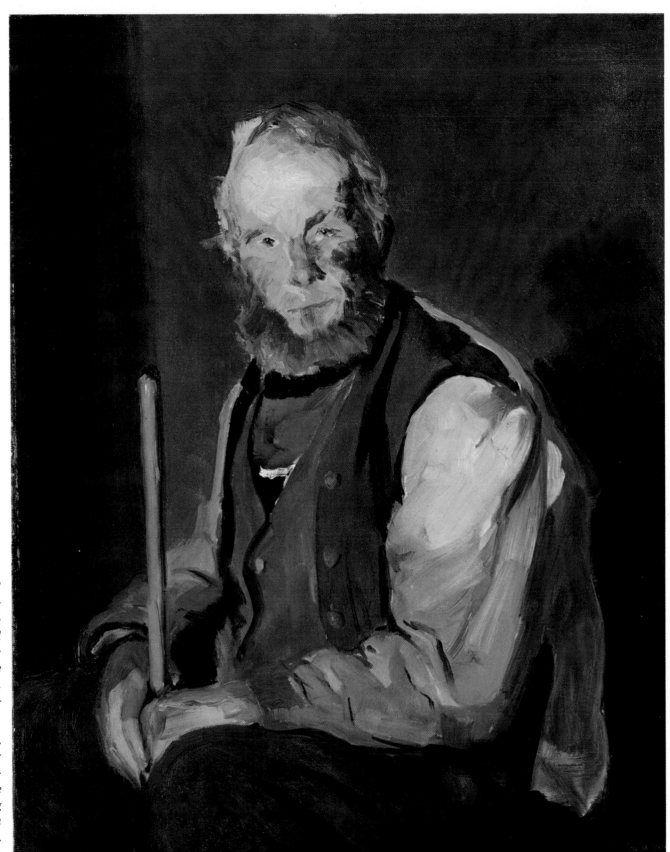

Himself, *1913. Oil on canvas, 32¼"*
x 26⅛" (Right). Henri spent his last
summers in western Ireland, where
he fell in love with the fishing and
the people. He was surrounded by
trout streams and characters. The
Art Institute of Chicago, Chicago,
Illinois. Walter H. Schultze memo-
rial Collection.

Night, Fourteenth of July, *ca.1897.*
Oil on canvas, 32" x 25¾" (Far
Right). Henri's early French land-
scapes, sensitive and moody, make
us regret that he gave up everything
to paint the figure. The Nebraska
Art Association, Lincoln, Nebraska.
Nelle Cochrane Woods Collection.

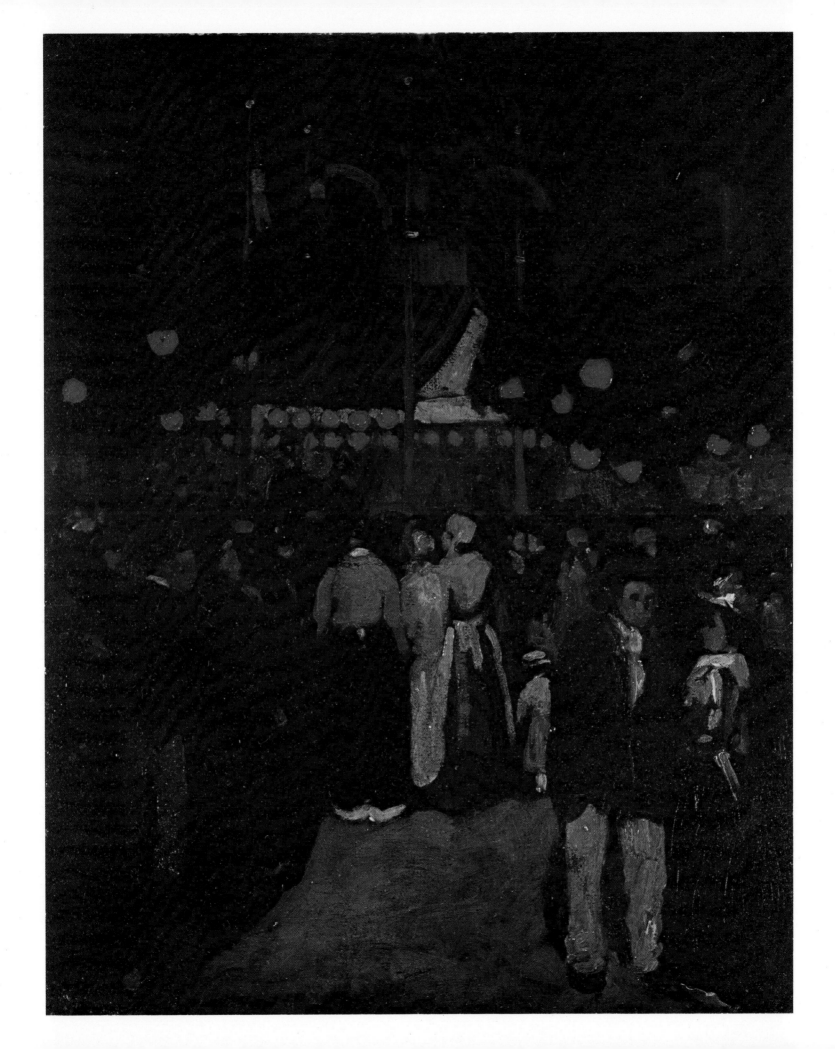

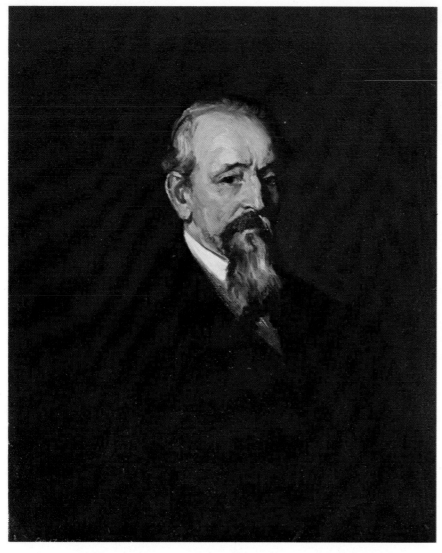

Portrait of John J. Cozad, *1903. Oil on canvas, 32" x 26" (Above). Henri admired his father tremendously, and his love for the hot-tempered, strong-headed old gambler shines through in this picture. For Henri, his father didn't have many faults, and he looked at him with a boy's wondering eye. The Nebraska Art Association, Lincoln, Nebraska. Mrs. A. B. Sheldon Collection.*

George Luks, *1904. Oil on canvas, 76½" x 38¼" (Right). Henri wasn't particularly close to Luks—his fastidiousness couldn't put up with Luks' outrageous and unpardonable behavior—but he certainly appreciated him as a character. By showing him in his dressing gown, Henri might have been hinting at Luks' laughable and unbelievable picture of himself as a prize-fighter, yet the big black tie reveals Luks' artist side. Henri caught the quizzical look in Luks' eye, as though Luks knew he was lying, and knew you knew. The National Gallery of Canada, Ottawa.*

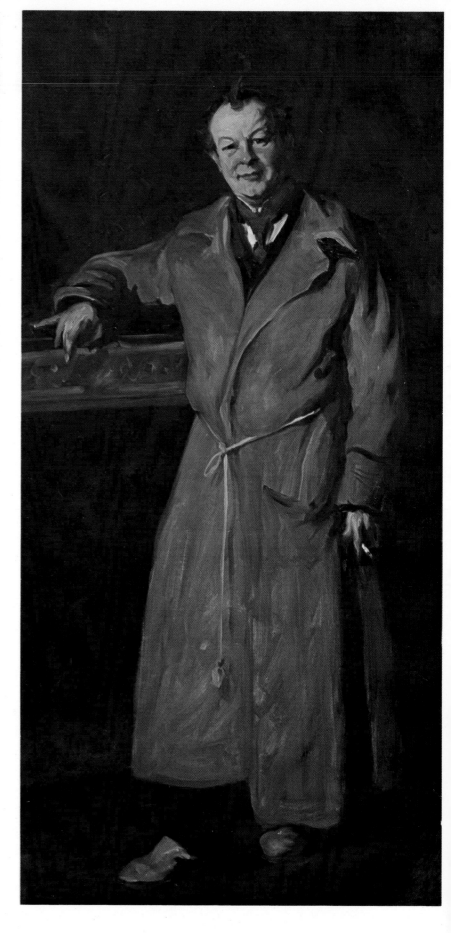

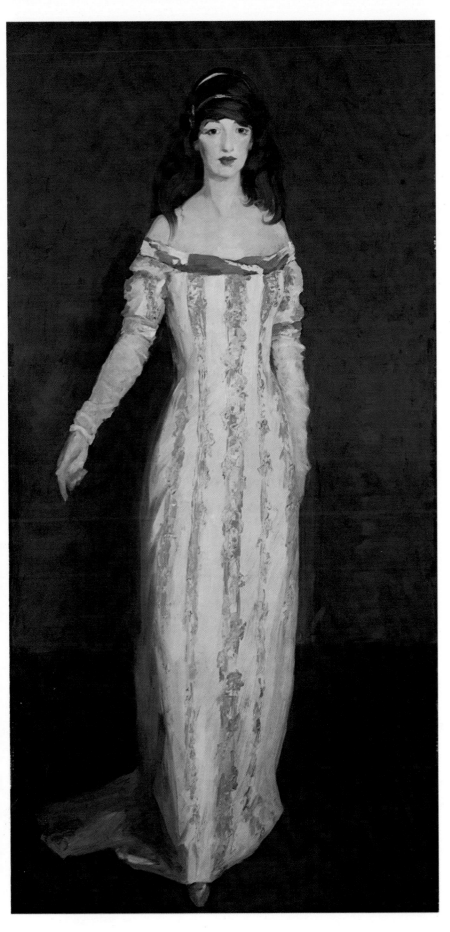

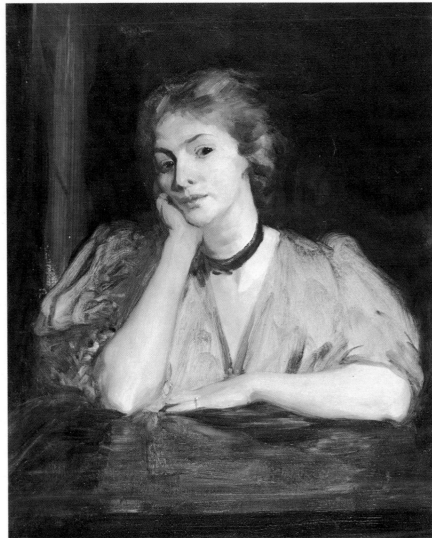

Miss Jessica Penn, *1907. Oil on canvas, 32" x 26" (Above). Jessica Penn was a well-known model, and this early portrait is quiet and penetrating, without the flash and brio that occasionally mar Henri's later work. Some of his remarks about portraits are noted in* The Art Spirit: *"Something you want to say definitely about the subject; this is the first condition of a portrait." "The work is done when that special thing has been said." "The color in her cheek is no longer a spot of red, but is the culminating note of an order which runs through every part of the canvas simplifying her sensitiveness and her health." (Henri p. 20). The Columbus Gallery of Fine Arts, Columbus, Ohio. Ferdinand Howald Fund.*

The Masquerade Dress, *1911. Oil on canvas, 76½" x 36¼" (Left). Marjorie Organ, Henri's young second wife, met him when she was doing a comic strip for the* Journal. *She first saw Henri at Mouquin's restaurant and then listened to some of his talks. He started painting her portrait two days after they met, and their courtship was a complete secret from all their friends. She gave up her career and devoted her life to "The Boss," sharing his travels and his work. The Metropolitan Museum of Art, New York, New York. Arthur H. Hearn Fund.*

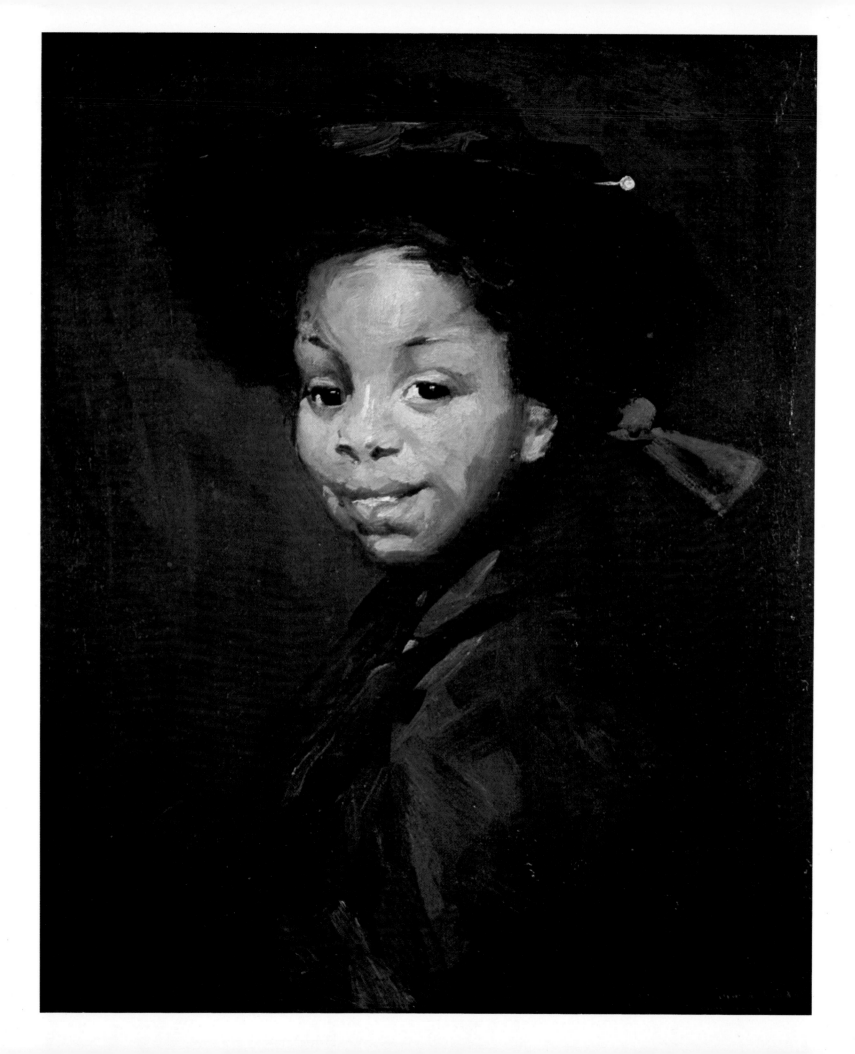

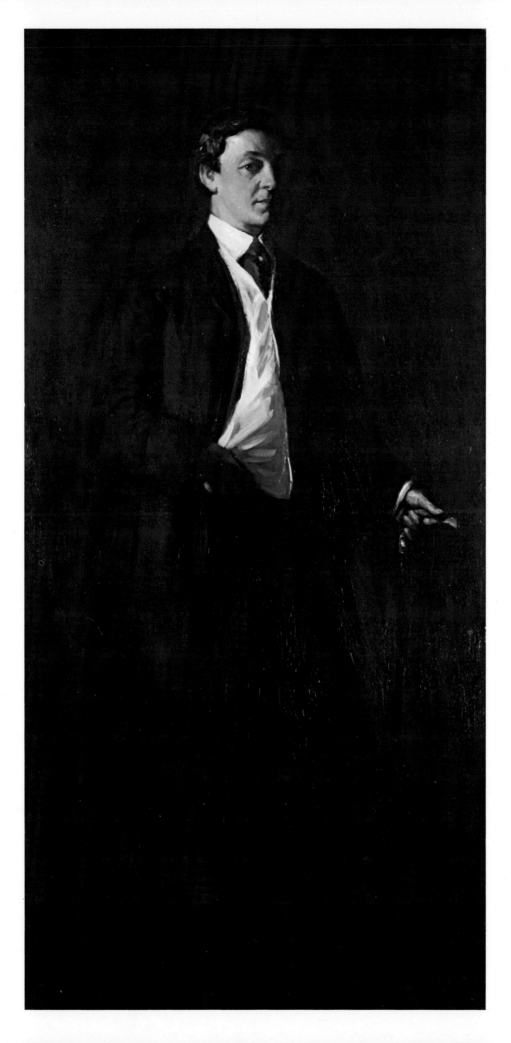

Eva Green, *1907. Oil on canvas, 24⅛" x 20³⁄₁₆"*
(Far Left). Henri, although he had no children
of his own, was fascinated by them. He was
very good at catching the flash of intelligence.
He said that he would rather see a wonderful
little child than the Grand Canyon. "The whole
canvas should be like a laughing person coming
into the room." (Henri, p. 259). He painted Eva
Green on Christmas Day, 1907; this time, he
caught the moment. The Wichita Art Museum,
Wichita, Kansas. Roland Murdock Collection.

Portrait of William Glackens, *1904. Oil on*
canvas, 78" x 38" (Left). Henri's portraits of
his friends and family are among the best things
he ever did. Henri was tremendously proud of
the men he had trained, and he took a great deal
of satisfaction in Glackens' and Sloan's ac-
complishments. The Nebraska Art Association,
Lincoln, Nebraska. Thomas C. Woods Fund.

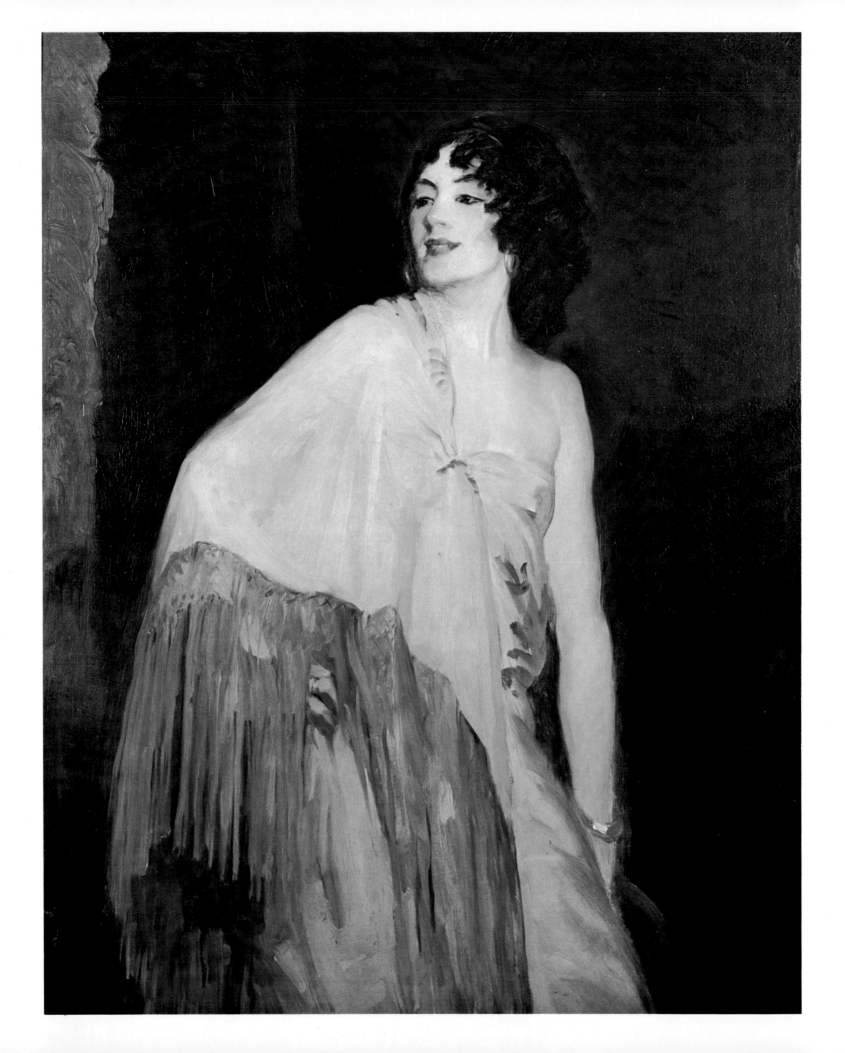

coming year. There are a number of us here now and all work on independent and personal lives—our own individual lives. Glackens, Davies, George Luks, Redfield and a few others, each different from the other." (Homer, p. 107).

In 1902 Macbeth gave Henri his first one-man show at a dealer's, mainly landscapes and scenes of New York and Paris. Henri had that high opinion of his own worth that sustains an artist; he was convinced the work was good and original. He felt that he was ahead of his time, but the critics were really very cordial. There were lots of newspapers in those days and writing was remarkably good; Frank Sullivan said that when he died he wanted to go where *The World* is, and work for it. Although the critics were their close friends and allies and gave the show good reviews, people complained that Henri's paintings were not finished, as indeed they were not, and only two paintings were sold.

He spent the summer of 1902 with Linda's family in the hill country up by Wilkes Barre, Pennsylvania. It was not a recipe for ecstasy, but it saved money and soothed other people's nerves. Henri was an extremely kind and considerate husband, which is more than you can say for many artists. His Pennsylvania landscapes have a note of their own; compared to the glorious American summer, a November day in France is very short.

In the fall of 1902, his second one-man show at the Pennsylvania Academy was a critical success. But the exasperatingly slow sales drove Henri to concentrate on figures, in the hope that he might make his fortune as a portrait painter, which he did not. He was not supple enough, either as a person or as a painter. That same fall, he began teaching at the New York School of Art, where Chase was the great star.

In 1903 Henri discovered the island of Monhegan in Maine, though there may have been painters there as early as the Seventies. He and Linda had been spending the summer in Maine when they heard of this island off the coast, where the boat with mail and whiskey comes once a day, and the fog about that often. The lobsters and steamers and surf were so remarkable Henri thought of building a studio there. Later George Bellows and Rockwell Kent, both Henri students, were also strongly attracted to the place.

In New York that winter, he taught four classes at the New York School and put on a show at the National Arts Club in the old Tilden house on Gramercy Park consisting of work by himself, Sloan, Glackens, Luks, Prendergast, and Davies. Despite the friendly critics, both Sloan and Luks scored low on gentility and finish. Occasionally Henri got a portrait commission, and he was very busy on juries and in art politics generally.

Then, after a long siege of illness in the winter of 1905, Linda died, with Henri's brother Frank as her doctor. Henri was not a very successful widower. He had been extremely dependent on her, as he was on people generally; he camped at the Sloans' every evening, not always in the best of humor, putting a strain on their relationship. "Henri at dinner and through the evening. We sit up until 3:00 a.m. for no reason whatsoever." (*John Sloan's New York Scene*, ed. by Bruce St. John: New York, 1965, p. 5). He pretty much moved in on them and had dinner there every night if he didn't have anything else to do, but he was often grouchy and bit their heads off. The Sloans had been very fond of

Dancer In a Yellow Shawl, *1908. Oil on canvas, 42¼" x 33½" (Opposite Page). Henri was intensely aware of the importance of rhythm. "When a fine dancer appears before you in a very significant gesture, you are caught only by the folds of her drapery. She has established in you a trend of interest. What enters your vision is only the sequences of this established interest." (Henri, p. 49). The Columbus Gallery of Fine Arts, Columbus. Ohio.*

Linda, and Sloan did a nostalgic etching of the four of them which gives the flavor of their evenings.

He spent a lot of his time at Mouquin's and the Café Francis, where he was the center of attraction. The Café Francis was owned by James B. Moore, who loved playing host to the gang, both there and at his home, "The Secret Lair Beyond the Moat" on West 23rd Street in the depths of Chelsea. He kept his charming girls there, whom he called his daughters. There was a shooting gallery in the basement, a metal frog for pitching coins, and a wall for his friends to paint on. Sadakichi Hartman said that "ever since his Paris days Henri has been known to surround himself with a crowd of artists, who, although no disciples, were willing to listen to his theories and criticisms, and to consider him as a sort of leader. At present he is the partriarch of the Café Francis crowd, a number of young painters, illustrators, and literati who believe in the poetical and pictorial significance of the "Elevated" and the skyscraper, of the city crowds and the rows of flat houses. To these men Henri expounds his philosophy of art, and he seems to take his monologues over his *entrée* or *café noir* as seriously as any of his brush performances."

In 1906, Henri became a full member of the National Academy, which meant official approval. He was teaching furiously and talking constantly, and he sold better than his friends. His portrait commissions advanced his fortunes if not his art. In the summer he took a class of young ladies from the School to Europe; Chase had been doing this for years, but it was still pretty dashing, and Henri was the most fascinating of widowers. They spent six weeks in Madrid; Henri loved Spain so much that he preferred its summer climate to New York's. Very much the lord and master of his class, he had a separate studio where he painted strident full-length pictures of his favorite dancers, gypsies, and bullfighters: they are splashy, picturesque, and brilliantly painted, though often clumsy and unconvincing. He had Spanish friends, writers, and the people he painted, so he was not dependent on his young ladies in the evenings. Evidently he spoke the language, or at least enough. He was particularly struck by the gypsies, who are indeed astonishing; they were the most savage people in color he had ever known. His *Gypsy Mother* catches the wild, almost mad look. They felt they were your equal, and that you were worthy of them. They had much respect.

Next winter he moved out of the Sherwood into a magnificent studio on Bryant Park for which he paid the exorbitant rent of $2,500 a year. He hoped that he would get enough portraits to swing it. Still lost without Linda, he was deeply depressed by the death in 1906 of his father who had been his model all his life. His mother moved into the studio for a while but the Sloans felt he was not always very considerate.

Sloan said that Henri "won't do the five o'clock tea drinking that is necessary for portrait work in this country today," but it was not that simple. (Van Wyck Brooks, *John Sloan: A Painter's Life* New York: 1955, p. 83). Like his father, he enjoyed fights and provoked them. In 1907 he had an unusually severe run-in with the Academy jury, which turned down the work of his friends. People wanted to know if he was going to

start a secession; that was the new European word. In the spring there was a lot of talk about the gang's having a show of their own. Through Davies, Macbeth agreed to let them have his gallery for two weeks in February 1908. The original group consisted of Henri, Luks, Davies, Glackens, Sloan, and Lawson, later joined by Shinn and Prendergast. The five from Philadelphia had a unified style, while Davies, Lawson, and Prendergast were asked to join because they were personal friends and strong painters in their own right.

The term "The Eight" was first used in print by Frederick James Gregg but he may not have invented it. Having *The Sun* at their backs was a great advantage; American artists have rarely had the critics in their pockets. Henri, with his flair for publicity, handled the press. "All are men who stand for the American idea. It is the fashion to say that skyscrapers are ugly. It is certain that any of The Eight will tell you: 'No, the skyscraper is beautiful. Its twenty stories swinging towards you are typical of all that America means, its every line is indicative of our virile young lustiness.'" (Homer, p. 131). Davies, Lawson, and Prendergast would never have said anything of the kind.

Henri was a very competitive man, and by the end of 1907 he had taken away Chase's students, forcing him out of his own school so that Chase had to go back to teaching at the Art Students League. Henri thought he had the future in his hand, and indeed many of his ideas are still around. In his class, students expressed their personalities, just as in a progressive school.

That summer he took another group to Haarlem, his cathedral town. He loved the Dutch, and he was incredibly prolific. He was at the top of his bent, and his Dutch children became famous. He may have painted better before, but this is the way he painted from here on out; very brilliant, very appealing, and rather superficial. He was so appreciative a traveler that when he got back to New York he found Holland sunny by contrast, which no one else has been able to do. While he was away the infinitely obliging Sloans had moved him into another spectacular but less expensive studio in Tonetti's barn; it's doubtful if he noticed, since he took generosity for granted.

In the great exhibition of The Eight at Macbeth's in February, 1908, each man got twenty-five running feet of wall space. Henri had worried about the show but it was a tremendous hit. Attendance averaged 500 people a day and they were flooded with publicity, most of it favorable. When the show closed, Sloan said: "We've made a success—Davies says an epoch. . . . Macbeth is pleased as punch." (Homer, p. 138). What's more, they sold: two Henris, two Davies, one Shinn, one Luks, and one Lawson. Four were bought by Gertrude Vanderbilt Whitney.

They deserved their success, for they had never painted better. Henri's six pictures are among his best. The right wing howled at their radicalism, which only aroused the public's interest, but as *The Sun* correctly said, "Any young painter recently returned from Paris or Munich—the Munich of the secessionists—would call the exhibition of The Eight painters very interesting but far from revolutionary."

During the spring of 1908 Henri was elected to the National Institute of Arts and Letters, which is about as conservative as you can get, and just before taking his class to Spain he married Marjorie Organ, a twenty-two year old red-headed cartoonist on *The Journal*; she must have had talent, for she started out as a cartoonist at the age of seventeen. As Flossie Shinn wrote, ". . .no one knew Henri was married until they were all on board (not even the Sloans). Think of the consternation among the twenty pupils! Wouldn't it jar you to think you were sailing with an eligible painter (first having invested in a becoming steamer rug, a sea-shore bag, and scented soda mints) and then be confronted with a golden-haired bride, just as the gang plank creaked its good byes to the gaping crowd!" (Ira Glackens, *William Glackens and the Ashcan Group* New York: 1957, p. 110).

Marjorie loved Spain, and the great Spanish life took up again, with the tremendously long nights. Henri worked furiously, but these are not his best paintings: they are harsh, heavy, and badly drawn. They spent a month in Paris on the way home, and after seeing thirty pictures by Matisse at the Salon d'Automne Henri firmly believed that The Eight exhibition was much more notable.

During the winter of 1909, because of trouble with the New York School over slow pay, he opened his own school in the Lincoln Arcade, a fabulous rabbit warren of studios and machine shops on Broadway at 69th Street, with Eugene O'Neill bunking on the floor in the corner and Prince Troubetzkoy down the hall. Here Henri had his greatest success as a teacher; everybody from Guy Pène Du Bois to Paul Manship studied with him. Because of Marjorie, who was his favorite model, as Linda had been, he had his evenings again, and the studio overflowed with friends and students, talking about everything under the sun. Henri didn't just teach painting—he taught a way of life.

The original show of The Eight was still touring the country when Henri and his friends began planning much larger exhibitions. Shinn later said that there was no demand for their work, but they still needed a place to show. In 1910 Henri and Sloan, Davies, Walt Kuhn, and Walter Pach put on the tremendous "Exhibition of Independent Artists," with 260 paintings, 219 drawings, and some sculpture. It was the first wide-open, no-jury, no-prize exhibition in the country. All The Eight were in it except Luks, who had a show of his own coming up. There were so many people at the opening they had to send for the police. As Sloan said, "it was terrible but wonderful to think that an art show could be so jammed." (Homer, p. 154). It was a remarkable tribute to Henri; at least thirty-eight of the hundred artists were his pupils, and many of the others were old friends from Philadelphia and Paris. In every respect, including the fact that sales were poor, the Independents came straight out of The Eight. They thought they were against cliques when in fact they *were* one. Not everyone adored Henri, and lots of independent artists stayed away.

Like the exhibition of The Eight, the Independent Exhibition of 1910 was Henri's idea, and he dominated it. The Armory Show in 1913 was his idea, too, until it got out of

hand. His influence was very strong in the American section, which Glackens selected, but few people looked at the American section. The men who ran the Armory Show—Davies, Kuhn, and Pach—were Henri's men, but the international section ran away with them. Henri withdrew from the management not out of shyness but because he disapproved and knew what was coming. He was just as familiar with modern art as Davies or Walt Kuhn, and he did not see how it could do them any good.

From his own point of view, Henri was right, for the Armory Show destroyed his position as head of the progressive forces in American art. After 1913, The Eight were old hat: something fatal had happened to them. The show shook Henri's hold on the group, and even Sloan drifted away. Henri was no fool, and he caught on fast. He did not make a fuss about it, but his ascendancy over The Eight and over the fighting edge of American art was broken. More and more, he turned from his friends to his pupils; his private world, which he had thought included everything, became undeniably private again.

With his own school, his new studio on Gramercy Park, his shows, and his painting, Henri led a busy life. "I am at one time my own business man, secretary, laborer, canvas stretcher, errand boy. I attend to shipments of pictures, framing, glass cleaning, necessary social festivities, recovering business relative to art movements. I must respond to the demands and enquiries of some students who came to me in the spirit of students to master for years. I have come very close to working 18 hours a day at my job." (Homer, p. 195). Even he could only paint so many hours a day. People felt that the teaching cut into his painting, but he painted all he could and more than anybody would buy. He had energy to burn. Forbes Watson said that Henri was "an inspired teacher with an extraordinary gift of verbal communications, with the personality and prophetic fire that transformed pupils into idolators. He sought, above all else, to cultivate spontaneity. He always attempted to bring out the native gift. He gave his followers complete respect for an American outlook." (Henri, p. 5). Henri would have been proud of most of it, and he would have agreed.

Forbes Watson said that in Henri's *The Art Spirit*, the book of his teachings collected by a devoted student, those who knew him can recognize the very tones and manner of utterance that he employed, yet from the very beginning his book strikes a note that is lacking in the paintings. "There are moments in our lives, there are moments in a day, when we seem to see beyond the usual. Such are the moments of our greatest wisdom." This insight is not always present in the bravura painting, the blinding highlights, the square black shadows.

He had a high sense of mission, for he believed that the work of the art student is no light matter. His teaching is both more serious and more subtle than his own very direct work, with far less striving for effect, far more attention to tone.

He had little interest, he said, in teaching his students what he knew; he wished to stimulate them to tell him what they knew. Some of his judgments are no longer true:

"Art tends toward balance, order, judgment of relative values, the laws of growth, the economy of living—very good things for anyone to be interested in." (Henri, p. 15). He stresses the element of enjoyment and happiness in a way that is now unacceptable. "A work of art which inspires us comes from no quibbling or uncertain man. It is the manifest of a very positive nature in great enjoyment, and at the very moment the work was done." (Henri, p. 16.) For Henri, the brushstroke at the moment of contact conveyed inevitably the exact state of being of the artist at that exact moment. This is not true of all painters; he was thinking of himself, and Frans Hals. For an artist to be interesting to us he must first be interesting to himself.

He became so much the studio artist, tied to his model and his easel, that it's surprising to be told that "the sketch hunter has delightful days of drifting about among people, in and out of the city, going anywhere, everywhere, stopping as long as he likes. He is looking for what he loves, he tries to capture it. Happy the man who has memories of days of this sort, of wonderful driftings in and out of the crowd." (Henri, p. 17). The sketches, "or rather the states of being and understanding we had at the time of doing them all, are sifting through and leaving their impression on our whole work and life." (Henri, p. 18).

He stressed the predominant value of gesture, yet most of his figures are standing still, even the dancers. But when he said you should work with great speed, that there is no virtue in delaying, he was certainly giving his own method. He has fascinating things to say about backgrounds, for he believed that all things change according to the state we're in. No one outside the Orient ever gave so much attention to the brushstroke. But it is harder to see than to express; for Henri, Rembrandt was a man of great understanding, who had a rare power of seeing deep into the significance of things.

He was very good on the sudden insight, the moment of vision, the happiness it gives, and the pleasure of expressing it. His system is simple and direct: what the artist feels, the viewer sees, for beauty is the sensation of pleasure in the mind of the beholder. A surface painter, he felt that there was an undercurrent, a real life beneath all appearances everywhere. "I do not say that any master has fully comprehended it at any time, but the value of his work is that he has sensed it and his work reports the measure of his experience." (Henri, p. 92). The artist sees with the same exceptional insight and joy that you feel when you look at his picture: if you want to know what the court of Spain was like, you can find its soul in Velásquez.

Henri was an excellent painter and a wonderful teacher, but his ventures into technical theory were unfortunate. Disregarding his own warning that painting is a mystery, he came to believe that there was an infallible system, and that the Chicago painter Hardesty Maratta had found it. Once Henri's mind was convinced, his art was powerless to protect him, and through his influence, Sloan, George Bellows, and Eugene Speicher were badly affected. Their friend, the critic and painter Guy Pène Du Bois, had every reason to say that systems are crutches for the lame in art.

Maratta, who had gone into the business of selling paints, promoted a line of colors that were intended to take the uncertainty out of painting. Henri fell for the whole theory—hook, line, and sinker. Yet Henri was not a susceptible man, for he did not fall for theosophy or cubism or psychoanalysis. What is more, he was in the Messiah business himself, he had his own message to the world. It was not only colors that Maratta sold, he had a system of composition as well which ensured the production of fine paintings almost on demand.

Nowadays, the Maratta system is hard to accept. Perhaps by 1910 Henri had already lost his way and was looking for the light. His painting was not improving, and all around him he heard strange voices warning him that he was headed in the wrong direction. He knew what was going on in Paris, even if he did not believe it. Maratta gave him a counterfaith firmly based on science. What more could a reasonable man want? Henri admitted to a certain mystery about painting, not only in the color, but in the proportion, yet this element of darkness is irksome to a reasonable man. How much better to have a system of color combinations and geometric ratios that not only explained the great paintings of the past, but could produce the perfect pictures of the future?

It was less surprising that John Sloan, who was a humorless man rather given over to systems, ate up this doctrine of salvation, but there must have been some crack in Henri's determined mind by which it could enter. Maratta was a constant visitor to the studio, where Henri became deeply involved in the geometrical construction of pictures, which he investigated with his usual thoroughness; an extraordinarily methodical man who came late to spontaneity, he kept such detailed records that a caricature by Sloan shows his studio stacked to the ceiling with bundles of documents, like a lawyer's office in Balzac.

Maratta's definitive treatise never appeared, but he put out a chart for finding triads and chords in sounds and color, in which the twelve-tone scale had its exact color equivalents, and he published a set of diagrams called "The Web of Equilateral Triangles." Henri and Sloan, Bellows, and Randall Davey spent a tremendous amount of time working on these theories. Henri designed a set palette with separate colors prepared in advance. If the resulting pictures turned out to be poor, Henri admitted that you had to use your head a bit.

Maratta was one of many prophets abroad in the land, all of whom had their converts. Jay Hambidge, a Canadian illustrator, held forth on mathematical theories of composition in a 10th Street bar, and Henri and Leon Kroll attended his lectures along with Alfy Maurer, whose head was not very solid. The atmosphere of these earnest searchings in Greenwich Village studios on gray November evenings is hard to recapture. After World War I Hambidge taught at Harvard and Yale, and his books on dynamic symmetry were considered prophetic, even revolutionary. Henri and his friends wanted scientific answers, and they got them from Maratta and Hambidge. Why should art be a mystery? Henri laboriously worked out Hambidge's theory in a manuscript which

still survives, like an alchemist's log.

The effect of these theories on Henri's painting was far from good. His work had already leveled out and Maratta and Hambidge did not help. After the Armory Show in 1913, Henri's influence shrank, due to causes as well. He had thought that he and his doctrine would be the art of the future. They were not. They were not rejected all at once, and their decline didn't happen merely because of the Armory Show, for we exaggerate the importance of specific events. It was a gradual process. Henri did not compromise with abstraction or pretend it was not there; he had his own vision. But the other vision was the one which spread.

John Sloan's place as disciple was taken in later years by George Bellows, who lived right around the corner on 19th Street. One of those happy artists who are immediately successful, Bellows was very good company, and Henri did not resent his pupil's rapid rise. As generous as ever, Henri was still a famous and successful painter. Things were always good with Henri, but it was clear that they would never be great. He played pool at the National Arts Club or went to the prize fights with Bellows. He liked to walk the streets at night and look in the hardware store windows, for he found life and the city everlastingly interesting and even beautiful.

Always a great reader, he read George Moore aloud to Marjorie. They went to see Eugene O'Neill's plays at the Greenwich Village Theater and Chekhov at the Cherry Lane. Like so many of these men, he was a tremendous admirer of Isadora Duncan. He was still influential in the art world and so good at finding money for struggling artists that even Everett Shinn remarked on the important people he knew; if there had been foundations in those days he would have been a consultant. His Gramercy Park home was crowded with people, the way he liked it, not just the old gang but rising talents, like Gifford Beal and Paul Dougherty. Marjorie was a good hostess, though J. B. Yeats chided her for dropping her own work. Guy Pène Du Bois said Henri was man enough to have a great many enemies, but Du Bois liked that kind of statement; other artists were a little jealous of Henri's ascendancy, for they had their own hunger for greatness.

During the summers he concentrated on his painting. World War I didn't bother him personally, though it kept him from the Europe he loved and sent him to Santa Fe. He found his people there too, Indians and Mexicans, people with dignity and character. It is a tribute to Henri that he found so many of them, everywhere.

On their first trip to Ireland just before the War the Henris went to Achill Island, off the coast, which they found unbelievably primitive and unspoiled. After the war they bought "Corrymore," the farthest west house in Ireland, which had belonged to the famous Captain Boycott. Henri painted the children and fished for trout, though the local people thought him mad, when the sea was full of cod. He loved the life. "There is nothing to equal this way of working. No telephone, no visitors, I don't even read the newspapers. . . half the day is in the studio and the other half is in the open, rain or shine, on the lake, and a lot of climbing over the rough bog." "The Boss," as Marjorie called

him, "started in fishing right off—no painting for the first six weeks—just outdoors from about two until midnight. He and Pat fortified by a fine lunch and a flask of Irish. . . . We have dinner at midnight, then each to his favorite couch to read. I last until about l:30 and then drop off. It's always three and often later when we mount the stairs to the bedroom. Day is on and great drawings are out the window if I wasn't so sleepy." (Glackens, pp. 224–225).

When Henri died in St. Luke's hospital of bone cancer in 1928, he was surrounded by canvases and fishing tackle. In one of his letters from Santa Fe he had written: "I am having a wonderful time in my life," and it was true. (Homer, p. 203).

At Knoedlers, *pencil, 8" x 10". Collection of Knoedler and Company, New York, New York.*

JOHN SLOAN 1871–1951
No Ordinary Man

John Sloan was born on August 2, 1871, in Lock Haven, Pennsylvania, a lumber town on the Susquehanna, where they locked up the girls in the spring to save them from the loggers. His father's family were cabinetmakers and undertakers—the two went together in those days—while his mother's family made paper. There's a mill in the town still. His great-grandfather was a cousin of Joseph Priestley, the discoverer of oxygen. "I used to spend happy hours visiting my great-uncle Alexander Priestley, considered a failure because he drank sherry and did not make money. He had a wonderful library and a print collection with elephant folios of Hogarth, Rowlandson, and Cruikshank." He also had the great magazines illustrated by Leech and Abbey. "One of the most shameful memories I have from my childhood is an occasion when Uncle Alexander came to call on us. I went to the door, and smelling the sherry on his breath I turned him away." (Helen Farr Sloan, *John Sloan's Poster Period:* Lock Haven, Pennsylvania, 1967, pages not numbered). Sloan always associated prints with the smell of sherry and pipe tobacco.

When Sloan was five the family moved to Camac Street in Philadelphia, where the clubs are. He spent every Saturday at the public library, and by the time he was twelve he had read through Shakespeare and Dickens. He started to draw at Central High School, where he was in the same class as William Glackens and Albert Barnes, who later discovered Argyrol, but they were interested in baseball.

Sloan always had summer jobs to help out, and he could never bear to remember the expression of defeat on his father's face when he told him he had to leave school. At age sixteen Sloan took over as head of the family, giving up his dreams of dentistry. His father walked with his head bowed for the rest of his life. Sloan went to work at Porter and Coates, the principal bookstore in Philadelphia, where he read Balzac and Zola in his spare time and made copies of Dürer and Rembrandt which the store sold for five and ten dollars apiece. He taught himself how to etch from P. G. Hamerton's *Etcher's Handbook.*

Sloan had been brought up on the drawings of the popular English artist Walter Crane, and he was good at writing light verse for greeting cards. When one of the assistants in the store, A. Edward Newton, left to found his own business he took Sloan along to design calendars, match covers, and the like. Hand-painted boxes for Maillard chocolates were the main account. The twenty to sixty girls in the shop kidded Sloan unmer-

cifully, for he was always a soberside. Newton, whom he did not like, offered to send him abroad to study, but he refused the offer because of lack of interest in art. Later, when Henri urged him to go, he was "afraid of being caught in the snares of the art student's life in Paris—all that business of piling up saucers on café tables with a housekeeper mistress on the side." He was not very gracious about Newton's offer, which he felt was a threat to his independence.

Sloan lived with his parents until he was thirty, but when he took up free-lancing he rented a six-by-ten studio on Walnut Street, and as a result all his life he liked to etch in a small room. When he called on the art department of *The Inquirer* with his portfolio, they offered him a full-time job. He had no facility for quick reportorial work but the editors liked the poster-style drawings he did for the feature pages and the Sunday Supplement. He learned his technique from Walter Crane's drawings, from Japanese prints, and from a Japanese artist who came over for the Chicago Exposition in 1893. This style, out of Botticelli by Art Nouveau, supported him for years; it has absolutely nothing to do with the realistic city pictures for which he is now famous. His newspaper work was pure Philadelphia illustration, in the tradition of Edwin Austin Abbey, Howard Pyle, and N. C. Wyeth. He referred to his ten years on the newspaper as "my college years." He had no interest in painting, and if he had not met Henri, his father in art, he would have remained an illustrator, like Joseph Pennell.

In 1892, Charles Grafly introduced him to Henri, just back from Paris. This was the beginning of art for Sloan and for the whole Philadelphia crowd. They all called Henri, who was 31 at the time, "the Old Man," and Henri would have enjoyed the thought that he had a Svengali effect on them. When they had drifted apart, Sloan resented Henri's influence and he maintained Henri was blind to the intellectual substance of art, but in these early days Sloan's attitude was one of adulation, which Henri was quick to appreciate. Henri taught him everything. Most painters who amount to anything make it on their own, but Sloan as a serious artist was Henri's creation and the same is true of Glackens and of Shinn. This probably applied to Luks also, but Luks never would admit anything. Sloan's best pictures, painted under Henri's direct influence, are perhaps better than anything that Henri ever did.

Henri was not only Sloan's technical and artistic teacher, he formed his outlook on life and gave him support and encouragement over the years. When Henri said that contemporary success meant ultimate failure, Sloan applied it to himself; if his pictures did not sell, they must be good, and it turned out he was right. According to Van Wyck Brooks, Henri was a domineering older man who liked to lay down the law, repelling those who refused his domination. But Brooks knew Henri much later, when he was more set in his ways; in the great early days, there is no evidence that Henri repelled anybody. Sloan did not think he would have been a painter if he had not come under Henri's direction; Henri could make anyone want to be an artist.

The two men could not have been more different. Henri was a commanding person-

ality who loved to shine, while Sloan was a prickly man, all bristles and sharp edges, though later in life he liked to hold forth well enough. It was Sloan's fierce independence that made him the perfect disciple; nobody could say that he was a lap dog. A painfully slow worker with absolutely no facility, Sloan had a great deal of trouble getting the time he needed to paint, while Henri knocked his canvases off in the morning. According to Henri, Sloan was the past participle of "slow."

Sloan called his new and larger studio on Walnut "a home for homeless and indigent artists of the press," (Van Wyck Brooks, *John Sloan, A Painter's Life:* New York, 1955, p. 21) many of whom ended up as commercial artists, which is a good way to earn a living but not to make a name for yourself. The forty years between the first illustrated newspapers and the triumph of photo-engraving were great times for artists. There was tremendous demand, and many men who could draw didn't want to paint, and were not interested in art. The art department of *The Press*, where they all hung out, was a grand dusty cavern with drawing boards and cockroaches. Sloan looked back upon these days with more nostalgia than Henri, who did not relish his cot in Sloan's studio after Paris.

Sloan may not have been a fast worker but he was remarkably steady and conscientious: for ten years he was at his desk from two in the afternoon till eleven in the evening, drawing decorations, headings, tailpieces, and a full page for the Sunday paper. At *The Press*, in the Walnut Street studio, and later in New York, Sloan and his friends formed a mutual admiration society, bolstering each other up. You can do it by yourself, but it is much easier if other people help. There is a real group phenomenon in talent, and this group had it. They were a real school, perhaps the best defined school we've had up to the Stieglitz Stable, and until their own admirers came along they admired each other. Henri was tremendously generous with his praise, and his praise was self-realizing. It is wonderful to be told that you are as grand as you think you are.

The last to leave Philadelphia for New York, Sloan made one false start, when Glackens got him a job on *The World*, but he said that nobody worked hard enough in New York, which is difficult to believe. Probably Sloan was afraid to leave the nest: he was a late learner, set in his ways, and fearful. Henri bucked up his spirits and bombarded him with good advice from Paris and then from New York: "You want to be a great artist . . . a man to make anything of himself has got to flock by himself." (Brooks, p. 34). For Sloan was lonely in Philadelphia after the others left. "If I don't have some companionship damned if I don't think I'll be driven into marriage." (Brooks, p. 40). Henri was worried about him: "Don't in the heat of the thing ruin your chance of success and of life's happiness by any too hasty doings." Henri lectured him about girls, and how terrible it was to marry the wrong wife. "Your success and happiness mean a great deal to me. Of course I am not worried about your taking a mistress and all, most men do more or less. . . . Don't forget that you are John Sloan, and don't give up the old studio ideas. For you are no ordinary man." (Brooks, p. 33).

When Sloan married Dolly Wall, the match had all the elements of disaster. Dolly's

Book Presentation to Henri, *on publication of* John Sloan *by Albert E. Gallatin, January 1926. Pencil, 12" x 8". Collection of the Chapellier Galleries, New York, New York.*

father was an Irishman who claimed to be the inventor of naphtha soap, but her parents died when she was young and her brother farmed her out with the Good Shepherd Sisters, where she stayed until she was twenty. She started drinking at fifteen and had a complete blackout on the five years she spent in the convent. After Henri left the Walnut Street studio the gang used it for their parties, and Dolly used to come in to clean up. She was four feet nine inches tall, exactly Queen Victoria's height, imperious enough, but also alcoholic, manic-depressive, and suicidal. Yet in many ways she was good for Sloan. She made him stand on his own two feet, and she got him out of the house where he was being smothered by his mother and father and his two sisters. She made a man out of him, she made him take care of himself and of her, she got him out of his rut and out of Philadelphia. Without her, it's doubtful if he would have done any of these things. When sober, she was completely loyal, spunky, affectionate, and an excellent cook. She made a home and a life for him. She never pushed him for money or success; she believed in him completely and she made him believe in himself. Sloan came first. She helped him to be John Sloan. She was very important in his life, more than most wives are. She was a pusher and a doer, and she was Sloan's outboard motor as well as his game leg.

When they moved to New York in 1904, they lived in a studio in Chelsea and Sloan finally got to work on his painting. The studio was hot in summer, cold in winter, and when Dolly felt lonely she went back to Philadelphia to get drunk. In New York she thought the wives of Sloan's friends looked down on her, and she was probably right. Edith Glackens came from West Hartford, which still takes itself seriously, while Shinn's wife belonged to the rich Biddle family; even though she claimed to be a poor Biddle, this was enough to put Kitty Foyle at a shattering disadvantage any time. She got along well with Linda Henri and the two couples saw a lot of each other in New York. But Dolly was from the wrong side of the tracks, that's what it amounted to.

The diary that Sloan kept for his first eight years in New York recaptures a great island of the past; it's by far the best source of the period, with all the unexpectedness of the truth. The very first entry, January 1, 1906, is a startler: "Played golf today with Henri and Davis!" (Bruce St. John, *John Sloan's New York Scene 1906–1913:* New York, 1965, p. 3). They welcomed the New Year at James B. Moore's "Secret Lair Beyond the Moat" and the Davises came to dinner with their boy Stuart. Sloan had known Davis on *The Inquirer* even before Grafly introduced him to Henri. On the 5th of January there was another party at Moore's, in the shooting gallery in the cellar. Obviously, New York was not such a bad place after all; they were all having the time of their lives, except for Henri. On the 7th, "a sad but very beautiful afternoon," (St. John, p. 4) just after Linda had died, they went to Henri's studio in the Sherwood Building and Henri gave Dolly some hats and dresses. They ordered a beautiful planked steak at the Café Francis that night but the waiter slipped and they ate roast beef instead. Sloan was always bringing people home to dinner, and Dolly never minded; it was grand for him to have a home and a woman of his own. After Linda's death Henri was closer to them than he

had ever been, even dependent, and this change in his relation to the moody man he so much admired was a great boost for Sloan.

On January 8, Ernest Lawson came to dinner, and there was the first mention of "some seven of the crowd" (St. John, p. 4) chipping in ten dollars a month for a year to pay the expenses of an exhibition. On the 11th and 12th Henri stayed till after three, but that was all right, Sloan was not an early riser. All during this time he earned his bread and butter by doing a big weekly drawing for the *Philadelphia Press* in which the women's figures have long curling lines like waves.

In these Chelsea days, Sloan painted his masterpieces. The notes in the diary often refer directly to his best pictures. "A clear, very cold day, and the streets very beautiful with snow. Madison Square at dusk with lights and snow. The old Fifth Avenue Hotel as seen across the snow covered place, the electrical signs against the western sky looking down 23rd Street from 6th Avenue." (St. John, p. 4). This is vintage Sloan, and the last part at least is a direct description of *Sunset, West Twenty-Third Street*, which he was working on at this time. "Saw young girls at their lunch hour strolling through the path arm in arm—benches on either side filled with all sorts of men interested in them and not interested in shade of trees, heat of sun, odors of human life, and sweat." (St. John, p. 47). And, "In the afternoon, walking on Fifth Avenue, we were on the edge of a beautiful wind storm, the air full of dust and a sort of panicky terror in all the living things in sight. A broad gray curtain of cloud pushing over the zenith, the streets in wicked dusty murk." (St. John, p. 40). This is the start of *Dust Storm, Fifth Avenue*, which Sloan sold to the Metropolitan in 1921, the first painting bought by a museum. And the following passage certainly refers to *Nurse Girls, Madison Square:* "A group of young hoydens on an early spring day are very consciously entertaining the men of leisure who occupy the benches. Meanwhile, their charges shift for themselves." (St. John, p. 126).

Sloan had exhibited in the Pennsylvania Academy Annual, perhaps the most important show in the country, as early as 1900, and in that year he also exhibited at the Carnegie Institute in Pittsburgh and the Art Institute of Chicago. These psychological successes can be even more important than sales—they are what an artist is working for. He had more praise at this period than at any other, and contemporary judgment was right. The pictures of this period are masterpieces, and people knew it at the time and told him so. They helped him believe he was a great man, which is what he wanted to be.

John Butler Yeats called Sloan's New York pictures his poems about the city: "A window, low, second-story, bleached blond hairdresser bleaching the hair of a client. A small, interested crowd about." (St. John, p. 133). "Walked through the interesting streets on the East Side. Saw a boy spit on a hearse, a shabby old hearse. Doorways of tenement houses, grimy and greasy door frames looking as though huge hogs covered with filth had worn the paint away and replaced it with matted dirt in going in and out. Healthy faced children, solid-legged, rich full color to their hair. Happiness rather than misery in the whole life. Fifth Avenue faces are unhappy in comparison." (St. John, p.

13.) Guy Du Bois said Sloan was a little sentimental about the East Side, as were many who did not live there. He saw the roaring life of the streets, not the sick people inside. His best etchings were done at this time too; for a while, he could not miss, and all his work was good.

When he and Dolly were flush they went to Mouquin's to celebrate. They were always surrounded by friends, new and old, but mostly old. When he saw Shinn he was "always warm to him tho he's mighty different from the scalawag that worked with me ten years ago on *The Inquirer* and *The Press* in Philadelphia. He left me saying that he had an engagement with a ten millionaire uptown." (St. John, p. 14). One night on the town he and Morrice discovered that they had had a great deal to drink, which was not unusual. "Morrice eating onion soup with cheese in it was an amusing bald head and strings of cheese that hang to his beard [sic]. George Luks discoursed on the merits of *The Ingoldsby Legends*, and was amusing and quiet." (St. John, p. 16). The next day Sloan woke with a much deserved headache, but Dolly, little dear, had to stay in bed all day, which she often did. Morrice came in just before sailing and Sloan gave him an etching. "He says he will send me a panel when he gets to the other side. I hope he don't forget it for I regard him as one of the greatest landscape painters of the time." (St. John, p. 16). He didn't forget, and Sloan always kept Morrice's picture on the mantlepiece in the studio.

Sadakichi Hartman came to call with Albert Groll, a stern man whose high-skyed landscapes of the Southwest made a tremendous hit. Hartman was one of the first to recognize and write about Sloan's city pictures. But life was not all roses. Sometimes when they had friends for dinner Dolly could not make it. Forty years later, Sloan spoke about the "sad and terrible times we had in those first New York years. . . . Dolly was having the D.T.'s. Some of our friends knew what the trouble was. . . . Others were her worst enemies, getting her started on drinking bouts. I never knew where she got the liquor she hid around the house, or the money to buy it. I tried to repay friends who loaned her money. . . . It is the thought of debts I know nothing about, which is unbearable." (St. John, p. 19).

Sloan took over Henri's classes at the New York School when Henri went off to Aiken, South Carolina to paint the portraits and live the life of the rich. After three days, Sloan decided that Henri earned his salary. These were solid days of teaching morning, afternoon, and night—no dropping in once a week the way some instructors did at the League. Walter Pach was in Henri's class, and in his case Sloan thought it was all ideals; Sloan thought Pach might turn out to be the best student but he would miss his guess if he did.

Ernest Lawson, their other Canadian friend, always seemed to mind his own business, yet as early as 1906 he had a hot argument at the Café Francis with Sloan over Henri's work as a teacher. Lawson said Henri was hurting his own work teaching and that he wanted to teach everybody. Sloan loyally and wrong-headedly replied that Henri

Hairdresser's Window, 1907. Oil on canvas, 31⅞" x 26" (Opposite Page). Sixth Avenue may have been the Fifth Avenue of the poor, but there was a lot less privacy. Mme. Malcomb was glad to get the publicity for her hair-bleaching, and the client doesn't seem to mind. The Wadsworth Atheneum, Hartford, Connecticut.

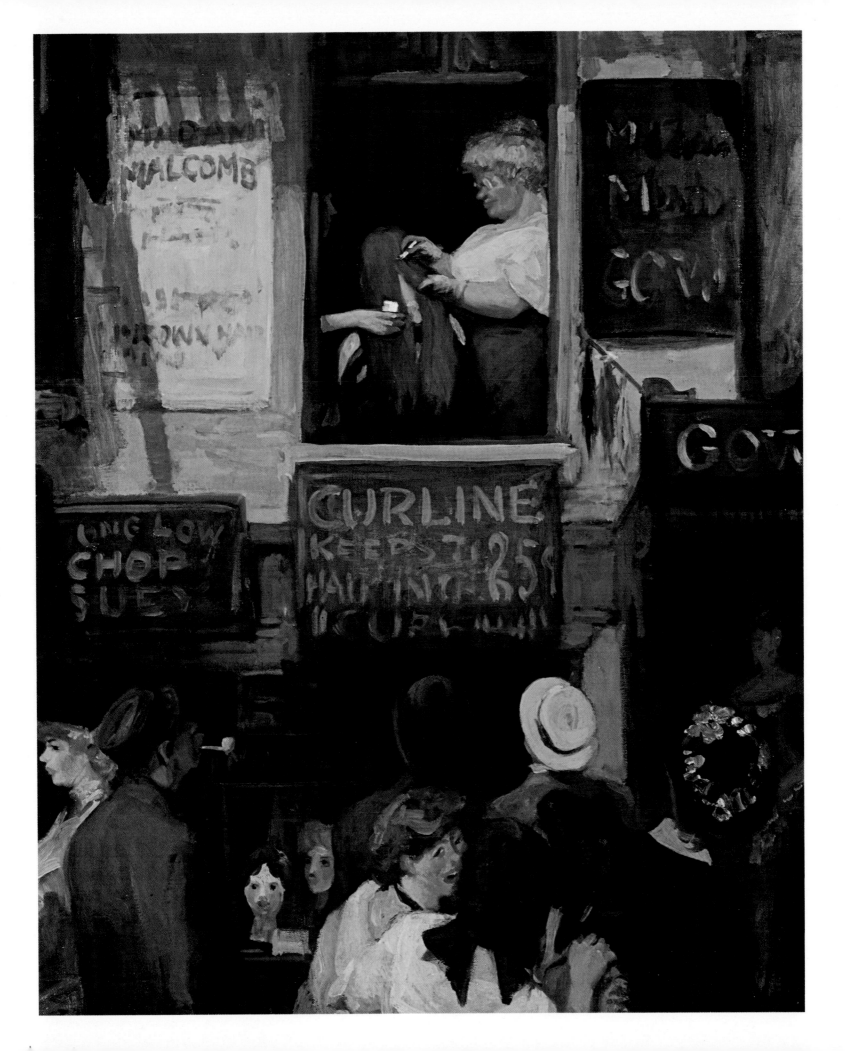

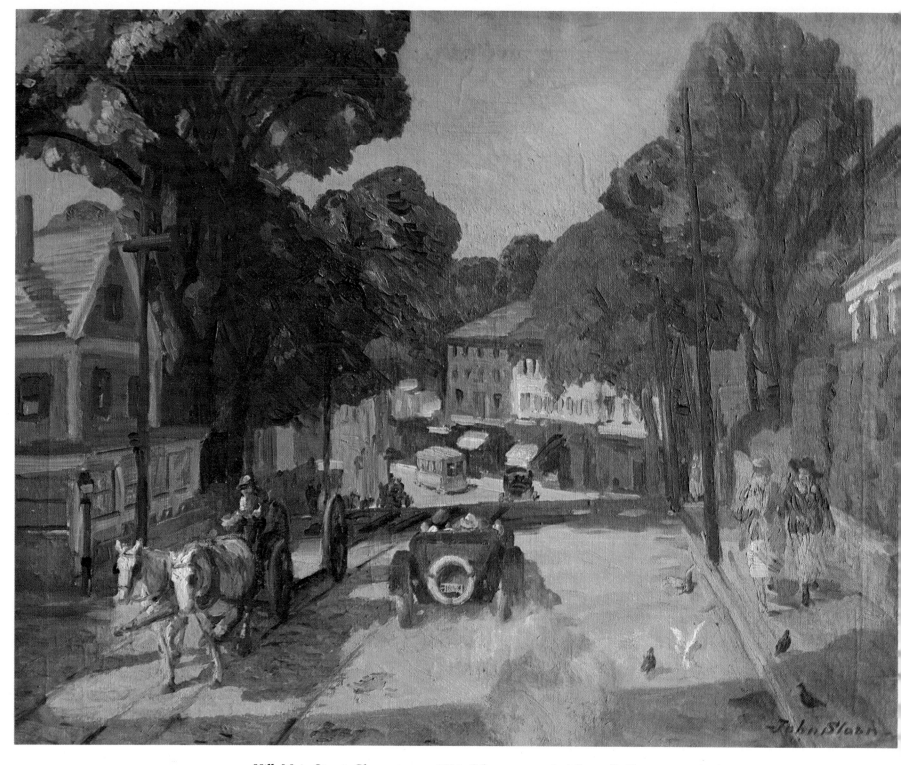

Hill, Main Street, Gloucester, *ca.1916. Oil on canvas, 26¼" x 32". Sloan painted a lot of good pictures at Gloucester. He developed a real feeling for landscape, which he had started painting along the Palisades while he was still in New York. The Parrish Art Museum, Southampton, New York.*

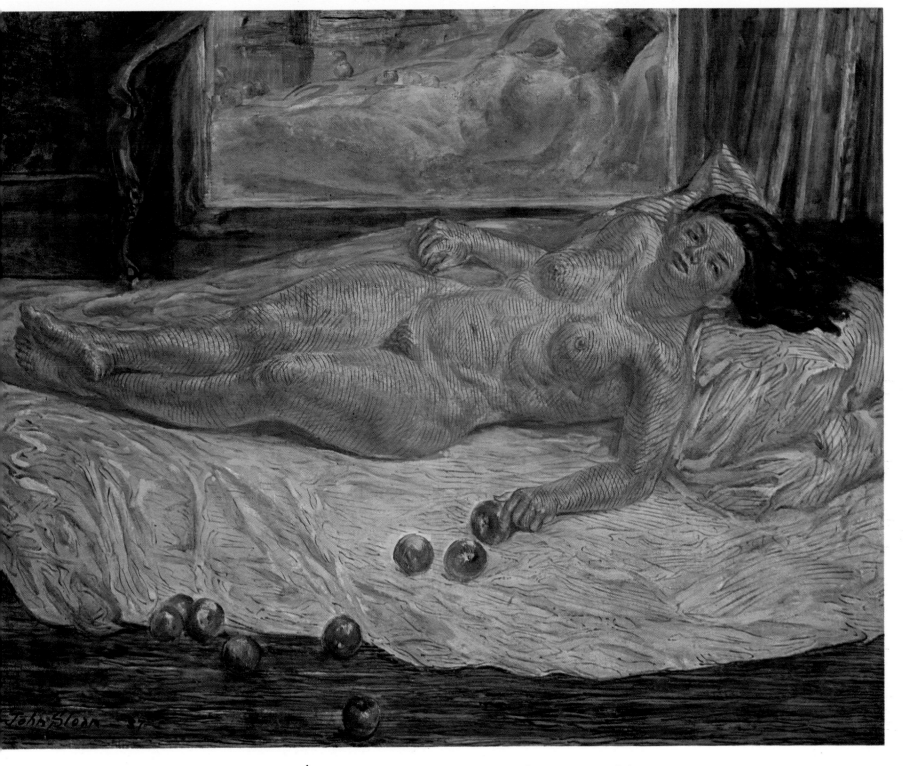

Nude and Nine Apples, *1937. Oil on panel, 24" x 30". In later life, Sloan painted a great many of these large, striped nudes in a heroic effort to attain sculptural, three-dimensional form. He said that "Every good picture leaves the painter eager to start again, unsatisfied, inspired by the rich mind in which he is working; hoping for more energy, more vitality, more time—condemned to painting for life." (Sloan, p. 332). The Whitney Museum of American Art, New York, New York.*

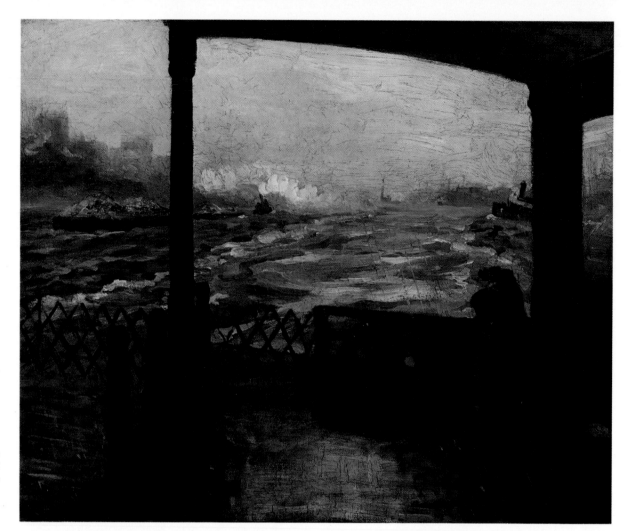

Wake of the Ferry, *1907. Oil on canvas, 26" x 32". "Another theme perhaps evoked by some nostalgic yearning for Philadelphia. The ferry of course is the first lap of the road home. A melancholy day when she, to whom the coming landing means nothing, seeks the sad outlook of the vessels' broadening wake." (Sloan, p. 209). The Detroit Institute of Arts, Detroit, Michigan.*

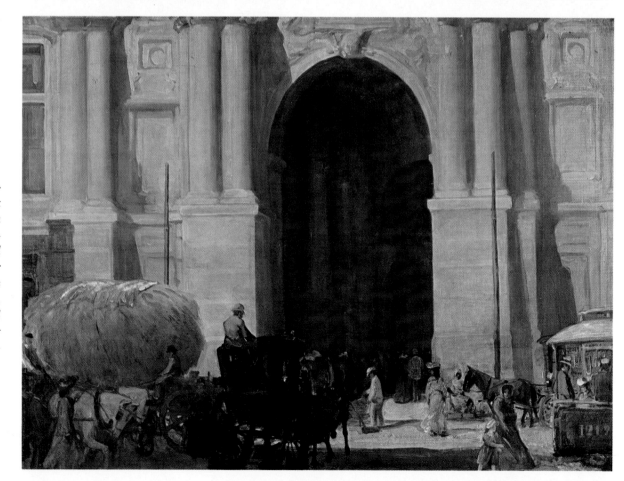

East Entrance, City Hall, Philadelphia, *1901. Oil on canvas, 27¼" x 36". This was painted while Sloan was still drawing for the Philadelphia Press. "In the late 90's a load of hay, a hansom cab, and a Quaker lady were no rare sight in the streets of Philadelphia." (Sloan, p. 201). The picture has a mellow glow, and the old city hall looks far grander than in reality. The Columbus Gallery of Fine Arts, Columbus, Ohio. Howald Fund Purchase.*

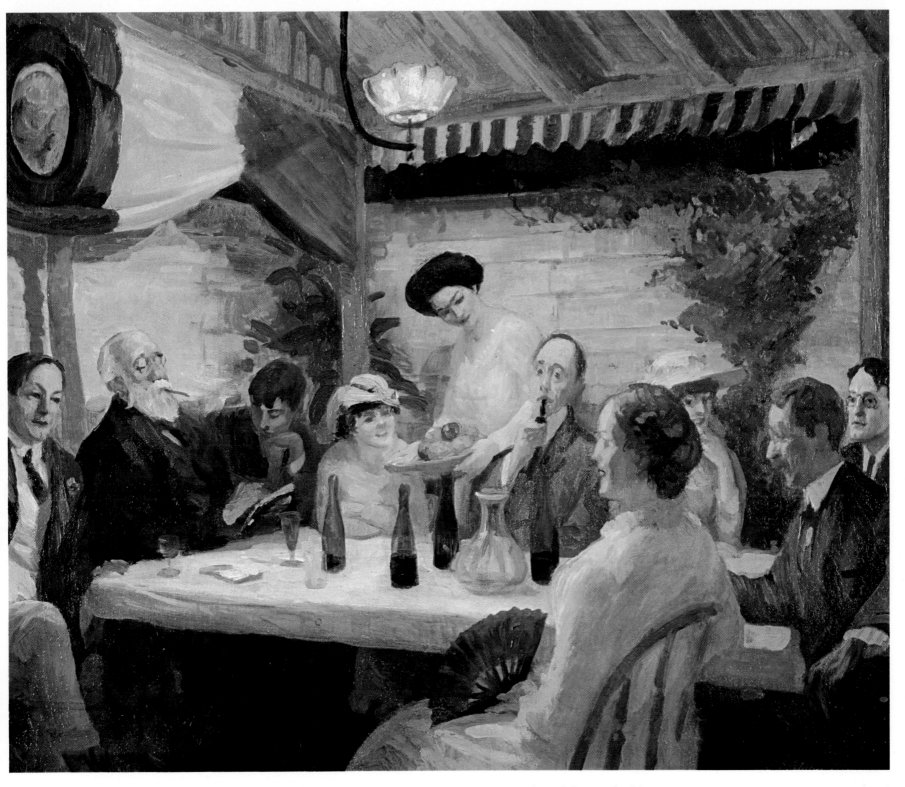

Yeats at Petitpas, *1910. Oil on canvas, 26⅜" x 32¼". The painting above shows from left to right: Van Wyck Brooks, John Butler Yeats, Alan Seeger, who wrote* Rendezvous with Death, *Dolly Sloan, R. Snedden, Ann Squire, John Sloan, and Fred King. The restaurant with its backyard dining room lasted into our time. The Corcoran Gallery, Washington, D.C.*

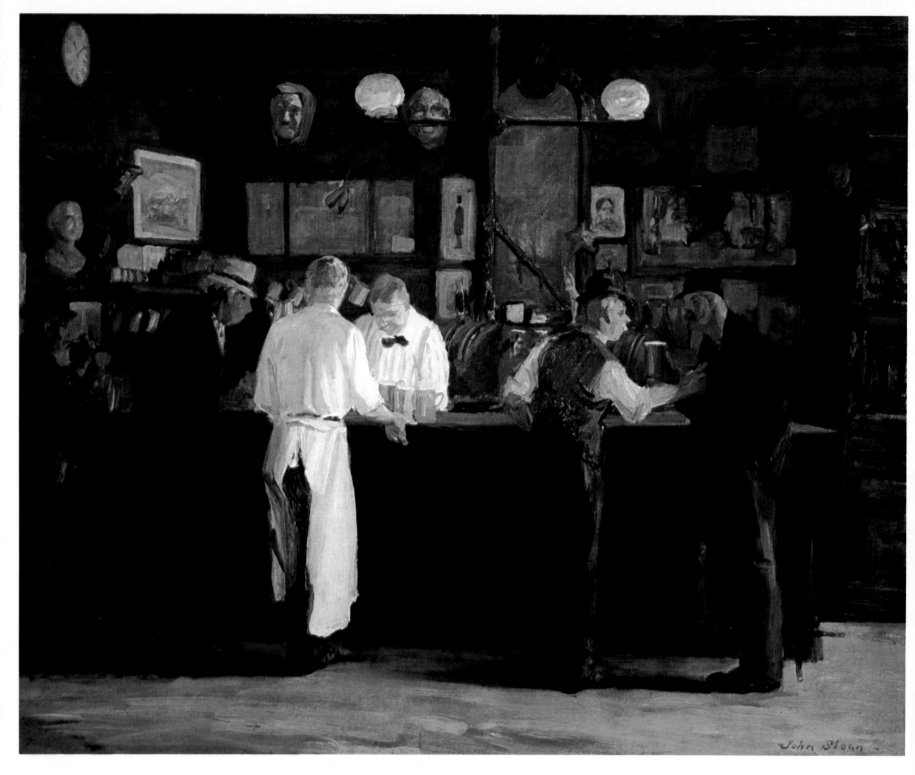

McSorley's Bar, *1912. Oil on canvas, 26" x 32". Sloan painted several fond recollections of the little low-ceilinged old room at McSorley's wonderful saloon. This is the first and finest rendering of "The Old House and Home," as it was called. You can almost smell the stale ale and the sawdust. The Detroit Institute of Arts, Detroit, Michigan.*

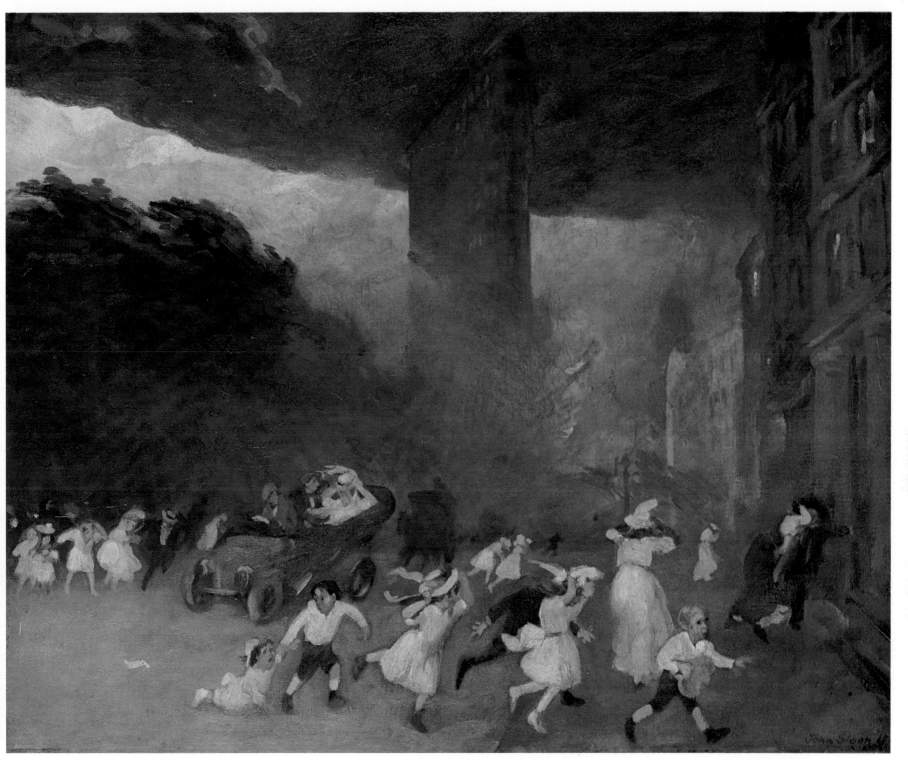

Dust Storm, Fifth Avenue, *1906. Oil on canvas, 22" x 27". "A dramatic moment on a Sunday afternoon in summer. Fifth Avenue covered by a great gray canopy of cloud, the air full of dust. An early type of automobile chugs up the avenue." (Sloan, p. 208). The Metropolitan Museum of Art, New York, New York. George A. Hearn Fund.*

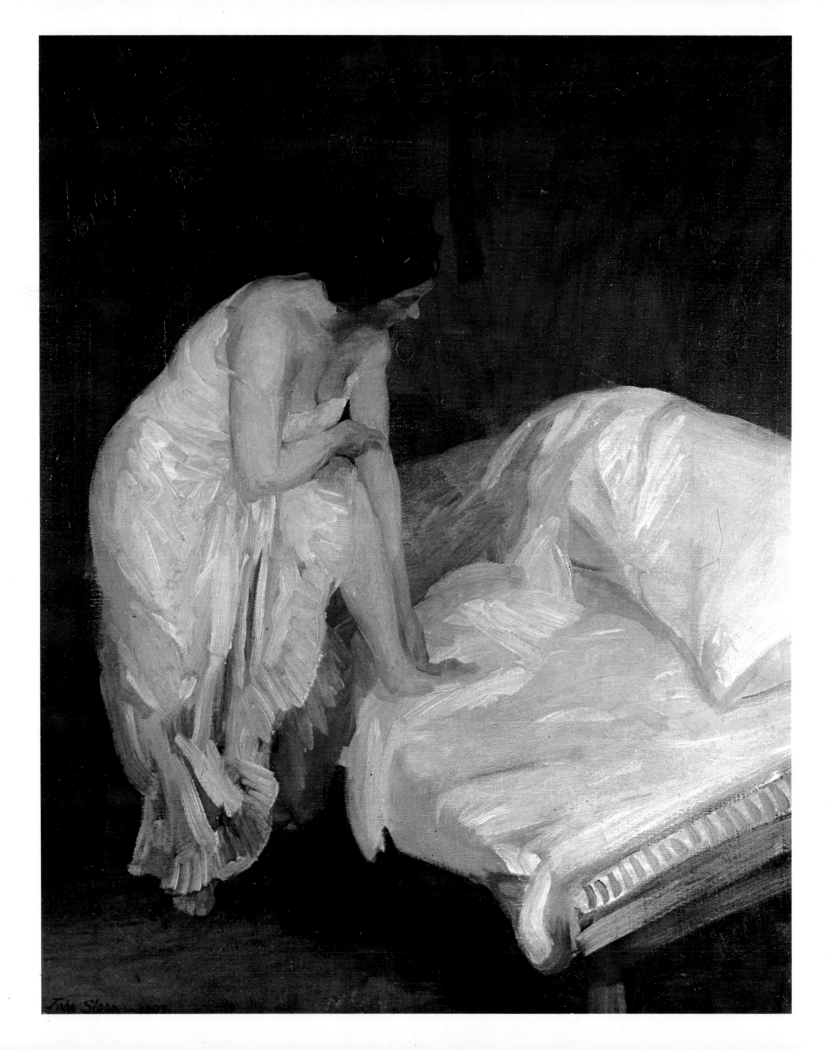

was quite capable of doing so and that he was the greatest American painter. "I hate this tendency of smaller men to yap at Henri." (St. John, p. 26). Meanwhile, Sloan managed to do commercial art while going on with his own work, which is what most artists say they will do and find they can't. They end up doing the commercial work, and their own work fades away. Even Luks dropped illustration as soon as he could; it uses up exactly what you need for your own painting. People will pay for what *they* want, while few people will pay for what *you* want to do.

In 1907 he sent *Dust Storm, Spring, Madison Square, Girl and Etching Press*, and *Ferry Ship* to the Carnegie International, but he was also working hard at black and white. Arthur Dove helped him learn lithography. He left etchings to be submitted to Theodore Dreiser at the editorial offices of *Broadway Magazine*, and he gave a proof of *Turning Out the Light* to Evergood Blashki, Philip Evergood's father. These plates are among the best American etchings of all time. The medium suited him perfectly and they were immediately acclaimed by other artists—Mahonri Young said that his plates were never sketches, they were complete works, as serious as important pictures or statues, novels or symphonies. *Memory* is a great memorial to Linda Henri and their lives together. *My Mother* is touching beyond belief, a monument to the nineteenth century sickroom, while *Turning Out the Light* is a hymn to night and love in the city.

Mouquin's was for celebrations with the crowd, but there were any number of little French restaurants that were incredibly cheap. Sloan and Dolly read George Moore, but then they went to Hammerstein's Roof and saw a miserable performance. Glackens' painting of that theater in the Whitney Museum is a knockout, but that does not mean all the acts were good, far from it. Shinn, of course, thought all turns were beautiful but he was completely stagestruck. Sloan was intrigued by the trial of Harry Thaw for the murder of Stanford White, though this was Shinn's world, not theirs. "Evelyn Nesbit, his wife, was a model and White, among others, used her. White was the kindliest sort of man tho sensual." (St. John, p. 44). Henri made an amusing drawing of *Reading the Evidence* or *Mrs. Sloan at Home*, with Dolly on the floor surrounded by billowing newspapers.

In between bouts of painting and etching, listening to Henri, and talking with the gang at Mouquin's and the Café Francis, Sloan made the rounds of the magazines looking for work. It was not easy on Sloan, who was a prickly and shy man. Some men breeze in and get the job even when they're drunk. Sloan had a strange system: he would wait until he got an illustrating job, then paint like hell up to the deadline, and do the illustration in no time flat. But he could not paint without the commission.

Having Henri around all the time got to be quite a strain. "Dolly gets in an argument (quite senseless) with Henri. A horrid evening on the whole." "A rather dull evening as Henri is feeling tired." "Henri, old man, feels a bit gloomy." (St. John, p. 48). His lady students were sorry for him too, and thought he should remarry; he seemed to Miss Perkins so helpless and lonely. When Sloan came back from taking Miss Perkins to Jersey

The Cot, *1907. Oil on canvas, 36¼" x 30" (Opposite Page). "Like all pictures of the period, an extremely limited palette, providing many variants in the whites and grays. The canvas is pervaded with a sense of great peace emanating from a personality. How strange to know that this type of picture was regarded as the work of a "revolutionist in art" by the art criticism of this period in which it was painted." (Sloan, p. 216). The Bowdoin College Museum of Art, Brunswick, Maine. Hamlin Collection.*

City, "he made a start on a canvas . . . *The Wake of the Ferry* it might be called if it is ever finished." (He threw a rocking chair through the canvas after a fight with Dolly, when one of their friends got her drunk.) These were the first cracks in Sloan's friendship with Henri; Sloan had always seen him as god-like, and here he was irritatingly dependent on them. Wouldn't he ever go home? Wouldn't he ever leave them alone? It was a blessed relief when Henri had another engagement for the evening. Henri was not a very good guest; he did not bend easily. He was conferring a favor, and it never occurred to him that he was in the way. Guests should listen, while Henri continued to hold forth, which is not so much fun in your own house. To add to his troubles, Henri was having difficulties with the National Academy jury and angrily withdrew two of his paintings from the exhibition. Sloan loyally wrote in his diary "I know that if this page is read fifty years from now it will seem ridiculous that he did not have more honor from his contemporaries." (St. John, p. 109). Sloan liked Henri's *Gypsy Mother and Child*, red-skinned, red-black dark canvas, intense life in the woman's face. He admired all The Eight and considered Davies a great man.

Sloan allowed as how in case of complete mental breakdown, he might fall back on art criticism. Well short of that, he fell back on socialism, impelled partly by the Thaw trial which he had attended. He thought Thaw's mother was a grand old lady and that District Attorney Jerome was a grandstand player, and while Thaw looked loony, he found it hard not to sympathize with a man in such a fix. But his heart went out to the pansy-eyed Evelyn Nesbit; Irwin S. Cobb thought that she was the most beautiful woman he had ever seen. Besides, socialism was in the air, and artists and writers were catching it right and left. Dolly was a real worker for the Party, very much the militant. She did her work as an organizer and on the picket line, while Sloan made cartoons for *The Masses*, where he was art editor, and had a wonderful time getting the magazine out with Max Eastman. Sloan was a very good caricaturist, and he persuaded friends like Boardman Robinson and George Bellows to contribute. The job brought him new friends like Art Young, but it helped cool his relations with Henri, who had some sympathy with anarchism, but none with socialism. Rollin Kirby said *The Masses* cost Sloan his sense of humor, and it made his company uncongenial to Jerome Myers. Rockwell Kent, a pupil of Henri's, was hot for the cause, then as always, and he wrote from North Sidney, Newfoundland, in his beloved north country, that "you should have heard me planting discontent among the miners." Despite the fact that George Bellows was a good contributor, Sloan never liked him, for he thought he was a grandstand player, like Jerome. No one ever said of Sloan that he was without malice. At first he had liked Kent, who was as large as all outdoors, but Sloan cooled on him too.

The artists were glad to have their drawings in *The Masses* because they got so much space, for Max Eastman was always so desperately short of copy that Sloan could give them the full page. It was probably the best illustrated paper in the country, with more prestige than circulation. Sloan, who liked the work very much, did fifty-three of the

Four of the Eight: *Henri, Luks, Sloan, and Prendergast, Pencil, 12" x 4". Collection of the Chapellier Galleries, New York, New York.*

drawings himself. Max Eastman said he enjoyed Sloan's wit and artistic genius but would also have enjoyed the "absence of his cooperation." It was just as well for Sloan when he quit, for he almost stopped painting for several years.

After Henri remarried, his place in the Sloans' lives was taken by John Butler Yeats, who was already known as the poet's father. John Quinn brought him over from Ireland and supported him for years. He was a lonely old man, a brilliant and interminable talker, and the Sloans took him in the way they took in Henri. Yeats lived at Petitpas, a French boarding house on 29th Street, a place in the city for people who had to watch their money. It was wonderful for Yeats, who was a housepet wherever he went. He said that if Shelley lived in these days he would have preferred New York to Rome and New Yorkers liked him for that. When he met Bellows he said that Bellows was going to die young; people remember things like that when they come true. Ezra Pound came to Petitpas occasionally, and once John Quinn took Pound, Yeats, and the Sloans all the way to Coney Island in his big touring car: it was Sloan's first drive. Sloan loved Coney Island, the sand-gathering bathing suits, the smell of hot dogs and salt water, and the men waiting at the shoot-the-chutes for a flash of white flesh. But when John Kraushaar, his dealer, suggested that Coney Island pictures would sell he refused to paint any. Sloan himself said he had something of the mule in his make-up. Sloan said, and Yeats referred to Sloan's "won't" power. Yeats was a bit of a tyrant, as garrulous old men often are, and he was very fond of Dolly, which happens in these relationships.

Yeats worked on his self-portrait for years in Sloan's studio; it was in the Armory Show in 1913, and it was unfinished when he died in 1922. Sloan said that Henri and Yeats were the great influences in his life. He and the old man talked books a great deal, for Yeats was as literary as an Irish painter can be. He genuinely admired Sloan's paintings, wrote articles about them, and told him he was the best of the bunch. Perhaps because they were both great talkers, Yeats did not think much of Henri. He did not consider him an original thinker, and felt Henri's brilliant painting lacked distinction.

Sloan and Dolly spent the summer of 1914 in Gloucester, their first real stay in the country. They spent the next four summers there and rarely spent a summer in New York again. It was enthralling for them both, a real break-out, but it practically meant the end of the New York pictures, which are usually paintings of summer scenes. At Gloucester, Sloan tried working outdoors for the first time, which, like fishing, is an exhilarating feeling but the beneficial results are often on the artist rather than the art. His New York scenes are painted from memory, from the sudden perception which Ezra Pound says art consists of. It was impossible to paint outdoors in the city—the cop would tell you to move on.

Most of the Gloucester pictures are pleasant views of rocks and tides and inlets, but there is only so much you can do with that subject matter. He was not a surf painter like Frederick Waugh or a poet of the fishing village like Gifford Beal, with its violent and heart-rending smells.

They rented a little red house which they loved and on gray days, which were many, Sloan painted Dolly in red, Dolly in blue. They led a quiet life, which helped keep Dolly sober, and if they needed company Randall Davey and Stuart Davis were nearby. It was the first new place Sloan had been in for years, and he loved the sea air and the look of the land. He wanted to get away from painting Sloans; he succeeded in getting away, but he never did as well again.

In Gloucester, Sloan tried to lighten the color in his landscapes, partly under the influence of Yeats, who talked quite a bit of nonsense along with his good things. In his figures, Sloan tried to get a sense of sculptural form, which certainly they had lacked. He wanted to get away from Henri, and he did, but there was nowhere else for him to go. For Sloan, Gloucester was a new life, and as a life it was good. His Gloucester paintings are among the best of the seaside school, but if he had only painted them, he would not be the famous man he is today.

Henri discovered Santa Fe just as he had pioneered Monhegan; the gang followed him everywhere but to Ireland. Randall Davey drove out to New Mexico in a Simplex with clashing gears, loved the place and bought a ranch. Sloan followed next year and moved into the Calle Garcia, in the hope that getting away from people would help Dolly with her drinking, but the place was full of their friends. By this time Sloan had given up commercial work completely and lived by teaching in New York in the winter. He was a severely conscientious teacher with what he called a sharp but honest tongue, in the Eakins-Anshutz tradition. Sloan said he was harsh because the students frightened him. His *Gist of Art*, the book made from his teaching, lacks the serene quality of Henri's *Art Spirit*. Sloan was a good talker, but he painted better than he talked. Henri's best teaching was inspiration; so was Sloan's best painting.

Teaching lashed him into a state of consciousness and made him think, but like Henri he probably taught and thought too much. He was one of the pillars of the Art Students League, and he developed a following of his own. He had great students like Reginald Marsh, who owed too much to Sloan's theory of plastic form, Peggy Bacon, who found herself in Sloan's etching style, and Sandy Calder, who blithely went on in his own highly distinctive way despite Sloan and his sculptor father and grandfather. The students didn't get very close to Sloan, but then few people did: even Dolly called him Sloan.

Santa Fe was the first foreign country Sloan had visited, and Calle Garcia was the first home he ever owned; later they moved farther out in the country, for the usual reason. He exulted in the marvels of the dry land and the picturesqueness of the poverty-stricken people. There was an orchard and a garden and flowers. For a man and woman who had spent their lives in the city, it was wonderful. He brought out the old Charcoal Club table from the Walnut Street studio, which appeared in his etching of *Memory*.

This was the first steep place he ever lived, with blue mountains behind—a whole

Self-Portrait, *crayon, 6" x 4".* *Collection of the John Sloan Trust. Courtesy of the Kraushaar Galleries, New York, New York.*

new dimension that the East never had. Autumn was golden with aspens. He could not stand Taos, with its hordes of artists, but he was enthralled by the Indian dancers, and indeed they are an amazing spectacle. He liked to do his own version of the Corn Dance, feeling the same overwhelming surge of emotion Isadora Duncan had given him. This fierce, dry man knew that there was another world. He rendered admirably the startling landscape of the Southwest, with its dots of trees and its prominent jagged edges. His original dark tonality helped him here, for most artists spoil their Western paintings with too much white light.

More and more he painted the figure, and his nudes became rounder and harder and redder. It's easy to see what he was trying to do, but this natural painter lost his vision. He enjoyed his work, but the cross-hatched figures are mechanical. He lost touch with his material, but he kept right on working.

The winters of his later years were spent in the Chelsea Hotel, in the New York he loved. After Dolly died he married a devoted student, Helen Farr. Occasionally he re-painted another version of McSorley's bar, or the El going around the bend. They are his best later pictures, because they are closest to his earliest.

ARTHUR B. DAVIES 1862–1928

A Stately Dance of Nymphs

Arthur B. Davies was the mystery man of The Eight. The deaths of Luks and Lawson were clouded enough, but their tragedies were predictable. Davies' life was as secret as his death, which is the way he wanted it.

As Edward Root, an upstate New Yorker, said, "The early life of Arthur B. Davies was passed in the Mohawk Valley where the Saguoit and Oriskany creeks converge into it from the south. The hillsides in the locality slope gently upward to a height of some two thousand feet. One sees them for miles in sharp perspective—dotted with red and white farms; patched with forests of beech, maple and hemlock; and spread with broad expanses of arable land. Everywhere the lily-shaped elm graces the countryside, growing alone above herds of black and white cattle. The landscape is vast and yet intimate; wistful and yet satisfying . . . a proper nursery for the poet, the artist, and the man of thought." (Duncan Phillips, ed., *Arthur B. Davies: Essays on the Man and His Art:* Washington, D.C. 1924, p. 61).

Utica itself, with its dark mills, had little effect on Davies, but he found his magical landscape in the hills above Genesee Street. The feeder streams of the Erie Canal are made of silver, and if you get up early in the morning you can see unicorns in the meadows. In Davies' day, a Celtic mist hung over this valley where the people took their singing seriously. This mist has risen, but it is needed to understand Davies, and he used it to understand himself. People believed in poetry then; it had a large part in their lives, and Davies painted the realms of gold. We remember Davies because of his part in the Armory Show and the rise of modern art, but he lived in lands forlorn. His artistic world is no more real to us than the world of Puvis de Chavannes, who has survived by the praise of men we praise, yet if it were not for their chance connections with today's art, both painters would be completely forgotten. Now meaningless, their work meant a great deal in their time, and it is possible to reconstruct its effect; there are even people who remember. It was difficult in 1908 to grasp what the Philadelphia gang was saying, but Davies was understood immediately. We believe in French painting, but Davies early pictures, heavy with emotion and with titles like *Rose to Rose*, could easily have hung in the Royal Academy. For Bryson Burroughs, the curator of paintings at the Metropolitan Museum who painted centaurs and nymphs, Davies work was part of the "fantastic, visionary genius of the Celt, that same Celtic genius which taught the geog-

raphy of hell to the medieval world and which is the source besides of so much that is precious in our inherited treasure of legendary romance and adventure, for Davies too had created a world apart, appropriate and consistent, which sensitive people are lured to and where they find sanctuary from commonplace affairs." Every one has a paradise and this was theirs.

Davies' paintings now look strange because we still look at them, while paintings of the same type by his contemporaries stay in storage. They didn't look strange at the time: many other pictures showed demi-gods. The last centaurs and satyrs were sighted in the Twenties, and the pipes of Pan are heard no more. It was a lovely realm of beautiful dreams—a refuge from a world that was harsh, dangerous, and unpredictable.

Outside his paintings Davies was a very practical man. He dressed like a businessman, with tall collars, and some people remember him wearing white gloves, though that may be a trick of the mind. Like Henri and Sloan, Davies prided himself on getting things done. A baseball fan who knew all the averages, he was proud that nobody would take him for an artist.

Davies was born in 1862, the fourth child of a Welsh Methodist minister. He was an unusually gifted boy whose make-believe fountains and fortresses were long remembered by one of his playmates. At the age of twelve, after seeing an exhibition of landscapes at the Utica Art Association, he had recurrent dreams of standing in a room hung with landscapes by George Inness. Utica, with its Italian villas and Victorian mansions, was then at its peak, and it was referred to as one of the principal cities of the United States. A local painter, Dwight Williams, recognized Davies' talent immediately and spoke in Whitmanesque accents of the boy as "lithe, active and ruddy, playing ball with his companions." (Phillips, p. 61). It is a youthful idyll by Henry James, on the home grounds, for James was born in Albany and the family property in Syracuse supported him all his life.

When his father was called to a Chicago church, Davies studied at the Art Institute. There's a wonderful passage in Dreiser's *The Genius* about the old school before it moved across Michigan Avenue, full of dust and casts and students, with palettes scraped off on the walls. On the side, Davies worked for the Chicago Board of Trade. Because his lungs were weak his family sent him to Colorado where he spent some time with the Blackfeet and had a taste of cowboy life, as Edward Root did later. According to his daughter Ronnie Owen, "he was given a white mare, and rode all the way to his Mexican post going via the Rockies, taking three months." (*Arthur B. Davies*, exhibition catalog, with an essay by Sheldon Reich: Tucson, Arizona, 1967, pages not numbered). For two years in Mexico City, Davies worked in the drafting room of a firm of foreign engineers, painting at the local Academy and studying colonial church art, for he had an inquisitive eye. Yet the melancholy and magnificence of Mexico was not what he needed.

Back in the States, he stopped off in Cazenovia to see his old teacher Dwight Williams and to paint the haunted landscape of the Mohawk Valley, which stayed with

him all his life. In 1887 he lived in Greenwich Village with the boyhood friend who had admired his early engineering exploits and made his living drawing illustrations for *Century Magazine* and *St. Nicholas.* He had trouble with editors because he disliked changing his drawings; nobody likes making changes, but Davies was particularly stiff-necked. In 1888, at the age of 26, he exhibited his first painting at the American Art Galleries.

On the Coney Island boat, on his way to the summer opera, he met a remarkable young lady named Dr. Virginia Merriweather, who had studied medicine in Vienna and was already chief of staff at the New York Infant Asylum. Their love of music brought them together, but it's difficult to see what else they had in common. They became engaged, and on a Sunday early in 1892 they visited Congers, New York, on an excursion train run by a firm of real estate developers. They fell in love with an old farm and bought it, and in June they were married in it. They moved in, and Davies took up farming, with very little success. Dr. Davies went into private practice and she was remembered vividly "first as a horse and buggy doctor, later in battered jalopies—dressed in rough work clothes—her lovely face aristocratically severe under funny little knit caps— for close to 60 years she went tirelessly about her job of bringing Rockland's babies and healing its sick." (Gertrude Dahlberg, "Arthur B. Davies—One of Rockland's Greatest," *The Country Citizen:* New City, New York, September 6, 1962).

While his wife found her place in life immediately, farming in Rockland County was not Davies' goal. She loved the life and he did not. The view from his studio across the Hudson was spectacular but Davies never felt at home as he did in upstate New York and later in Italy, which were the landscapes of the soul.

In 1893 he exhibited at the Academy and sold his first painting, *Ducks and Turkeys,* a subject closer to his early farming than to his later painting. When Benjamin Altman, the department store magnate, offered to put up the money for a trip to Italy, Davies took off like a wild duck, leaving his young family in the lurch. This solo trip did not strengthen his family ties and Dr. Davies wasn't one to suffer in silence. Italy changed him as France changed his fellow artists, and the Davies we know came out of the Tuscan countryside and Italian painting, with the small stiff figures, the wide horizons, and the long flat shape.

In 1894, Macbeth showed five of the paintings Davies had done in Europe, and from then on his pictures were acclaimed in a way we find difficult to believe. Macbeth did a great deal for Davies, who soon was living on the top floor of Macbeth's Fifth Avenue gallery and spending weekends at Congers, which doesn't indicate a happy homelife. His first one-man show at Macbeth's in 1896 consolidated his fame, but he wasn't getting along any better with the *dottoressa* and by 1900 they were separated. His wife would not give him a divorce, and he struggled with this situation all his life.

Sometime after 1902 he became acquainted with Edna Potter, and by 1905 they were living together in New York as Mr. and Mrs. David A. Owen. Their daughter Ronnie Owen, who was born in 1912, told Sheldon Reich that her mother, one of the "Mad

The Flood, *ca.1924. Oil on canvas, 18" x 30". Davies constantly reworked his paintings, and sometimes repainted early pictures in a later manner, but* The Flood *has none of the calm and quiet stylization of his mature style. Here is a tremendous wind blowing everything before it, and the two crouching figures are fleeing for dear life. The Phillips Collection, Washington, D.C.*

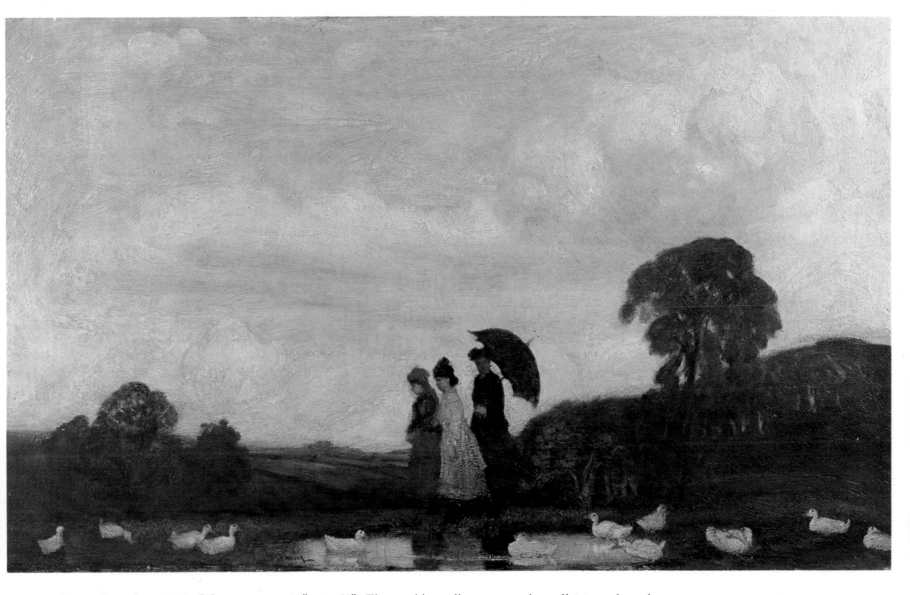

Every Saturday, *1904. Oil on canvas, 18" x 30¼". The weekly walk soon wanders off into realms of romance, with white ducks all in a row. But these are still real people; later they become nymphs and goddesses. The Brooklyn Museum, Brooklyn, New York. Gift of William A. Putnam.*

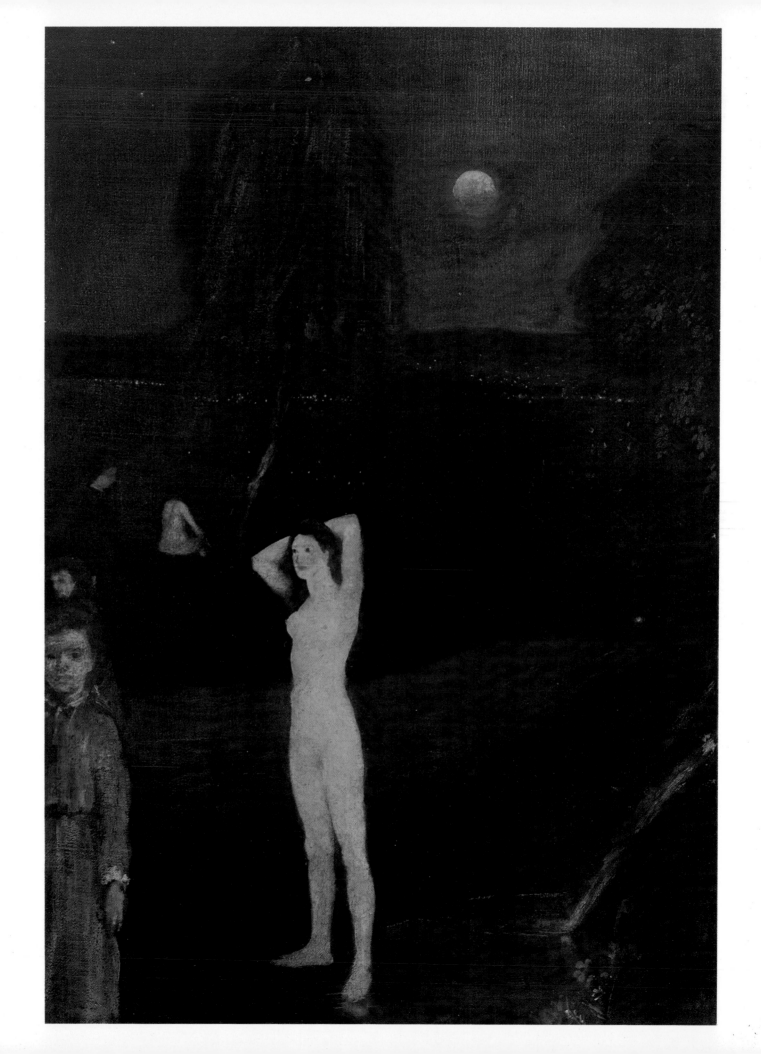

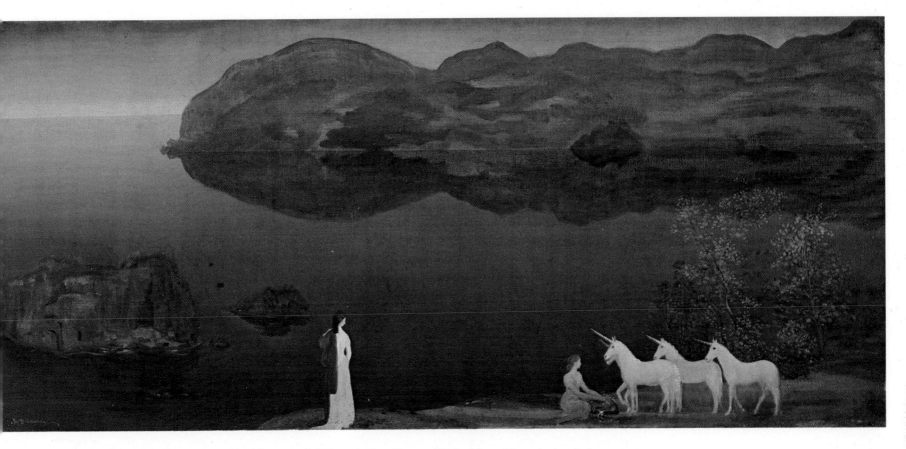

Unicorns, *1906. Oil on canvas, 18¼" x 40¼" (Above). For Henry Geldzahler, this painting belongs specifically to the world of the Rossettis and Burne-Jones, of Moreau and Bocklin. Except for Davies' brush with Cubism, arising from his involvement with the Armory Show, this dreamland was his natural habitat all his life. The Metropolitan Museum of Art, New York, New York. Bequest of Lizzie P. Bliss.*

Full-Orbed Moon, *1901. Oil on canvas, 20½" x 15½" (Left). Davies was an extremely idiosyncratic and often surprising artist. There is a genuine affinity to Gauguin in this scene, and possibly a hint of madness—not in the painter, but in the picture. For someone who painted so often in the tradition of Puvis de Chavannes, the cut-off figure in the corner is extraordinary, and there is a touch of Edvard Munch in the staring eyes of the nude woman. The Art Institute of Chicago, Chicago, Illinois. Mr. & Mrs. Martin A. Ryerson Collection.*

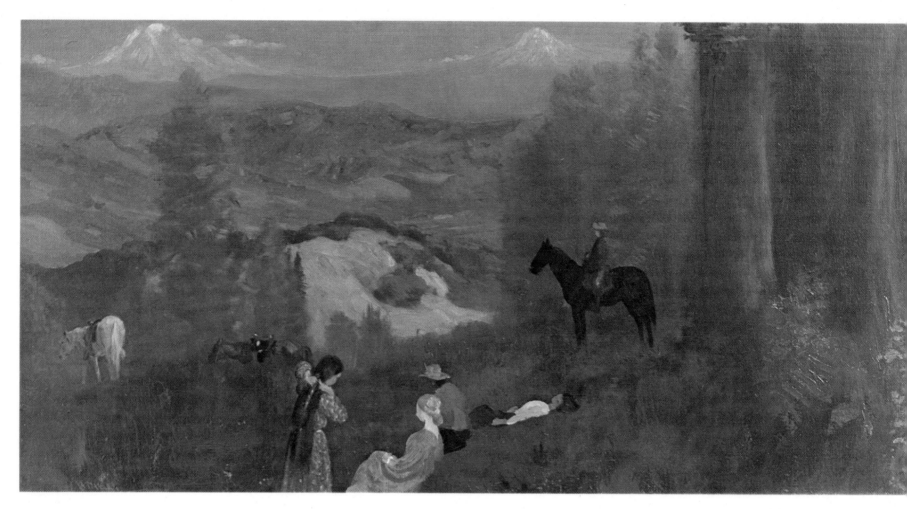

A Double Realm, *undated. Oil on canvas, 15" x 29". Davies liked to mystify, in his art as in his life, and he could throw a cloak of poetry over an ordinary riding party. The reclining figure strikes the right note; she's staring sightlessly into the other realm. The Brooklyn Museum, Brooklyn, New York. Gift of Robert Macbeth in memory of William Macbeth.*

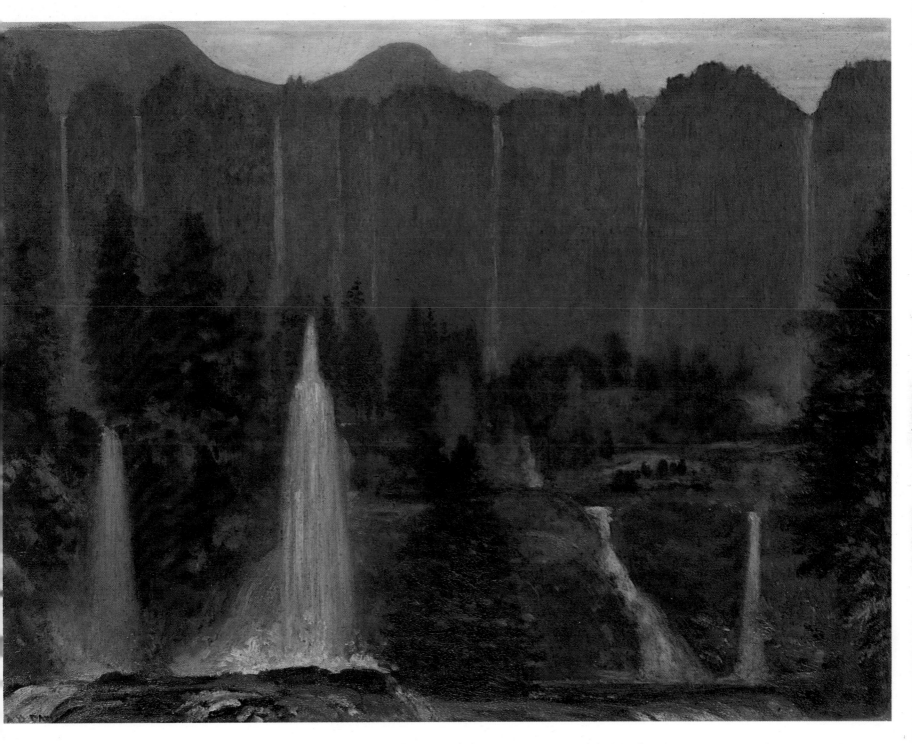

Many Waters, *ca.1928. Oil on canvas, 17" x 22". This painting looks like a reminiscence of the Tivoli Gardens outside Rome, transformed into something new and strange. It's easy to understand Davies' admiration for Odilon Redon, but it's more difficult to explain what Walter Pach called the astonishing depth of his intuition into all types of modern art. The Phillips Collection, Washington, D.C.*

Potters," was brilliant and very talented. "Mother was a real artist in spirit and perception. She could have been a first class painter and sculptor. But Papa strongly discouraged her artistic work. The real bond which kept her and my father together was mutual love of beauty and me." (Reich).

Davies went to extraordinary lengths to maintain his secret. Walt Kuhn's wife and their daughter Brenda, who were neighbors of the Owens, didn't know of the relationship. Brenda and Ronnie went to Friends Seminary School together for six years, yet neither knew that Ronnie's father was Arthur B. Davies. Mr. Reich believes much of the legend of Davies as a recluse resulted from the necessity for keeping the second family a secret. Even his dealer Frederick Price didn't know about Mrs. Owen. Davies arranged for the exhibition of The Eight at Macbeth's, but the show did not have the importance in his career that it had for the Philadelphia artists. For him, as for Lawson and Prendergast, it was just another exhibition; they were glad to be with their friends. At forty-six, Davies was a well-established artist whose reputation was not affected by the exhibitions. On the other hand, the Armory Show, which was crucial to him, to The Eight, and to American art in general, was known as "Davies' party."

After the Independents Exhibition in 1910, there was a great deal of talk by Henri and Sloan and their friends about a really big show, with foreign participation, but nothing spectacular would have happened without "the lucky discovery of a leader well-equipped with the necessary knowledge of art and a self-sacrificing and almost unbelievable sporting attitude." (Walt Kuhn, *The Story of the Armory Show:* New York, 1938, p. 11). Walt Kuhn and Elmer MacRae, both Henri pupils, had discussed the project with Jerome Myers, whom Henri had kept out of The Eight, and Henry Fitch Taylor, a painter who ran a gallery that was backed by Mrs. Whitney. Kuhn talked to the commanding officer of the 69th Regiment about hiring the drill hall on Lexington Avenue and Twenty-Fifth Street. John Quinn, a heavy buyer of The Eight, thought the whole idea was crazy, but he agreed to do the legal work; up to this time he had never shown any interest in modern European art. Kuhn brought Davies into the group and this was the beginning of their friendship. Davies taught Kuhn all that he knew about what was going on in Europe. When Kuhn was on a painting trip to Nova Scotia, Davies sent him the catalog of the Sonderbund Exhibition in Cologne, with a note saying, "I wish we could have a show like this." This decided Kuhn. He rushed back to New York and caught a ship for Europe, with Davies seeing him off and shouting: "Go ahead, you can do it!"

Kuhn arrived in Cologne on the last day of the exhibition, and watched it being taken down. Enthralled by the Van Goghs, he met the sculptor Lehmbruck and arranged for the shipment of paintings by Munch. In Holland he discovered Odilon Redon, who turned out to be one of the great hits of the Armory Show. He went on to Berlin to borrow paintings by German Expressionists. In Paris, Alfy Maurer introduced him to Vollard, but Walter Pach, a Henri pupil who knew all the French artists, really took him around. Appalled at the possibilities, Kuhn cabled Davies to join him, which he did.

Nude Figure Looking Up, *crayon and chalk on brown paper, 18" x 13 1/16" The Munson-Williams-Proctor Institute, Utica, New York. Gift of Frederic N. Price.*

For a week the three of them dashed around Paris from artist to dealer to studio.

Pach took them to see the Steins, the Duchamp brothers, and Brancusi. When they saw Roger Fry's second Grafton Gallery exhibition in London, they realized they were on to something big. After they got home, Kuhn wrote to Prendergast: "Davies and I have had a great time abroad, in fact a regular orgy of art. It is hardly possible to grasp the enormity of the undertaking, and we feel that it will be many years before a show of like impact will be gotten together." (Milton W. Brown, *The Story of the Armory Show:* New York, 1963, p. 87).

In New York, Davies miraculously made everybody get along with everybody else, which is unheard of, for as Dreiser said, the art world is a peculiar place. Frederick James Gregg, who had done such a magnificent job for The Eight on *The Sun*, wrote publicity for them, and so did Guy Du Bois. They made Glackens head of the selection committee for American art because everybody liked him. When money was needed, Davies got it from friends and patrons like Miss Lizzie Bliss, who here discovered her vocation for modern art. The Association which made the show possible consisted of all The Eight except for Shinn, plus George Bellows, Putnam Brinley, Mowbray Clarke, Leon Dabo, Jo Davidson, Guy Du Bois, Sherry Fry, E. A. Kramer, Walt Kuhn, Jonas Lie, Elmer L. MacRae, Jerome Myers, Frank A. Nankivell, Bruce Porter, John Sloan, Henry Fitch Taylor, Allen Tucker, and Mahonri Young.

As John Quinn said in his opening address in February 1913, "The members of the Association felt that it was time the American people had an opportunity to see and judge for themselves concerning the work of the Europeans who are creating a new art. The exhibition will be epoch-making in the history of American Art. Tonight will be the red letter night in the history not only of American but of all modern art." Quinn was absolutely right. It was certainly the most important exhibition ever held in the United States and the precise and poetic Arthur B. Davies was the man who brought it off.

In some ways, Davies and Kuhn didn't realize what they were doing, but Walter Pach certainly did. Davies theoretically knew what was going on in France, but Pach had an extraordinary talent for working himself in everywhere. He was very important on the Paris end of the show but in New York Davies ran everything.

It was Davies who found the money for the show. He had tremendous influence with rich lady collectors, to whom he sold his own paintings. Davies was the best salesman of The Eight; he lived purely off his work, he travelled, maintained his two households, and managed to form a collection on the side. The list of the people who bought his work is long and distinguished; they looked up to him and admired him, for he painted their aspirations. Moreover, the collecting advice he gave was first-rate. Lizzie Bliss, whose collection formed the base of the Museum of Modern Art, ended up with 24 Cézannes, and it's possible that the Museum itself was his idea. He advised Mrs. John D. Rockefeller, Jr., who supposedly spent more money annually on pictures than any

museum except the Metropolitan, and Ronnie Owen gives him the credit for the restoration of Williamsburg. Certainly he was an early adviser of John Quinn.

At first they made Alden Weir president of the Association in charge of the Armory Show because he was universally loved and admired, but he resigned because, as he said, "I was greatly surprised to find in your columns this morning the statement that I am the president of a new society openly at war with the Academy of Design." (Brown, p. 36). The choice was then between Davies and Henri, but according to Milton Brown there was some feeling that Henri was too clearly identified with the Ashcan School. Fortunately, Davies turned out to be a born organizer, for a show like the Armory Show is a colossal enterprise. Davies and his little group devoted a year to it, and had the time of their lives.

As Guy Du Bois says, "Davies underwent an amazing metamorphosis. He had been a rather perfervid dweller in the land of romance, an invention of his or of his Welsh blood, in which attenuated nudes walked in rhythmic strides borrowed from the languors of lovers. This was a moody and not too healthy world. Women adored it. Davies, keeping himself inviolate, lived a secret life from which he would sometimes emerge, nervous, furtive, apparently incapable of making the contacts of the real world. He would escape from a gallery which contained more than two or three visitors. That many annoyances, he told me once, defeated his enjoyment of the picture. Another time an invitation to see his work in progress was qualified with the condition that the address of the studio must afterward be forgotten. At meetings of artists he would be the most reserved and quiet one present. His presidency produced a dictator, severe, arrogant, implacable. The isolationist strode out in the open, governed with something equivalent to the terrible Ivan's rod of iron." (Brown, p. 39). Jerome Myers, who had been active in the Association, always insisted that it was meant to be a purely American show, but it was the revolutionary European paintings that made the greatest hit and deflected or blew apart the careers of many of the American artists in the show. One immediate effect of the show was a tremendous shift in collecting: Duncan Phillips, John Quinn, and Lizzie Bliss veered sharply away from the men they had been supporting, and new collectors like Walter Arensberg, Maitland Eddy, and Ferdinand Howald arrived on the scene. The American artists hardly knew what hit them, but the effects lasted all their lives. Only Mrs. Whitney stood by the American realists.

The large American section turned out to be unimportant. Henri had three paintings and two drawings, Sloan two paintings and five etchings, Glackens had three paintings, but it didn't matter. They were there, all right, but Marcel Duchamp, Matisse, and Picasso stole the show.

Quite a split developed within the Association between the clique who really ran the show, Davies, Pach, Kuhn, and MacRae, and the old Ashcan group around Henri. Certainly Henri was left out in the cold, and he was sore about the whole thing. A lot of the men felt that Davies ran the show out of his hat, but the split was actually over style.

Nude Figure Looking Down, *crayon and chalk on brown paper, 18" x 13¼". The Munson-Williams-Proctor Institute, Utica, New York. Gift of Frederic N. Price.*

The New York realists and many other people who wanted to advance the cause of American art were violently opposed to modern art, though it was already unwise to say so: They felt Davies and Kuhn, carried away by success, were killing American art.

Leon Dabo said to Jerome Myers at the time, "this man Davies has started something. I'm afraid it may be more of a calamity than a blessing, though it's a damn good show." (Brown, p. 195). And Myers remembered Davies saying to him, "Myers, you will weep when you see what we've brought over." And that was pretty much Myers' reaction: "And when I did see the pictures for the first time, my mind was more troubled than my eyes, for Davies had unlocked the door to foreign art and thrown the key away . . . more than ever we had become provincials." (Brown, p. 195). The Association broke up in recriminations, while the astonishing show went on to Chicago and Boston.

It is difficult to understand Davies' role in the whole operation. He was a symbolist, not exactly the art of the future, and the show threw him off course as much as anybody. The real beneficiaries were the painters around Stieglitz and modern art in general. The immediate effects of the show were startling, and in the long run abstraction triumphed completely. The Eight lost their war. For years, Davies' painting bore the traces of his struggle with Cubism. He even reworked his old canvases in the new style, but his experimental pictures are not his best. Davies saw what was coming, and he tried to make his peace with it. He was rewarded by having his own pictures hung in the Museum of Modern Art when his friends had gone out of style.

Membership in The Eight, or any other group, wasn't important to Davies. Because of his reticence and his need for secrecy, he kept everyone at arm's length. He had his own theories which took the place of color theory and dynamic symmetry. Along with Dr. Gustavus Eisen of Harvard, he believed he had recovered inhalation, the rhythmic secret of breathing of the Greeks. Dr. Eisen said that the happy juxtaposition of a painting by Davies and the famous Greek horse in the Metropolitan, whose authenticity has been questioned in our day, "contains a deciphering of a hidden truth which, since the time of the Renaissance, and perhaps even from the time of the Greco-Roman critics . . . has puzzled artists as well as art students. The secret of representing life in action and at rest was now revealed for the first time since classic Greece."

Davies had always been fascinated by rhythm. The dance was very meaningful to several members of The Eight, and Davies' dancing figures have a fine sense of flow. He experimented early and late with continuous composition which, according to Frank Jewitt Mather, a great admirer, "grows out of some sharply bent figure, from which others are derived in natural relation of repetition, reciprocating or opposing thrust." Ronnie Owen, loyal to her mother, has a different source for inhalation. "From late 1921 until his death he picked her brains about it and tried to put into his figures the lightness that she herself physically acquired . . . He himself was never able to practice it. Dr. Eisen once saw Mother demonstrate it but Father made it seem as though it was his idea and he had taught her." (Reich).

Davies had always been a great traveler, and in 1911 he and Edna Potter took a trip to Greece, which was far more his spiritual home than the harsh Cubism of the Paris studios. From 1924 on he and Edna Potter and Ronnie spent six months of every year in Europe, where he stayed away from expatriate revels. He died of a heart attack in his apartment in Florence in 1928, with Edna and Ronnie on hand. His death was unreported, though there were a great many rumors at the time. When Dr. Davies, who was still the legal wife, asserted her rights, all kinds of difficulties resulted, and Davies was buried in sight of High Tor, far from the Mohawk Valley and the Appennines he loved.

Reclining Female, Nude, *pastel on paper, 11¾″ x 16⅜″. The Columbus Gallery of Fine Arts, Columbus, Ohio. The Wilson fund.*

ERNEST LAWSON 1873–1939
A Palette of Crushed Jewels

Ernest Lawson loved to say, quoting Tennyson, that he was but a landscape painter. His work is consistent and distinctive and easily recognizable. He is the purest Impressionist we have, more so than Hassam, who also painted the figure, or Twachtman, whose earlier paintings are in the dark Munich manner. Like Prendergast and Davies, Lawson was totally uninfluenced by Henri, but alone of The Eight he painted in the very style against which Henri rebelled. Lawson was a good friend of the Philadelphia group, but stylistically he was more at home with Weir, Twachtman, and Hassam.

Lawson told very good stories and he liked to listen to people, but he was sceptical about what he heard. While Henri preached, Sloan argued, and Luks ranted and rambled, Lawson just went on painting. He knew what he wanted to do, and he was never diverted from his chosen way.

He found his style early and stayed with it all his life. He didn't worry about repeating himself or about changing with the times. Impressionism is the great style of modern landscape painting; Lawson adopted it and did the best he could within it. If his pictures are too numerous and too much alike, so are Monet's. From an artistic point of view his was a harmonious career, and his paintings sold easily at good prices until the Depression.

Lawson painted in many other places, but his work is closely associated with the Harlem River, Washington Heights, and Inwood, a section of New York which is now covered with giant highways and apartment houses. Even so, the underlying forms are there. It's a striking landscape, with a peculiar poignancy. Many men have painted New York, but no one else has tried this part of town.

There was a slightly strident American note about The Eight. Henri, who spent so many years abroad, rather fancied himself a spokesman for the mighty nation, and some of his nationalistic pronouncements are on the blatant side. Whoever he was speaking for, it was not Lawson, whose American citizenship was doubtful, and not even the best flagwaver could say that Impressionism was an American style.

Lawson's main interest, besides painting, was drinking, which threatened to become a full-time occupation. Lawson was not a spectacular drunk like Luks, for whom every saloon was a stage, and he was by no means a creative drinker. As an artist, Lawson didn't mind being typed: there wasn't anything else he wanted to paint, and certainly

there was no other way. Lawson's opinion of abstract art was presumably scurrilous, but it didn't bother him or affect his painting. While Henri thought he was leading American art into new paths, Lawson never had any such idea. His only purpose was to paint Impressionist landscapes, and he got a great deal of pleasure out of his work, the way other men do out of golf or fishing. Landscape painters are outdoors in all kinds of weather—mostly good—and they have enough to do to keep them contented.

Lawson put so much paint on his canvas that a sculptor friend once asked if he could cast a picture. His palette didn't run towards white, like Twachtman's, and his landscapes are never lost in light or mist. They remain perfectly real and recognizable, and you see exactly what Lawson saw when he was painting. He was by no means a complicated painter. His pictures may have been painted too fast, and they have yellowed a bit with time. Usually horizontal, they are painted in bands, with a rather high horizon, and there's not much sky. The typical Lawson colors are the tans and brown of subdued autumn and the white of hushed and dirty snow.

This daylight painter had a mystery in his birth and in his death. His parents were native Nova Scotians, and Canadians have always maintained that he was born in Halifax in 1873, though later he insisted he was born in San Francisco. His wandering parents left him to be brought up by relatives in Halifax. When he became an artist, one of them said: "Oh, Ernie I'm so glad you don't wear earrings." When he rejoined his parents at the age of fifteen in Kansas City, where his father practiced medicine, he had been painting and drawing for years. There he studied art with Ella Holman before he moved to Mexico City with his parents.

While his father worked as a company doctor for a foreign construction firm, Ernest became a draftsman and studied art at the Santa Clara Art Academy. His painting of a bullring looks like a reminiscence of Goya and Manet, but probably the similarity is in the subject. The Academy wasn't very inspiring, but he saved his money and on his eighteenth birthday left for New York, where he studied with Alden Weir and Twachtman. Lawson loved to say that when Weir looked at his first production he called it the worst landscape he had ever seen. Lawson painted like Weir and Twachtman for the rest of his life, and by 1893, when he left for Paris, his style was probably set.

Like so many foreigners, he studied at the Académie Julian, and two of his paintings were hung in the Salon of 1893. In letters to Canadian relatives he mentioned Whistler, but the main artistic event of his stay, to judge by his conversations in later years, was his meeting with Sisley at Moret. This was a great inspiration, though it never occurred to him at the time that he too might end up "poverty stricken, in declining health, bitter and disillusioned." (Henry and Sidney Berry-Hill, *Ernest Lawson: American Impressionist:* Leigh-on-Sea, England, 1968, p. 20). His own paintings of Moret look singularly like Sisley. When Lawson asked him for a criticism, Sisley told him to put more paint on his canvas and less on himself. Lawson liked to quote Courbet's remark that there are no schools or movements worth a moment's attention.

In 1894 he shared a studio with Somerset Maugham in whose novel *Of Human Bondage* there's a character called Frederick Lawson who stays away from the art schools, paints by himself at Moret, and has two pictures accepted in the Salon, but that's where the resemblance ends. For that matter, Maugham may have taken the name from the well-known English artist Cecil Lawson. When John Sloan illustrated *Of Human Bondage* in the Thirties, he and Lawson had drifted apart, but Sloan must have remembered Lawson's talk about old Paris days. Maugham was a friend of Morrice, who also figures in *Of Human Bondage*, and Lawson probably knew most of the Canadian artists in Paris. Maugham and Morrice went to Italy together, where Morrice painted beautiful pictures which look very much like Prendergast's.

All during these years, Lawson had been writing love letters to Ella Holman, and when he went back to New York on a trip their friendship renewed. She was a strong character, and she probably had her full share in bringing the marriage about. She had kept up her interest in her art and she wanted to break out of the grim world of school teaching. She had a great desire to go to France—Chase said Americans would rather go to France than go to heaven—and Lawson was the love of her life. She was an intelligent and high-minded woman, but their charming Victorian romance turned into a marriage by Dreiser. She couldn't live with Lawson, and there was no good life for her without him. She would not give him a divorce. She was never able to make a satisfactory life for them or for herself; Lawson's drinking got worse, and there were other women.

After their honeymoon in France, Lawson tried painting portraits in Canada and Mrs. Lawson went back to teaching school at Ashville, North Carolina; then and always, they were separated a good deal of the time. This was the bad pattern of their marriage, which was rickety from the start. Lawson taught for a while in Columbus, Georgia, which is by no means as close to Ashville as it sounds. He had no flair for teaching; he painted a few more portraits, which he hated, and then quit in disgust. There was only one kind of painting he enjoyed, and for the rest of his life he did it. Finally the family—there were two daughters now—settled down in Washington Heights, New York and the folded landscape of the Harlem River valley became the typical Lawson picture.

Lawson never had trouble exhibiting; he was accepted immediately in all the shows and sold easily. The critics could hardly call him a revolutionary. His revolution had been won by other men, and he possessed the qualities then subject to praise. Henri, with characteristics generosity, called him the biggest man we've had since Winslow Homer, while critics said that his canvases open one's eyes to the beauty of everyday scenes and the charms of familiar places, as indeed they do. Although Lawson had no social talent for being taken up by rich people, his sales were remarkable. The first American painting bought by Marjorie and Duncan Phillips was a Lawson—they ended up with a dozen—and Ferdinand Howald of Columbus bought twelve from the dealer Charles Daniel. Glackens sold a dozen to Barnes, for there are eight in the collection today, and Barnes is known to have sold and exchanged others.

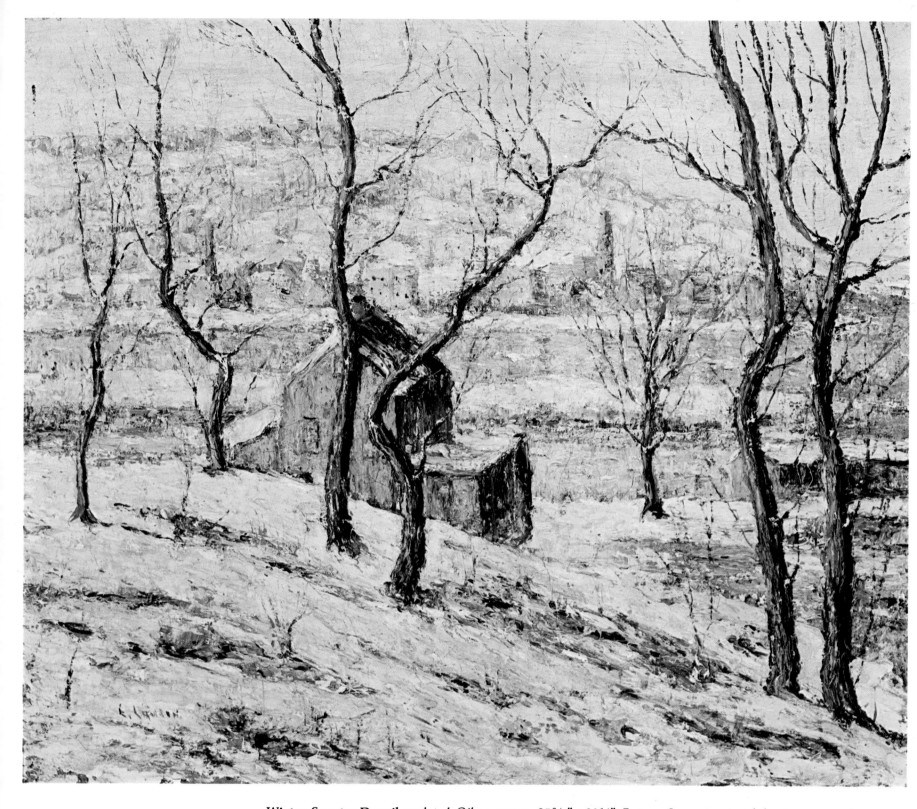

Winter, Spuyten Duyvil, *undated. Oil on canvas, 25³⁄₁₆" x 30¼". Because Lawson painted the rivers around New York, some critics have considered him a continuation of the Hudson River School. Lawson thought of himself as a traditionalist, and the only serenity he found was in nature and in these pictures. The Wadsworth Atheneum, Hartford, Connecticut.*

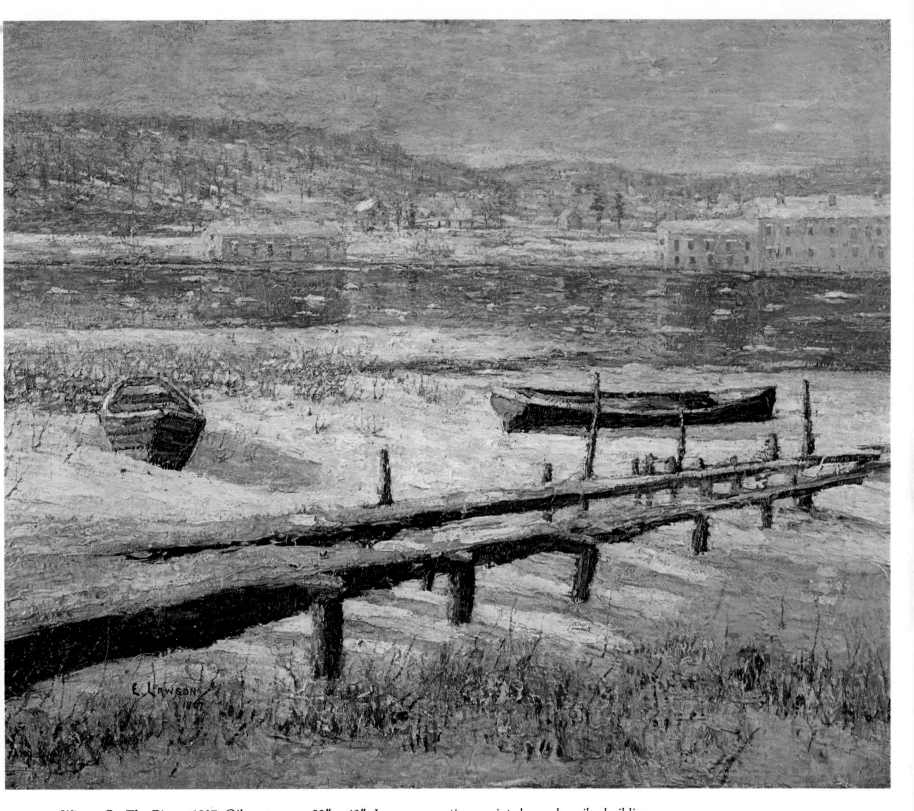

Winter On The River, *1907. Oil on canvas, 33" x 40". Lawson sometimes painted very heavily, building up the paint on the canvas so that it actually projects. His "palette of crushed jewels" sometimes looks like a relief map. His pictures have more solidity than most Impressionist paintings, just as they have more structure and more composition. The Wadsworth Atheneum, Hartford, Connecticut.*

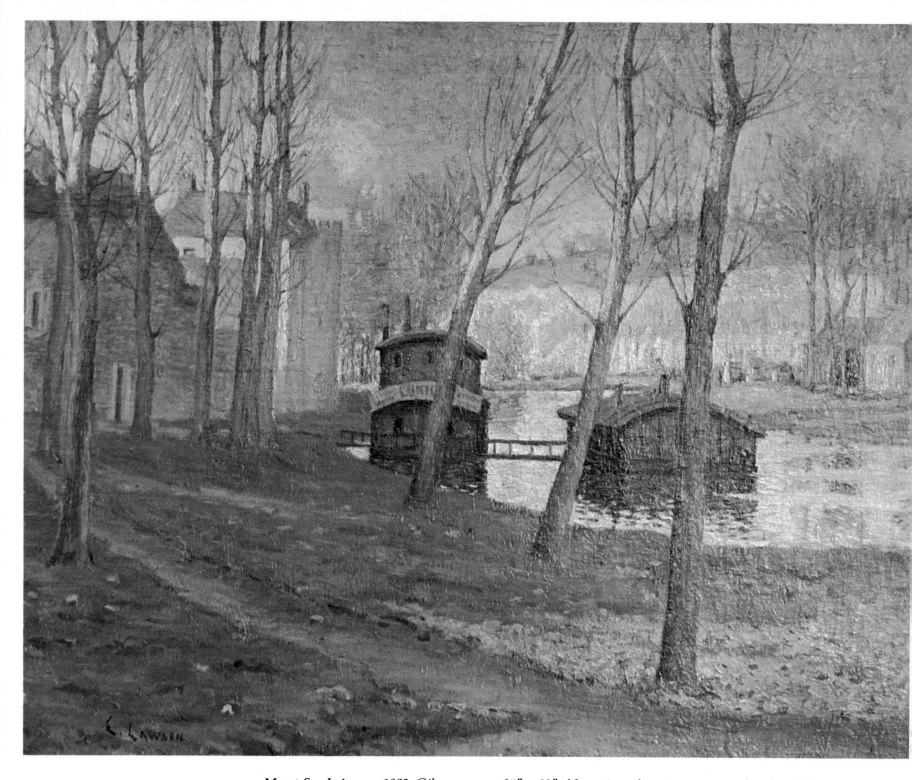

Moret Sur Loing, *ca.1893. Oil on canvas, 26" x 32". Moret is a charming town on the edge of the great forest of Fontainebleau, where Lawson met Alfred Sisley, the great French Impressionist. Lawson usually used American subjects, but his work rests on a French base. Randolph-Macon Woman's College, Lynchburg, Virginia.*

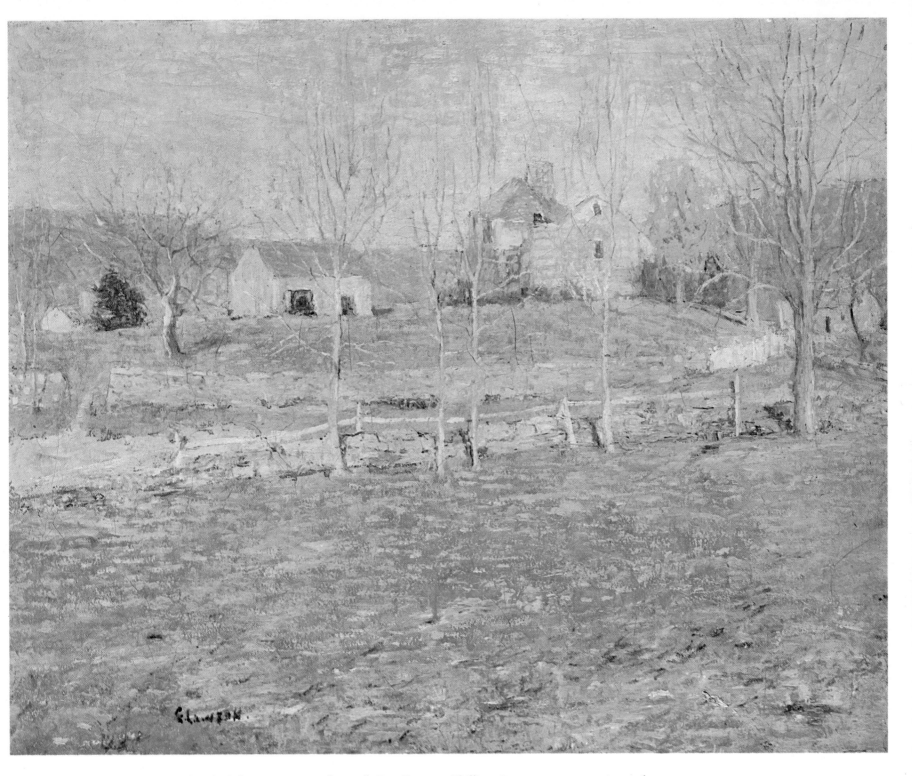

Abandoned Farm, *undated. Oil on canvas, 29" x 36". For Duncan Phillips, Lawson was a genius and, when he was up to concert pitch, one of the delightful romanticists of landscape painting. "Who but Lawson has felt too keenly the contrast between the ponderous bulk of a bridge and the sparkle of spring sunlight on bare or budding twigs." (Duncan Phillips,* Collection in the Making: *Washington, D.C., 1926, p. 57). He wasn't interested in the pure play of light; the houses and hills don't dissolve completely in mist. The National Collection, Washington, D.C.*

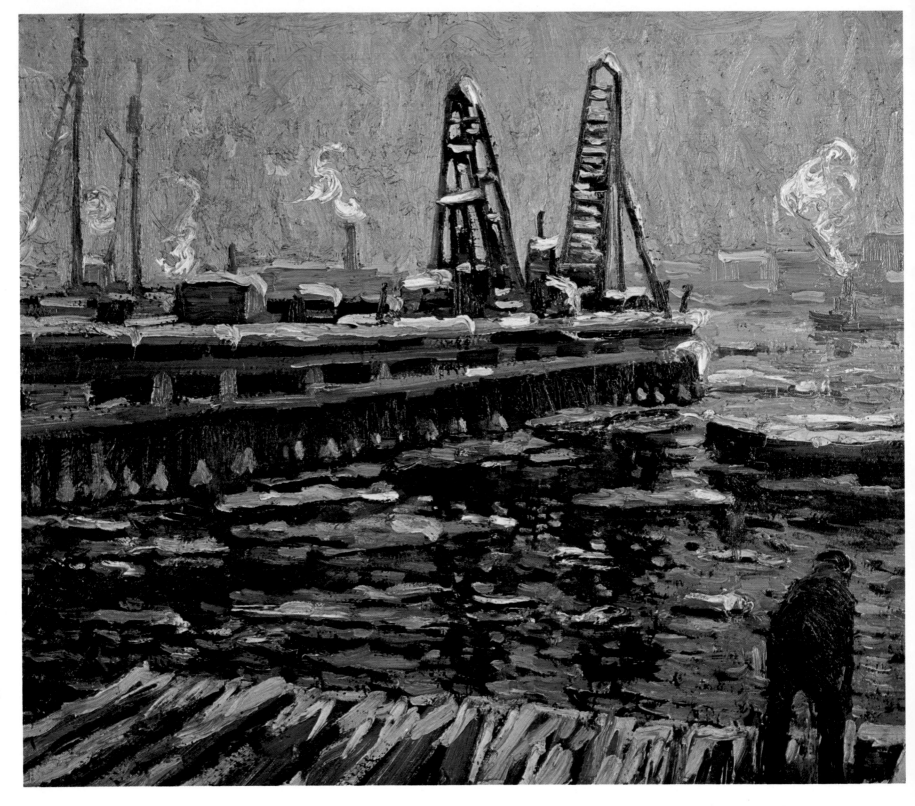

The Dock, *1909. Oil on canvas, 25" x 30". This is as close to an Ashcan School painting as Lawson ever got. It has the darkness and the grim city subject, but it still has his beloved water and the Impressionistic touch in the brushwork. The Munson-Williams-Proctor Institute, Utica, New York.*

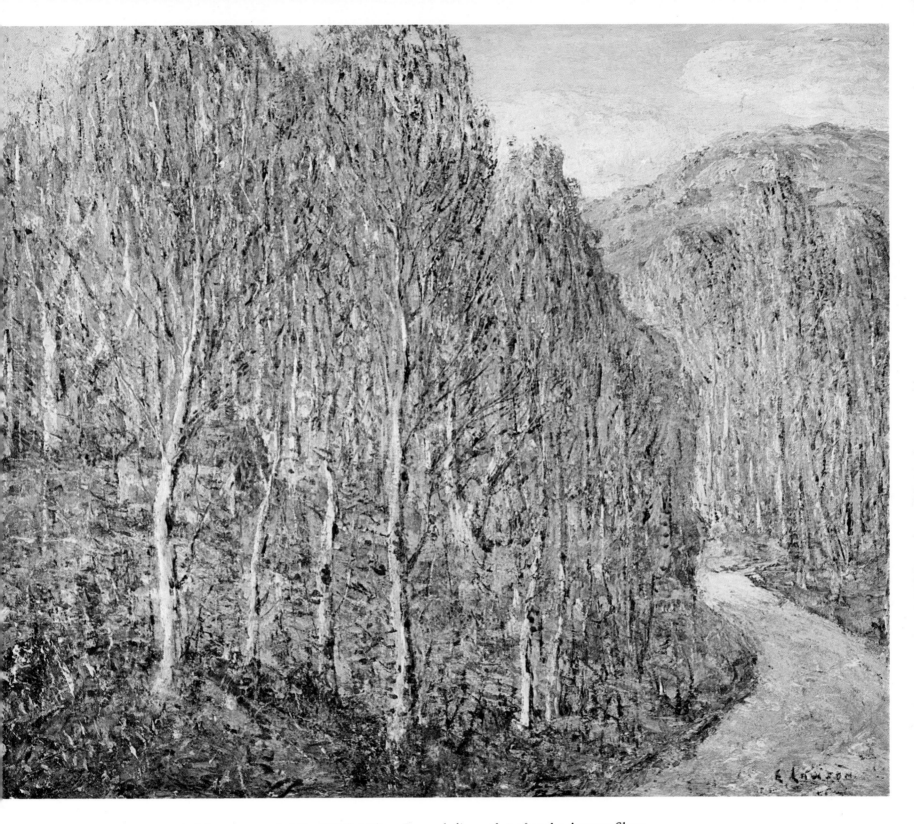

Birch Woods, *undated. Oil on canvas, 24½" x 29⅝". Milton Brown believes that after the Armory Show Lawson's work was influenced by Cézanne, but the influence is not very apparent. The Cézannes most like Lawson are the early Impressionist pictures. Lawson was well acquainted with Cézanne's paintings from his early Paris days, and he did not have to wait for the Armory Show. Lawson's own work did not evolve very much until it began to disintegrate just before his death. The Columbus Gallery of Fine Arts, Columbus, Ohio. Gift of Ferdinand Howald.*

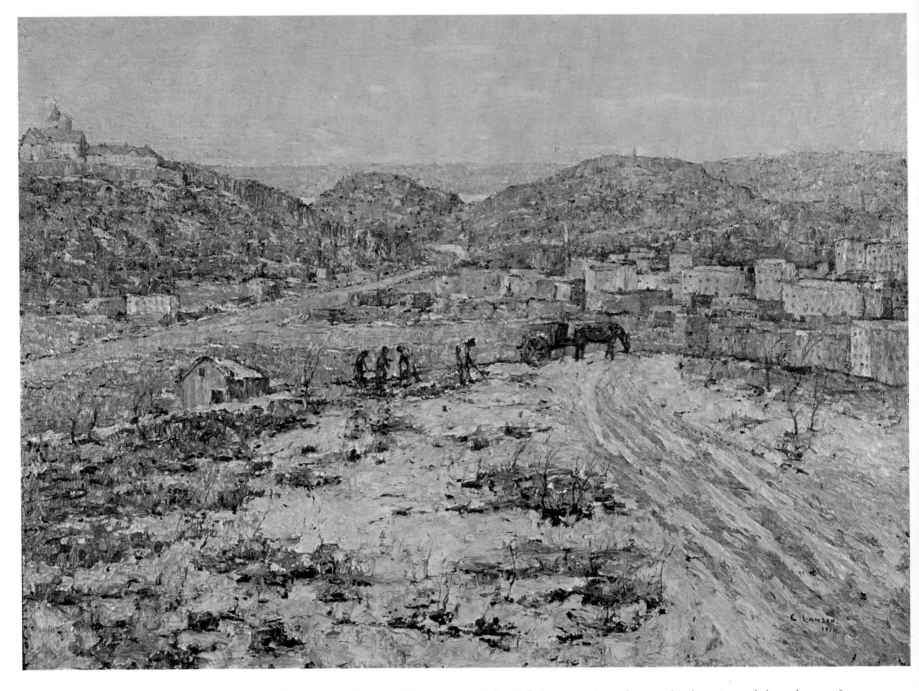

Hills at Inwood, *1914. Oil on canvas, 36" x 50". Lawson, the only pure landscapist and the only pure Impressionist of The Eight, said that he thought color could be used to depict the three major emotions in a man's life—anticipation, realization and introspection. His own landscapes are not that moody; they always have form and structure—and here, even a few men and a horse. The Columbus Gallery of Fine Arts, Columbus, Ohio. Ferdinand Howald Collection.*

Contrary to the shattering opinion of his wife, the other artists liked him. He didn't have a sharp tongue or a wounding manner, and he was helpful to his colleagues. He was quiet-spoken, pleasant, and a very good painter. He enjoyed parties and other men's conversations, and he had a good sense of humor, as well as character. He wasn't a group man, but belonging to The Eight was a great help for Lawson, who was too much alone for his own good. With Henri and his bunch, Lawson had his only period of friendship and fellowship after Paris. The Café Francis was wonderful for this miserable married man, who lived in the worst of both worlds. There weren't many French restaurants in the rest of his life. He was not particularly close to Henri and he probably didn't take him too seriously; Lawson was not an idea man, and he probably considered himself the better painter. But he certainly enjoyed being with Glackens and Prendergast and Davies; they went on seeing each other through the Armory Show and afterwards.

After the Armory Show, Ernest Lawson and Bryson Burroughs had a show in Paris, which was a rare event for Americans. 1915 was a great year for Lawson. He won a gold medal at the Panama Pacific Exposition as well as the Altman Prize at the National Academy. Daniel had a successful show and the Metropolitan bought a picture: "to make a view of Morningside Heights with its Cathedral and University seen from across the Harlem River like some idyllic island, lit by an Attic sky, is quite an artistic feat, notwithstanding the remarkably sunshot atmosphere New York has in its best weather." (Berry-Hill, p. 34). 1916 was almost as good, with a big prize at the Corcoran.

With the money from these sales, Lawson took his family to Spain in 1917. Since Canada was already a belligerent, Lawson took out an American passport and gave his birthplace as San Francisco. They rented a twelve-room unfurnished house in Segovia for fifteen dollars a month. Guy Du Bois wrote an imaginative article speculating on the influence Spain would have on Lawson's painting, but it didn't have any. When they came home he was elected to the National Academy and received the Inness Gold Medal. In 1919 he had a show at the Nova Scotia Museum of Fine Arts, including several Spanish pictures. The Museum bought four, which was certainly generous, and several more were sold to private collectors.

He spent the summers of 1919 and 1920 in Cornish, New Hampshire, the last summer the family spent together. His wife said she had a lot to put up with and consoled herself with making a home life for her children. "I greatly admired my husband's painting and we were congenial in many ways but he was a convivial soul who enjoyed the companionship of fellow artists. He often spent weekends visiting wealthy art patrons. While I did not complain about being left at home with the children, I withdrew into a life of my own. We got along in everyday living, except for his heavy drinking, and then I left everything and went to lectures on metaphysics, especially those given by Florence Shinn, who spoke on New Thought." She took the girls on a trip to Egypt, where the younger one died. "A little time afterwards, we went back to France, where we stayed for the next six years." (Berry-Hill, p. 40).

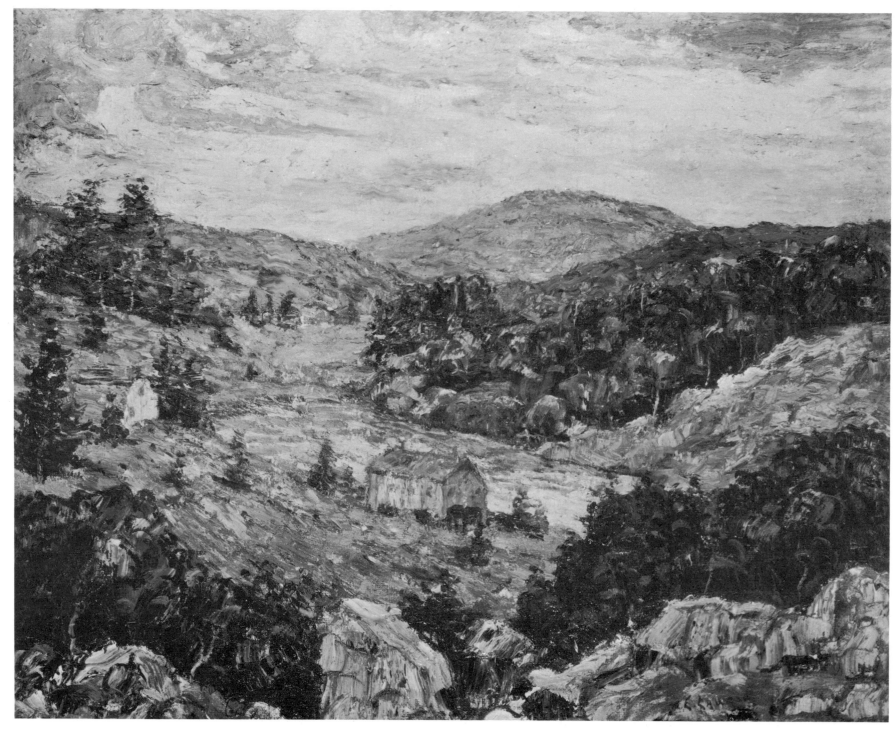

The Valley, *oil on canvas, 20" x 24". The Columbus Gallery of Fine Arts, Columbus, Ohio. The Howald collection.*

Early Summer, Vermont, *oil on canvas, 24″ x 30″. The Columbus Gallery of Fine Arts, Columbus, Ohio. The Howald collection.*

Cathedral Heights, *oil on canvas, 25⅛″ x 30⅛″. The Columbus Gallery of Fine Arts, Columbus, Ohio. The Howald collection.*

After his wife left for France, Lawson taught in Kansas City, where they had first met, and then for several years in Colorado Springs. When Katherine Powell, one of his students at Colorado Springs, moved to Florida with her husband he often stayed with them, and the trips to Florida provided him with the nearest thing to a home he'd had in years. In 1933, when the money stopped, Mrs. Lawson came back to live in New Mexico.

When the Depression came, Lawson had no reserves and he was driven to desperation. His painting had deteriorated in Colorado and Florida, and people spoke about hasty, inferior work and self-copies. Not only had his work fallen off—some of the Florida pictures are barely acceptable—but it was out of date. He had been around too long. Even in these hard times, Lawson got his share of prizes, but he had no talent for helping himself, and he became pretty hard to help. He became "poor Lawson," a person to avoid. He had been so successful for thirty years that he did not know the little tricks that you need to get by. He made the rounds of the New York galleries, borrowing five dollars here and there. He had loyal friends and dealers: the trouble was that there were no buyers. As he wrote Katherine Powell, "I have in stock, my dear Madame, various styles in landscape, Romantic, Lyric, Sylvan gentle streams meandering through tender meadows; mountain tops tipped with tender glow. In fact everything your sweet fancy dictates." Edith Glackens organized a Round Club of her friends in Hartford to which each member had to buy a Lawson painting and pay for it on installments. On December 18, 1939, in Miami, he went to the beach in the morning and later in the day his fully clothed body was found in the water. His friends believed that he had drowned himself and that it was just as well. The paintings at Colorado Springs were turned over to Mrs. Lawson, who sold some of them at auction. They averaged thirty-five to fifty dollars, and one large painting brought a hundred and twenty.

WILLIAM GLACKENS 1870–1938

The American Renoir

Unlike Henri and Sloan, Glackens was a quiet man with a grand sense of humor. You couldn't get mad at him, not even when he told Sloan, walking home from Moore's at two o'clock in the morning, that Henri's teaching was bad for his painting. If the association of The Eight was one of the heart, as E. P. Richardson says, then Glackens was the heart. He could even get along with the terrible-tempered Dr. Barnes.

Glackens was born in Philadelphia in 1870 of railroad parents who were proud of their youngest boy and of his older brother Lou, who was a staff artist on *Puck* for years. His father spoke very little, like the fathers of both Sloan and Joseph Pennell; perhaps this was a Philadelphia trait. Glackens inherited the silence. When he went to Central High School with Sloan and Albert Barnes, Glackens was already drawing. Glackens got along easily in school, and when he was twenty-one he walked into a job on the *Philadelphia Record*. He did not seem that young at the time—the city editor was eighteen. The next year he moved to *The Press*, where Sloan was already working, along with Luks and Shinn. These friendships were never broken.

Glackens was the only member of the Philadelphia gang who never boasted about his newspaper days, yet he was the most skillful of the lot. Once he wriggled through a window at the scene of a murder and fell into a pool of blood; he also spent a night on the brim of William Penn's hat on top of City Hall, The men on the job were amazed by his magical recall. Shinn says Glackens didn't need pencil and paper. "His memory was amazing; one look on an assignment was much the same to him as taking an exhaustive book of that incident from a shelf where at his drawing board he opened it and translated it into pen lines." Glackens had no interest in things mechanical, "yet one glance into the smoking activity of Baldwin's locomotive works clicked his optic lens . . . intricate lathes, chucks, mandrels, planing machines, drills, castings, and cranes. . . . Glackens drew with such accuracy and fidelity to purpose that it would have been a short cut for a model maker to render them into working steel with nothing but the guide of the artist's picture . . . ships, a maze of spars, mast, and tackles, Glackens drew without knowing their individual functions, yet rigged them for a sailor's eye and safe passage." (Everett Shinn, *Recollections of The Eight:* Brooklyn, 1943).

In the evenings Glackens went to the Pennsylvania Academy with John Sloan, who introduced him to Henri, and for a while Glackens shared with Henri the studio on Wal-

nut which Sloan took over when Henri went back to Paris. "The Gang" met there once a week, and put on plays by a member named C. N. Williamson, whose titles—*The Widow Cloonan's Curse* and *The Poisoned Gum Drop*—sound like Shinn's later famous productions in his private theater at Waverly Place in New York. Glackens had caught the painting bug from Henri, without whose influence his career would have been identical to his brother Lou's. In 1895 Glackens went to Paris with Henri, and in a way he never came back.

He lived on the Rue Boissonade, which runs between the Boulevard Raspail and the Boulevard du Montparnasse, near the Boulevard Saint Michel, in the heart of American Paris. He hung around the Closerie des Lilas with James Wilson Morrice, whose friend Maurice Prendergast had already gone home, and went sketching with him at Bois-le-Roi, in the forest of Fontainebleau; he didn't bother to attend any other art school after the evening classes at the Pennsylvania Academy.

In the spring of 1896, Glackens, Henri, and Elmer Schofield, another Philadelphia friend, took a bicycle trip to Holland. The peasants wore costumes and so did the cyclists, so they laughed at each other. Henri made a wonderful sketch of *Me, Scho, and Glack*, in their short balloon knickers like Athos, Porthos, and a diminutive D'Artagnan. This was the epochal trip on which Henri discovered Frans Hals.

This trip was just a teaser for Glackens, who had a living to make, and when he got back to New York George Luks, who was "premier humorist artist" on *The World*, gave him a job. These were boom times for newspaper artists and these men were in demand. Glackens roomed with Luks, always an apocalyptic experience, over a shop. Downstairs, the signs read "Luks and Glackens, Furs and Feathers," which they loved.

Glackens never went back to Philadelphia except for numerous and dismal funerals. Sloan always said he liked the center of Philadelphia, but the center was small. Joseph Pennell said he lost his regular place in the Philadelphia scheme of things when he went away, but the truth is that Philadelphia lost its place for them. Soon, on the *New York Herald*, Glackens was doing two-page spreads of public events, fires, and funerals, with forty horses turning a corner and twelve caissons rolling along, three artillery men on each caisson.

By 1896, Glackens was sending the Pennsylvania Academy pictures which, though the paintings are lost, bore titles that lasted all his life: *At Mouquin's, Central Park in Winter, Battery Park*. He covered the Spanish-American War for *McClure's*—from the landing of the troops at Daiquiri to the raising of the American flag at San Juan Hill, where Sloan said that Glackens was lying on the ground with his face pushed in the mud, only lifting his head to yell "Cowards!" as the cavalry charged by.

In New York, Glackens lived near Mouquin's and plugged away at his painting. He painted only one paid portrait, of Hopkinson Smith, "The American Thackeray," but it was not a success. He first exhibited with a dealer in New York in 1901 with Henri, Sloan, and Van Deering Perrine, who according to Shinn was once excluded from his

Chez Mouquin, 1905. Oil on canvas, 48³⁄₁₆" x 36¼" (Opposite Page). Glackens' most famous picture catches the mood of The Eight at the top of their form. When they could afford it, they had a wonderful meal at Mouquin's, as their friend James Moore is shown doing here, with one of the young ladies he called his daughters. According to Ira Glackens, the face at the far right belongs to Charles Fitzgerald, the art critic of The Sun, and the lady with him is Mrs. Glackens. The Art Institute of Chicago, Chicago, Illinois. Friends of American Art.

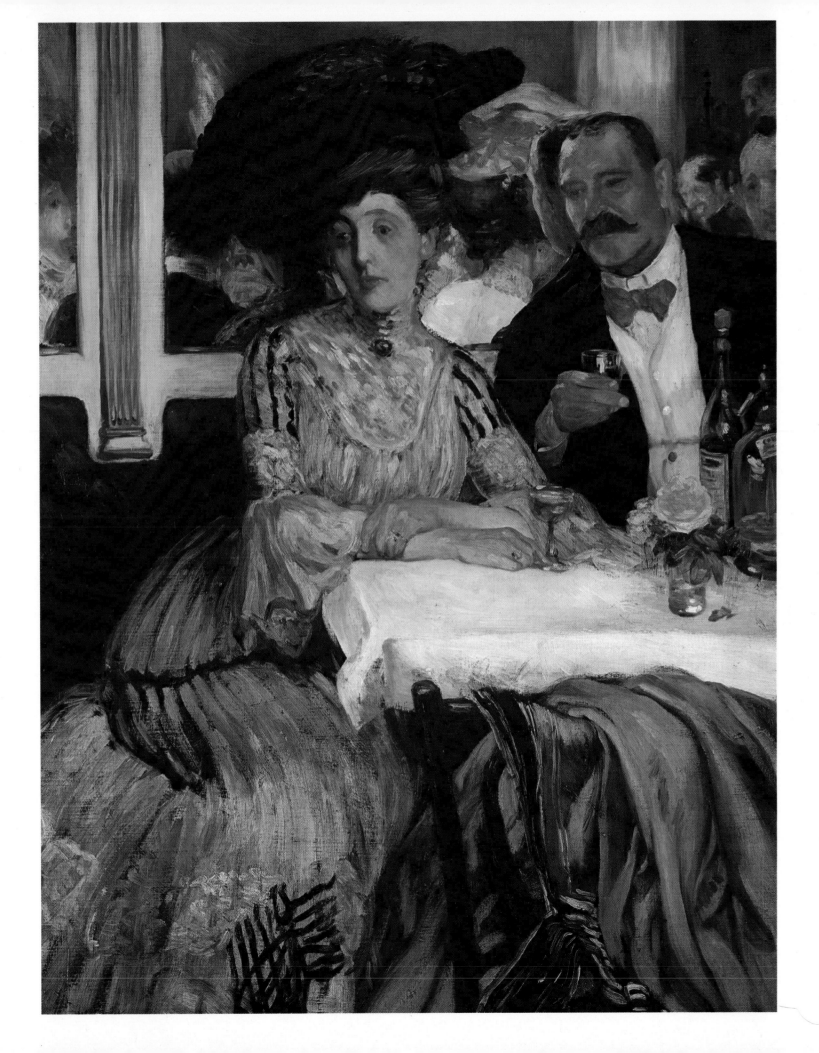

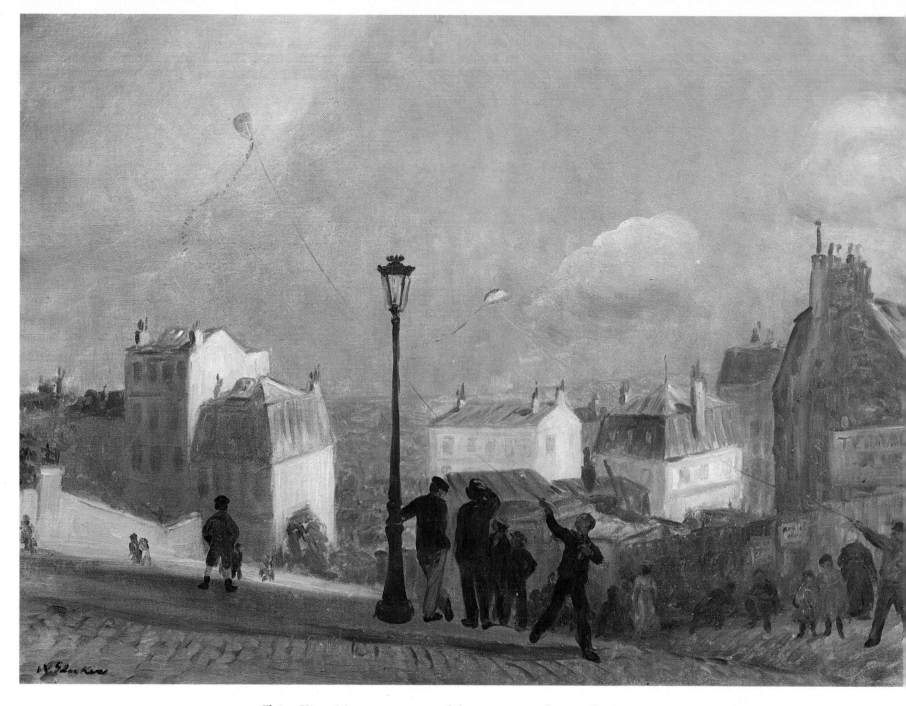

Flying Kites, Montmartre, *1906. Oil on canvas, 26" x 34¼". This lovely picture was painted in Paris in 1906, on the Glackenses postponed honeymoon. Glackens always felt at home in France, and his contentment shows in his work. The Boston Museum of Fine Arts, Boston, Massachusetts. Charles Henry Hayden Fund.*

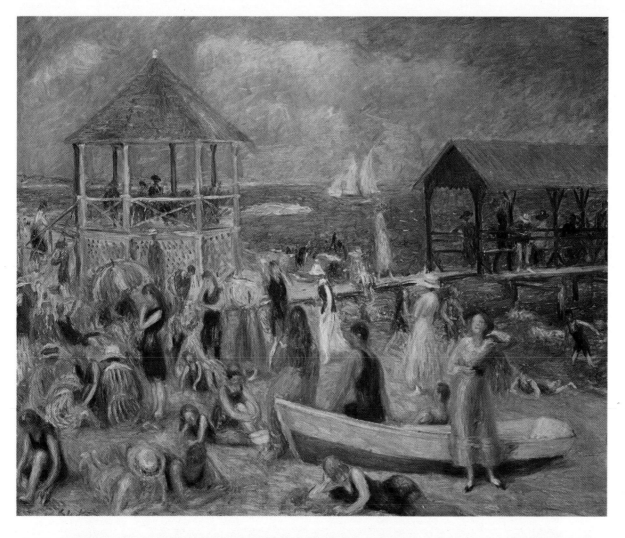

Beach Scene, New London, *1918. Oil on canvas, 26" x 31⅞". The Glackens family spent their summers at the shore, and the pier and the bandstand at New London gave Glackens a chance to paint the crowded scenes he loved so well, with figures squirming all over the beach, an abundance of animation, and a blaze of color. There is a fine smell of salt, and a breeze on the water. The Columbus Gallery of Fine Arts, Columbus, Ohio. Ferdinand Howald Collection.*

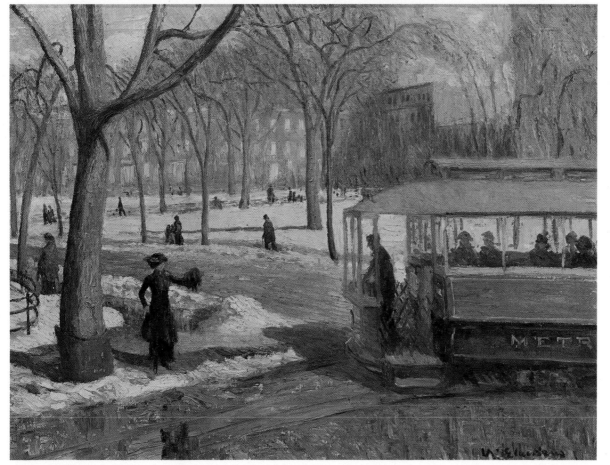

The Green Car, *1910. Oil on canvas, 24" x 32". Several of The Eight lived around Washington Square, and this may have been painted out of Glackens' window. Henri was a great admirer, and not just of his paintings: "There are beautiful drawings William Glackens has done of the children in Washington Square and his streets on the East Side with their surge of life. In being great works of art they are nonetheless documents of life." (Henri, p. 219). The Metropolitan Museum of Art, New York, New York. Arthur H. Hearn Fund.*

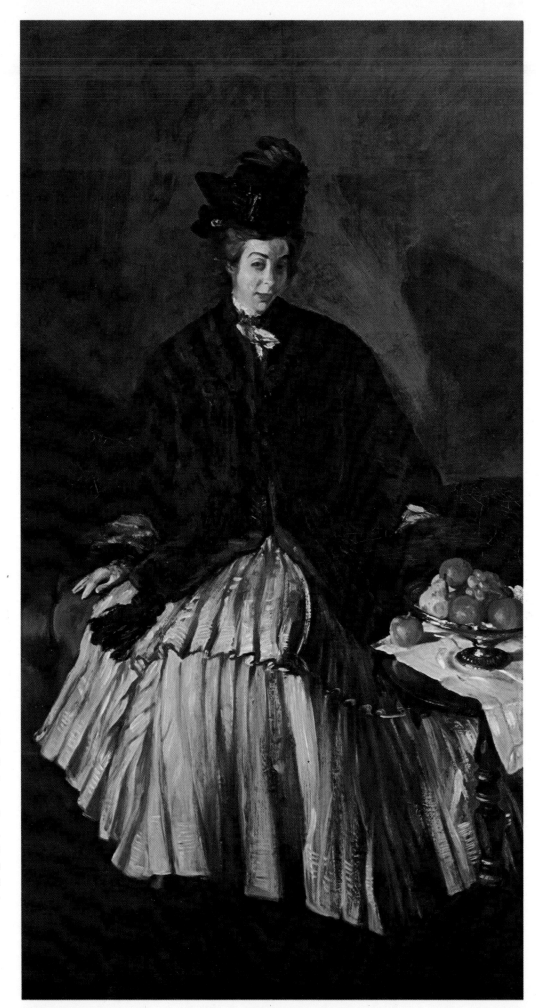

Portrait of the Artist's Wife, *1904. Oil on canvas, 75" x 40" (Right). Mrs. Glackens was a wit and a story teller, with piquant charm and a sharp tongue. Many of Glackens' friends were a bit in awe of her, and perhaps Glackens was too. The Wadsworth Atheneum, Hartford, Connecticut.*

Shoppers, *1908. Oil on canvas, 59" x 59" (Far Right). Mrs. Glackens is in the center, and Mrs. Shinn is at the right. Glackens was usually a fluent painter, but this picture drove him to despair before it attained its present serenity and tranquility. The Chrysler Museum, Norfolk, Virginia.*

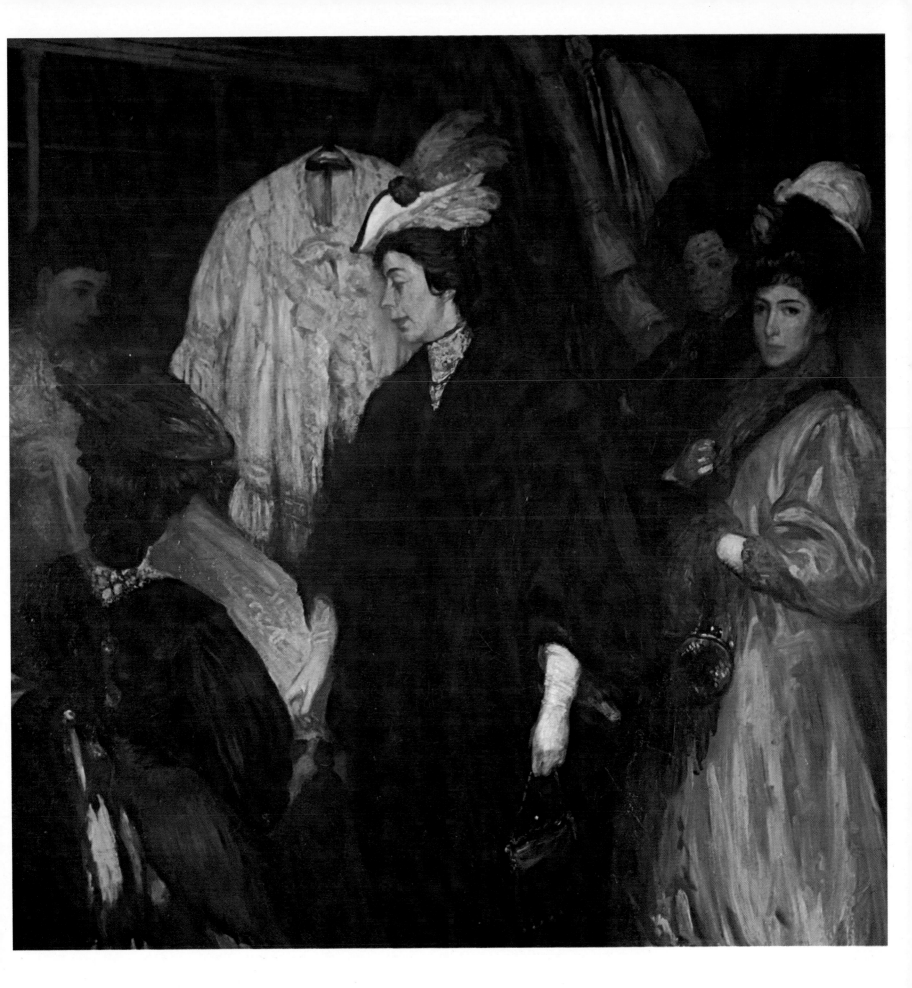

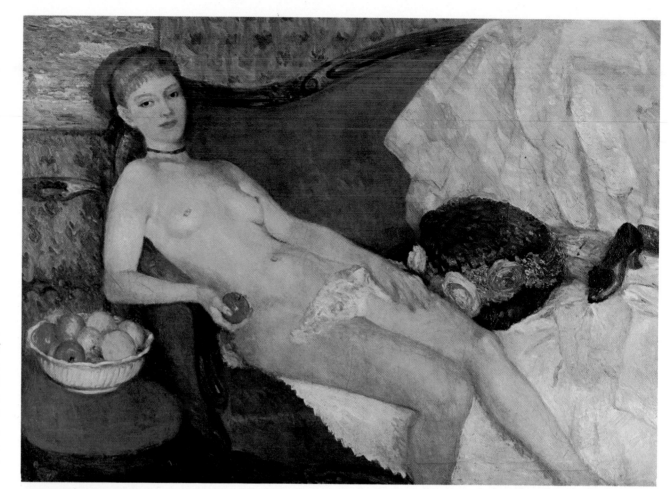

Nude With Apple, *1910. Oil on canvas, 40" x 57". This is the finest of Glackens' nudes. The pearly flesh tones have no hint of the Renoir red that spoiled a good many of his pictures. The young lady does have a slight tendency to slip off that sofa, though. The Brooklyn Museum, New York, New York. Dick S. Ramsay Fund.*

Luxembourg Gardens, *1906. Oil on canvas, 23¾" x 32". Glackens could find his subjects anywhere, and the Luxembourg Gardens in Paris suited him at least as well as Central Park in New York. He loved France so much that he carried it with him wherever he went. The Corcoran Gallery of Art, Washington, D.C.*

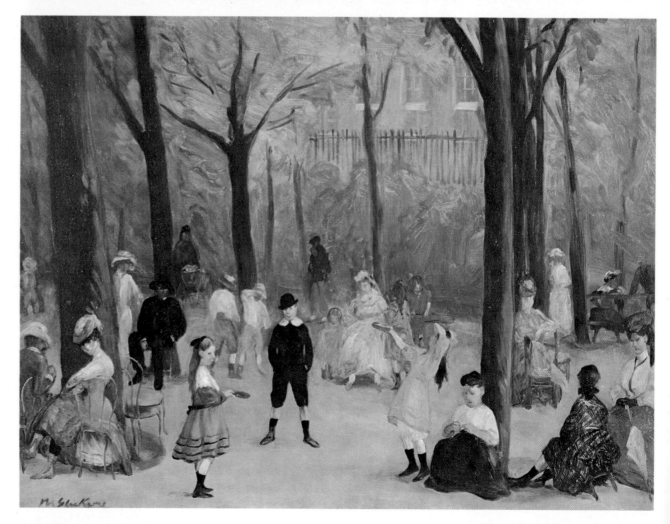

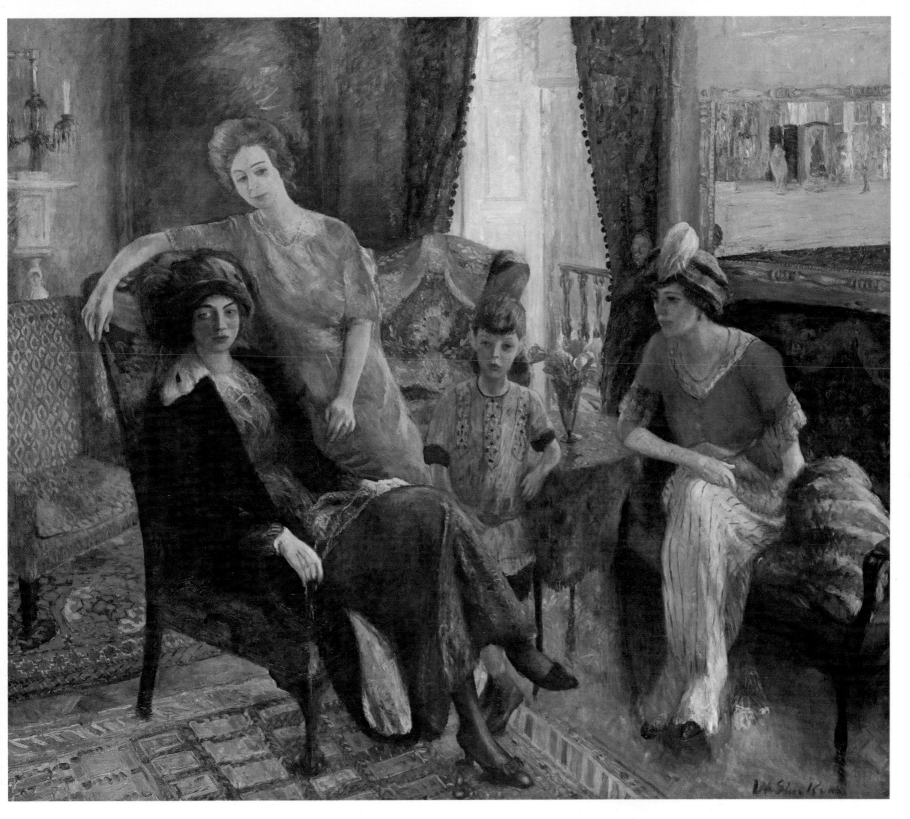

Family Group, *1910–1911. Oil on canvas, 72" x 84". This painting shows the two Glackens children, Ira and Lenna, Mrs. Glackens' sister Irene, who married the critic Charles Fitzgerald, and her lifelong friend Grace Morgan. The National Gallery of Art, Washington, D.C. Gift of Mr. and Mrs. Ira Glackens.*

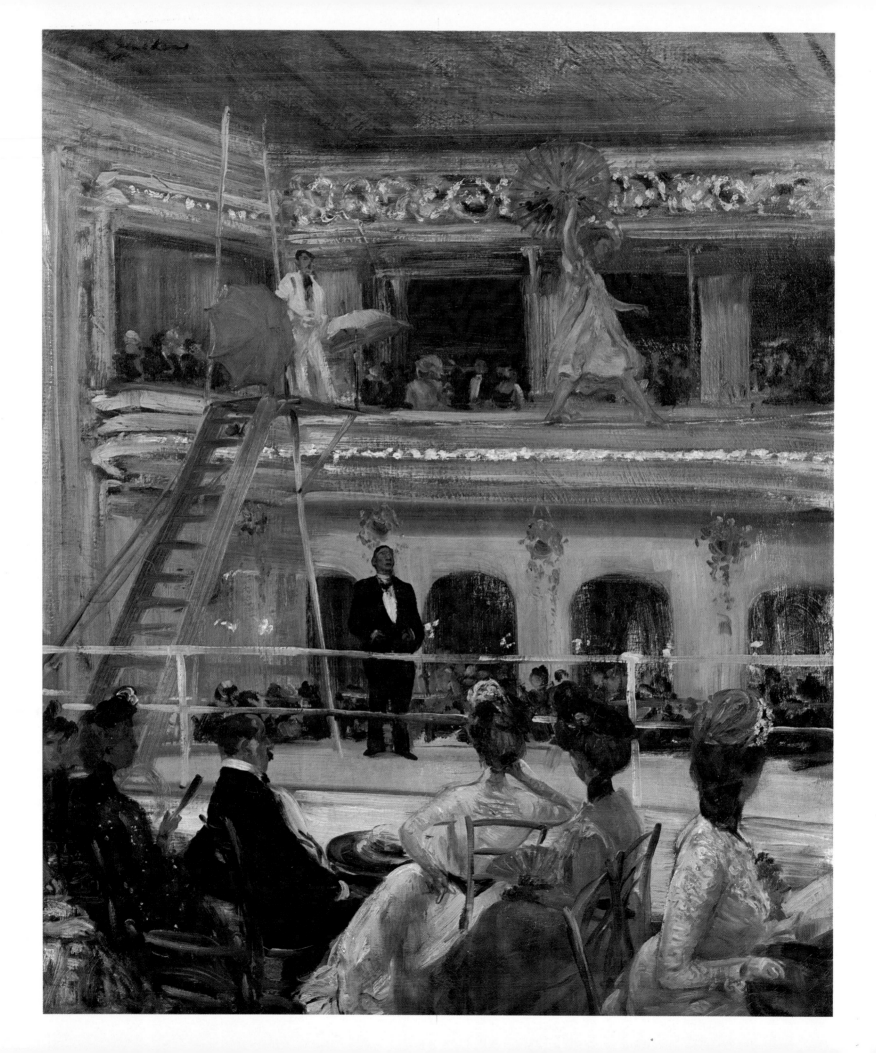

own exhibition because of the state of his clothes. Alfy Maurer, who won first prize at the Carnegie International in Pittsburgh that year, was also in the show. It was more than favorably reviewed in *The Sun* by Charles Fitzgerald, who later married Glackens' sister-in-law. Glackens and Jimmy Preston, who married his wife's roommate, used to close up Mouquin's at two a.m. and then go on to Stanley's for beer and deviled kidneys.

Glackens, most unworldly of men, was the only one of the bunch who married well in a worldly sense. Edith Dimock, a witty and strong-minded Chase student who lived in the Sherwood Studios and insisted she forced Glack to pop the question, came from a very grand Hartford family who lived in the largest and ugliest house in town.

When Edith announced that she was engaged to a young illustrator from Philadelphia with railroad parents, her mother wailed: "Oh, Edith we thought *you* were going to marry money." But Edith was very strong-willed and the family didn't have a chance. She and Glackens were married in the pink drawing room of the chocolate brown house in Hartford with James B. Moore as best man. Luks outdid himself on the train which brought the wedding guests up from New York, parading up and down the aisle with a flower on his nose announcing that he was J. P. Morgan, the patron saint of Hartford.

The young couple moved into the Sherwood Studios for a while. Glackens had been lonely before he was married, visiting the Shinns at Cornish, New Hampshire, in the heart of the St. Gaudens country: "Nothing but serious minded aesthetes permitted here. Pleasant jocularities not allowed." From now on he was lonely only when his wife was visiting her family. They were part of the Café Francis crowd, with Henri and his wife and all their friends, and the dinners at Mouquin's ran into the parties at the "Secret Lair," where Edwin Arlington Robinson, the poet, lived in a room in the attic. Lawson said that he ate up seven canvases at the Francis, and O. Henry had dined there under a painting by Glackens.

Glackens kept up with his illustration for a long time. He, Sloan, Luks, and Preston made a great many drawings and etchings for a deluxe edition of the works of the French novelist Paul de Koch. It was slow pay, especially when the company went bankrupt and the publisher went mad, but a grand opportunity for them all.

In 1906 Edith's father paid for a trip to Europe. Glackens got several good pictures out of Spain, but he also had a return bout of the malaria which he had picked up in Cuba during the Spanish-American War. Edith developed a violent dislike for Spain, and they were delighted to escape to France. Most of these men were in love with France. Glackens loved everything about it: the puffy clouds in the light blue sky, the wide cities and the narrow villages, and the food. Edith saw to it that dinner in their house was always delicious to the delight of their friends. They lived on the Rue Falguière, back of the Gare Montparnasse, with the Prestons. Alfy Maurer had a studio at the same address, as well as his place on the Marne. They saw Morrice several times, and wrote to Henri, whose enthusiasm for Spain they did not share.

At this period, both in Paris and New York, Glackens was on top of the world. He

Hammerstein's Roof Garden, *ca.1901. Oil on canvas, 30" x 25" (Opposite Page). Hammerstein's Roof Garden was on the site of the old Hippodrome, where the parking garage is today. The Eight went to the theater whenever they had a chance. For Glackens, this was a memory of a night off, which he has changed into a most unusual and original composition, with strong parallel lines. The arched back of the woman in the right-hand corner conveys her tension very well while she watches the act. The Whitney Museum of American Art, New York, New York.*

became a member of the National Academy, and *Chez Mouquin* got honorable mention at the Carnegie from a jury including Alden Weir and Thomas Eakins. He was painting his best. As John Sloan said with a touch of envy: "He should be happy, a wife, a baby, money in the family, genius." (St. John, p. 143). What else is there?

Glackens was not active in the formation of The Eight, but he went right along. He was not an active organizer like Henri and Sloan. Everybody liked his paintings; it was only later that critics spoke of the excessive influence of Renoir. Just because Glackens was always calm and pleasant didn't mean that things were perfect. His wife was closely attached to her family and the apartment on Washington Square, which seemed like a glimpse of heaven to Sloan, was not as convenient a place to bring up children as West Hartford, where there were maids and lots of help. Glackens liked to have friends and family around him all the time. Quiet himself, he liked the murmur of voices. He looked up to his determined and witty wife; William Merritt Chase said that he could not make her out, but she was probably a genius. This may have been one of her stories, but Glackens more than half believed it. She was glamorous to him, which is a wonderful way for your wife to be. A lot of her time was taken up by her children while Glackens looked up his old friends. Just before the show of The Eight he wrote Edith that he had dinner with the Sloans and with Henri and his mother: "I always thought she was his stepmother but as she had nearly reached the golden anniversary when Mr. Lee up and died, but I deduce she is his real mother." And, "Henri as usual got into a squabble with Dolly and they both sassed each other, neither was he over-respectful of his mother, however she is a dreadful old bore." (Ira Glackens, *William Glackens and the Ashcan Group:* New York, 1957, p. 86). Henri and Sloan talked of nothing but their show, and Glackens went away feeling horribly depressed. The *Evening World* was looking for someone to do the Thaw trial, which Glackens would have liked to do, but they gave the job to someone else.

Jim Moore came from the same family background as the murdered Stanford White, but their rich and dazzling host, who owned the Café Francis as a hobby, had troubles of his own. Sloan complained that Moore, not satisfied with driving people away on account of the bad food, now sat at one's table and talked of nothing else but his troubles. One night he even sent John L. Sullivan away from their table. He faced bankruptcy, the loss of "The Lair," and a dim Philadelphia future working for an auctioneer.

Henri and Sloan knew the show was important for their future, but they were not the only ones concerned about the forthcoming exhibition at Macbeth's. Glackens was worried about his own paintings. Actually, Glacken's six pictures in the show are as good as any he ever painted. *Chez Mouquin* is his masterpiece, with Moore living the great life he loved with his aristocratic-looking young lady, and Charles Fitzgerald and Edith Glackens showing in the mirror. Edith is also prominent in *The Shoppers*, the largest picture Glackens ever painted. His other paintings in the show depict Central Park and the Buen Retiro in Madrid, for Glackens loved parks wherever they were. Edith came

down from Hartford for the opening and afterwards there was a big party at the Sherwood; Sloan and Luks closed up a whole row of saloons, and even Prendergast had too much to drink. The critics were good to Glackens, and Huneker, who had succeeded Fitzgerald on *The Sun*, gave *Chez Mouquin* a tremendously appreciative review. If Glackens didn't sell, neither did Prendergast and Sloan, but they all knew they were painting well.

The summer after the exhibition of The Eight Edith rented a house on Cape Cod. This was their first seaside summer, and Glackens became an excellent beach painter. It gave him the kind of subject matter he liked, with people swarming all over the place and kids jumping up and down, with the foolish summer houses, the salt smell of bathing suits in the air, and sand in the sneakers.

On their way to the Cape they stopped off in Boston where they saw Prendergast and his brother Charles. Fitzgerald sent them the address, and news of Moore, who looked uncommonly well and was not drinking—"which is more than I can say of the most of my friends or even of myself." Fitzgerald heard that someone had a card from the new and picturesque Mrs. Henri saying that this was better than drawing comics: one of her cartoon captions was *What a Difference a Mere Man Makes*. Moore wrote from Philadelphia, that paradise of the commonplace, the unexciting, the bromide: "The old gang, Billie, has become a memory . . . no more chatty dinners, domestic infelicities, and bouillabaisses of the unexpected and unforeseen. Ah, me!" (Glackens, p. 132). Moore sent his highest regards to Mrs. Glackens, to Falstaff Fitzgerald, to Henri, to Sloan, to fashion-plate, snug-lapeled Gregg, and all the other notables that made up that mosaic of genius that he had formerly contemplated with awe.

Study for Nude with Apples, *pastel on dark pink paper, 8¼" x 11¾". Collection of Arthur G. Altschul, New York, New York.*

Glackens was not an admirer of Old Man Yeats, who had a habit of coming for dinner with a suitcase and shouting, "Where's me room?" Every time he was introduced to the old duffer, Yeats would say he was pleased to meet him. Finally Marjorie Henri, who was red-headed and Irish, yelled: "You've met him before, you gazoon!" The Glackenses liked her very much, and thought she made Henri a damned fine wife.

After the early New York years, Glackens didn't push himself very hard. His most ambitious canvases, which date from this time, gave him a lot of trouble. He kept right on producing all his life, but he stopped fighting his limitations. Some of his color looks like Bonnard, with the same unexpected purple and orange tones. *Family Group* and *Artist's Wife and Son*, which were both painted around 1911, have slightly stiff, uncomfortable figures, and even the lovely *Nude with Apple* slides off the couch. His later pictures lack the failures, but also part of the flavor; he had learned what he could do and he kept doing it easily.

His best patron was his childhood friend Dr. Barnes, who had become very rich. Glackens was the only friend Barnes had in the world, and even Glackens would not have put up with him if he had not been so wealthy. Barnes was the only man that Glackens had to kowtow to, and Edith resented this. It was the only time she was put in the humiliating position of the artist's wife in relation to a buyer.

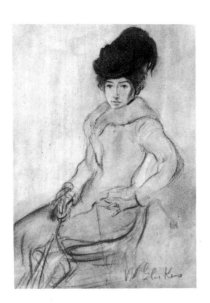

Florence Scoval Shinn, ca.1907, red chalk, 12" x 9½". Collection of Arthur G. Altschul, New York, New York.

When Barnes wrote to Glackens around 1910, renewing their Central High School acquaintance, they had not seen each other for many years. Barnes developed a crush on the young couple, and could not do enough for them, which was a trying experience, for Barnes was very difficult to get along with. He liked to have Stokowski or Mischa Elman in to play for Glackens, who believed that music was a conspiracy against the human race. Once when Barnes was browbeating Mrs. Barnes, Edith Glackens told him to shut up; there was a painful scene and Glackens was afraid they wouldn't be invited again in a hurry, but Barnes got over it: he didn't have anybody else to talk to. In 1912, the year before the Armory Show, Barnes sent Glackens abroad with $20,000 to buy pictures. In Paris, Alfy Maurer put him in touch with Leo Stein, Gertrude Stein's brother, who was remarkably knowledgeable, thus starting the great Barnes Collection in Philadelphia, which is still not easy to see. Glackens, who had not been in Paris since 1906, found that he still loved France and that he could live there forever.

Through Glackens, Barnes bought more paintings by The Eight than the rest of Philadelphia put together; not one of them had an important Philadelphia patron except Barnes. Glackens got Barnes started on the right road as a collector, with Cézanne and Renoir, but then Barnes went off on his own. Glackens' enthusiasm for modern art was muted, while Barnes plunged into Matisse with only a slight briefing from the Steins. He picked Soutine on his own, despite Edith Glackens' express disapproval. From then on, he bought what he pleased. Barnes ended up believing he knew all about art.

Edith believed in women's rights, while her sister Irene was a suffragette who had studied medicine and worked for Carrie Chapman Catt. The pair of them induced William to march in a suffragette parade down Fifth Avenue. According to the artist's son, prohibition and suffrage were the liveliest issues that ever struck the Glackens home. For a wine drinker like Glackens, prohibition was a disaster; at a tearful testimonial dinner for Henri, Glackens made the most important public statement of his life: "Henri's all right. But what are we going to do about prohibition?"

Both of Edith's parents died in 1917. They bought the house on 9th Street in 1919, where they lived for the rest of their lives, with summers in the country. Their second French period began in 1925, when they stayed abroad for two years. This was the high tide of the American ascendancy in Montparnasse, fully as brilliant a period as Greenwich Village before the War, and Glackens enjoyed them both to the full. Glackens kept his spontaneity and his sparkle in his work and in his life. He was a wise man, and he did what he liked to do, which was what he did best. Edith Glackens felt that he was not fully appreciated, but Glackens didn't read the critics anyway: they didn't know what they were talking about.

Glackens had the world's best time in France, which was then an American paradise and incredibly cheap. It was just as good as before, if not better. All his friends were there, and they saw more people than they did in New York. They rented a house at Samois, close to Fontainebleau and near Guy Du Bois, who almost became French

himself. Leon Kroll was there with his French wife, while Charles Prendergast was in France that summer. They rented bicycles and rode all over the forest. Yvette Guilbert, whom Glackens had seen at the *Herald* office in New York in 1897, gave a recital in Fontainebleau which the Glackenses attended, singing all the old songs that moved him so deeply. In the winter they took a villa at Vence, on the Riviera, from which they could see Corsica, and the peasant women in black came down from the mountain riding donkeys loaded with rosebuds. The Krolls were over at Cap Ferrat, and they had friends along the coast all the way to Cap d'Antibes.

They spent the winter of 1926–27 in the Rue de Varenne, Henry James' old stamping ground, and the winter of 1929–30 on the Rue du Bac, where Whistler had his studio. Glackens spent a lot of time at the Café du Dôme talking with Leo Stein. When Edith was away, as she was in 1928, he ate quail with Tom Slidell, a gentleman painter with cameo cufflinks who had a studio in Auteuil. From France, Glackens sent pictures back to his dealers, Kraushaar and Daniel, and sold just as well as ever. He spent a lot of time in Paris by himself, going to French doctors, on Edith's orders. The only person who never came through town was Henri.

They continued to go back and forth to France until 1936. The depression didn't bother them much, or change their way of living. They just were not as well off as they thought they were going to be. In the late Thirties, Glackens' health began to fail, and he painted smaller things. On May 18, 1938, he told Sloan that if he could not paint, or enjoy his friends, food, and wine, he did not want to live. The next weekend they spent with Charles Prendergast and his French wife in Westport, and on Sunday, May 22, while talking to Charles, he died. His son Ira said that he couldn't think of a happier life or an easier death.

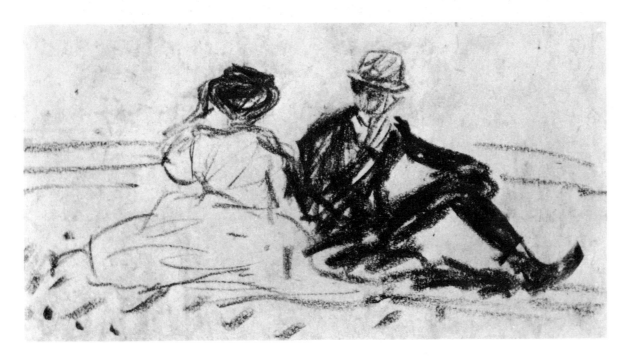

Picnic, *charcoal on brown paper, 4¼" x 5⅞". Collection of Benjamin Sonnerbey.*

GEORGE LUKS 1866–1933
Chicago Whitey

George Luks was an extraordinary character, hilariously funny, the best company in the world, and W. C. Fields came to resemble him. When drunk, which was often, he was cantankerous and ornery, and he died in a barroom brawl.

Luks was born in 1866, "just about the time our god damn Congress was trying to bash Andy Johnson out of office," in Williamsport, Pennsylvania, twenty-five miles from Lock Haven. He was brought up in Shenandoah, in the coal fields; his father and mother came from German families, and he was baptized a Lutheran. His father was a doctor, with offices in the drugstore, and the family, the most artistic in town, lived over the store. One sister sang with Lillian Russell, one brother was a violinist, and another played straight man to George in a professional vaudeville act. Their act broke up when George went off to Europe to study art and his brother went to medical school. George said that he was abroad ten years, living with a retired lion tamer in Düsseldorf and studying under Lowenstein, Jensen, Gambrinus, and some Frenchmen, "from whom I never learned anything, always excepting Renoir, who is great any way you look at him." (Bennard B. Perlman, *The Immortal Eight:* New York, 1962, p. 76). We have only Luks' word to go on, which was violently unreliable, for he avoided the truth; in fact, he avoided it with care. Presumably he went to art school in Germany, but when he surfaced in Philadelphia in 1893 as a staff artist on *The Press*, he had left painting behind him—if he had ever been serious about it in the first place. Though he might deny it, Luks learned about painting from Henri, and if Henri had not come along there's no reason to believe he would ever have been a painter.

He roomed with Everett Shinn, and they must have made quite a pair. Shinn was pretty colorful himself, while the liquor had not yet begun to catch up with Luks. According to Shinn, who was very much the dandy, Luks went in for "shadow plaids of huge dimensions, the latest word in suburban realty maps. Vests were featured, cream-colored corduroy, like doormats laid out in strips of a hawser's thickness, or bark-stripped logs on a frontier for stockade. . . . Once he wore a white derby with a black band; this one he might have found at a racetrack." (Perlman, p. 75).

In 1894, along with all the other men on *The Press*, Luks went to Henri's Tuesday evenings, though he was never an admiring pupil. Only two years younger than Henri, he didn't have it in him to be a good disciple. Henri demanded attention and he did not

particularly enjoy interruption, while Luks was violently disrespectful and made a great deal of noise. The two men were a complete contrast, Henri tall and serious while Luks, a short square man, swore that he had lived for the past month on the barnacles on the hull of a slave ship.

Luks was a great man at a party—a wonderful mimic, a one-man vaudeville show, subtle in a loud way, as Shinn said. In one of his acts he pretended he was escaping from a frozen pond, fanning the air with his hands for tree branches that weren't there. Not all his acts were so quiet, however, for he could imitate all the instruments in the orchestra. But mostly he was a boxer: he may actually have believed that he was Chicago Whitey, and that he had once been the light-heavyweight champion. Every day, when Shinn came to pull him out of the saloon across from *The Press*, Luks told Shinn he would never make the grade because he didn't drink. "Licker does it, licker and nothing else."

In 1896, *The Evening Bulletin* sent Luks to Cuba as a war correspondent. He had a glorious time, sending back twenty-nine combat drawings. "An insurgent scout has been overtaken by Spanish troops in a rocky defile near Guara. They fire upon him, and *The Bulletin* artist in Cuba sketches him as he falls from the saddle." (*Ibid.*, p. 87). Needless to say, the closest Luks had been to Guara was the nearest bar in Havana. When he was riding on a train with Stephen Crane and Richard Harding Davis he suddenly heard gunfire and hit the floor. It was all right for those fellows to sit up, "but I have a future." He said that he carried dispatches through the lines for the insurgents, disguised as a dog, with the papers in his mouth. When he was fired for drunkenness he immediately landed a job in New York on *The World*, which needed him to draw *The Yellow Kid* because Outcault, who invented the comic strip, had been stolen by Hearst. Luks got Glackens a job on the paper and when Shinn joined them the great days started all over again in New York.

Luks painted with Glackens in the studio they shared together. Luks was exuberantly happy as a newspaper artist, but when he started painting he painted pure Henri, which may possibly have been a return to the dark paintings of the Munich School in his youth. His streets are grimmer than Henri's, and his characters are more vivid.

All the other members of the Philadelphia gang loyally acknowledged their debt to Henri, but Luks was too rambunctious for gratitude. Moreover, he was capable of being downright mean. He disliked being in Henri's shadow. He thought Henri gave himself airs and pretentions. He considered himself a great man in his own right, and when he said the world never had but two artists, Frans Hals and little old George Luks, he wasn't joking. He didn't consider Henri his father in art. He liked to hold the floor, the barroom floor, and if people didn't listen he got obstreperous and unpleasant. He was damned if he would read the books Henri recommended. Sloan may have gotten a bit prickly later, but Luks with his drinking and his brawling was a problem from the beginning.

Yet Luks was the only one of the Philadelphia group who remained true to Henri's

Otis Skinner as Colonel Philippe Brideaux, *1919. Oil on canvas, 52" x 44" (Opposite Page). Luks painted a perfect character here; it's almost a mirror portrait, gay, amusing, bohemian, bamboozling, cocky, and crafty. Luks had the perfect opportunity, and he seized it to make his masterpiece. The Phillips Collection, Washington, D.C.*

Hester Street, *1905. Oil on canvas, 26" x 35³⁄₁₆" (Above). Though Luks specialized in large single figures, he could paint the city scene with the best of them. His New York had all the interest, diversity, and fascination of a Moroccan bazaar. The streets were always crowded, and something was always going on. The Brooklyn Museum, Brooklyn, New York. Dick S. Ramsay Fund.*

The Old Duchess, *1905. Oil on canvas, 30" x 25" (Right). Luks handled the old Duchess' proud pretense and pitiful reality so well because he had the same conflict. He was a connoisseur of old frauds; he was one himself. The Metropolitan Museum of Art, New York, New York. George A. Hearn Fund.*

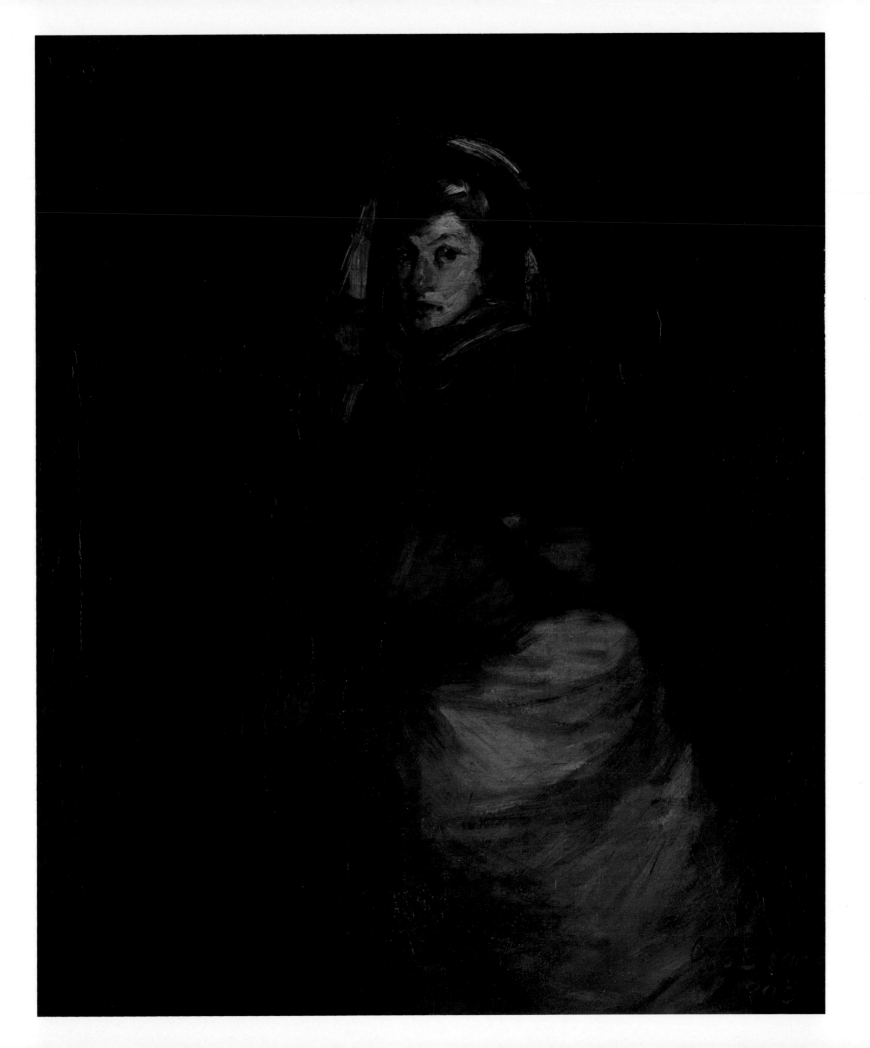

Mrs. Gamely, *1930. Oil on canvas, 66" x 48". Luks is at his best with characters he could grasp completely, and Mrs. Gamely was perfect for him. She loved her rooster and her stove, and Luks loved her randiness and rowdiness. The Whitney Museum of American Art, New York, New York.*

The Spielers, *1905. Oil on canvas, 36" x 26". Henri and Sloan were great admirers of Isadora Duncan, but Luks has really caught the spirit of dancing in these two slum kids. Here is all of Luks' understanding, and yes, tenderness. The Addison Gallery of American Art, Phillips Academy, Andover, Massachusetts.*

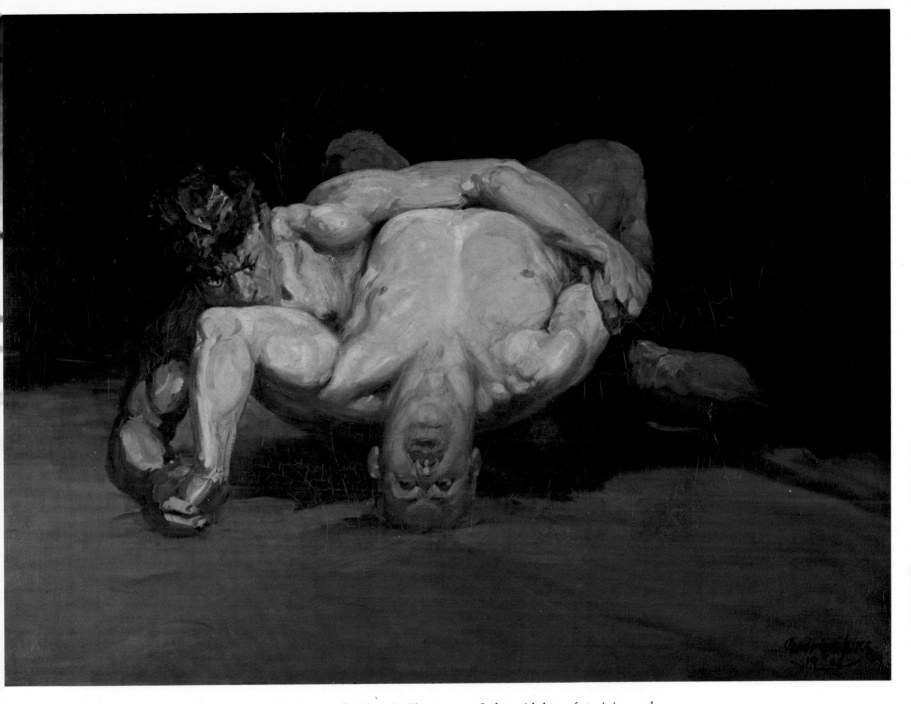

The Wrestlers, *1905. Oil on canvas, 48¼" x 66¼" (Above). This is super-Luks, with lots of straining and heaving, but wrestlers strain and heave, and so did Luks. George Bellows probably modeled his violent prizefight scenes on this picture. This is one side of the Luks legend, the side celebrated by Benjamin de Casseres. Underneath, Luks wasn't all that tough. The Boston Museum of Fine Arts, Boston, Massachusetts. Charles Henry Hayden Fund.*

Little Madonna, *ca.1907. Oil on canvas, 27½" x 22" (Left). Luks came close to sentimentality sometimes, as did Henri, particularly with children, but the action is so well rendered and the character is so well caught that we forgive him. The Addison Gallery of American Art, Phillips Academy, Andover, Massachusetts.*

manner of painting all his life. Prendergast, Lawson, and Davies were fully formed artists before they met Henri, and he never had any influence on them; they were friends, that's all. Luks was more loyal to Henri's style than Henri himself, for Luks never wandered into the wasteland of theory. Luks had a good mind and it was difficult to fool him. He didn't believe in theory, he just painted; he never lost touch with his material by thinking too much about it. Luks was very intelligent and he made good sense. His mind did not spin. Luks painted pretty much the same way all his life—he kept on doing what he was good at. Luks' paintings have drawbacks; they are sentimental about squalor, they are dark, and they are limited in range, but they represent a consistent way of looking at life. Drinking may have interfered with his work, but it's questionable whether he could have been better without it; it may not have had all that much effect. The remarkable thing is how much good work he turned out. For Luks was altogether exceptional, by no means merely a comic character. He was surprising in all directions and remarkable in everything, including his addiction to alcohol. He counted on his charm to carry him through, but it couldn't always do the trick. He was distressing to his friends and to his wives, who finally found him unsupportable—how could they not? He was married several times, though the number, like his painting, is blurred. One of his wives married Frank Crane, who had been their old art director on *The Philadelphia Press* and lived in Bayonne, New Jersey, where the Sloans visited them. When Mrs. Luks turned up as Mrs. Crane in 1906 Sloan hadn't seen her for years. The Cranes brought up Luks' son as Kent Crane and he didn't know Luks was his father until he was eighteen; Sloan painted his portrait and was pleased that Kent, who became an architect, dropped in on him over the years. One day at the Sloans' after they and the Cranes had just come back from Rockaway Beach, Luks brought his new wife to call. Sloan excitedly tried to explain the situation to Mrs. Luks, while Mrs. Crane, who was in another room, recognized Luks' voice, to her consternation. The Sloans did not tell Luks that his son was there, and the meeting did not take place.

But the second Mrs. Luks, if that was her number, didn't get any bargain. Luks kept right on drinking, which was what broke up the first marriage; he didn't always show up for dinner, and he came home very drunk. That's all very fine when you're his girl friend and drinking with him, but it's not so good when you're married and waiting alone at home. He'd stop off for just one little drink and turn up three days later with no hat, no necktie, and two black eyes. Then he'd behave himself for weeks on end. But Luks could be tremendously appealing, with his preposterous black preacher's hat and his glasses on a long black ribbon. Women loved him, and his last wife, Mercedes, a tall, handsome Cuban girl, put up with him till his death. His doctor brother, who practiced in New York, patched him up from time to time.

Sloan said Luks only took up painting because "The Old Stock Company," as Henri called the Philadelphia gang, seemed to be enjoying it so much. But Luks was far more than a buffoon. To Luks, the world was richly ridiculous and completely absurd; he

Woman With Macaws, *1907. Oil on canvas, 41" x 33" (Opposite Page). This swashbuckler of the brush, as Duncan Phillips called him, loved to paint waifs and witches, adventurers and derelicts. Duncan Phillips was fascinated by this roistering rounder, as was that gentle scholar Edward Root, and they both held with Hegel that disreputable characters, close to life, could be far more valuable than sober citizens. The Detroit Institute of Arts, Detroit, Michigan.*

lived surrounded by preposterousnesses. He saw things in a genuinely comic light and was delighted by contrast. The barroom boaster had a cracked glory all his own. While Luks didn't go on to greatness, like Goya or Rembrandt, neither did any of The Eight. But he kept on the track, and none of his work is meaningless. His last works grew out of his first paintings, and if they're not quite as fine as his early triumphs neither are Henri's, Sloan's or Glackens'. And Luks had successes all the way, as did the rest of The Eight.

Luks suffered from the terrible plague of alcohol, which leaves you shaken and subject to panic. The wonder is that he painted as well as he did for as long as he did—he was one of his own foundered characters. Sloan painted the lives of the poor from the rear window, while Luks, for better or for worse, was inside his pictures. He understood his battered sitters because he was battered himself. He had the squalor within, which is not necessarily better. If there's a note of falseness in Luks, why, so there is in many vivid characters: they know perfectly well that they are cracked and startling. Luks had a real feeling for the radical wretchedness of life and the unlikeliness of it all.

He had an affinity for gaiety, for the lilting note in dreary dives, where indeed he often supplied it. Getting drunk in bars, Luks had the divine note of laughter, of irrepressible high spirits, and of Homeric fantasy, yet saloons were pretty grim places, except for the interior illumination. As John Butler Yeats said, and he was not a drinking man, the second whiskey is the way you feel when you enter heaven.

When Luks was recovering from a bender, pale, shattered, encircled, and invaded by the terrifying gulfs, reefs, and abysses, he could still straighten himself out and work, as many writers can. In our culture, drinking and talent have an affinity, and Luks wasn't destroyed by alcohol; his brain didn't get addled, and he didn't lose his talent. And he *enjoyed* drinking—in fact, he loved to get drunk. It was the only thing worth doing besides laughing and painting and women.

Luks had extraordinary vitality, which he certainly needed, and extraordinary facility. He could draw with both hands at once. Drawing a comic strip, which is killing work for most men, was easy for Luks. He enjoyed the jokes and the characters for all they were worth, which was a great deal of money. He enjoyed everything, except when he got beaten up, but that was part of what happened. He wasn't one of the really successful drinkers, who drink a quart a day in blissful peace—he wasn't that lucky.

Luks had a real feeling for the characters he painted, for example, the awkwardness and glee of the little girls dancing in *The Spielers*. It's difficult for an artist to paint something he is not. Otis Skinner as a half-potted brilliant braggart and bounder, that's Luks to the life: he didn't need to read himself into the part. The wrestlers straining on the mat, that's Whitey Lewis knocking out Bob Fitzsimmons. He was just as defiant and wrecked as the old lady with the goose. As for pigs, he had a great sympathy for pigs: they're not so different from people. All the Philadelphia bunch could paint the New York streets, but only Luks could paint the people. In the cellar under the floor of the Hell Hole

Postcard to Henri from Luks, 1903, 5½" x 3½". Collection of the Chapellier Galleries, New York, New York.

Glackens' Café, *watercolor on paper, 8" x 9¼". Collection of Arthur G. Altschul, New York, New York.*

Saloon, the owner kept a pig, which he fed on the garbage. Eugene O'Neill and his friends used to get the pig drunk so they could laugh when it got the blind staggers. Only Luks could paint that pig.

Guy Du Bois, who was extremely intelligent and also a drinker on a heroic scale, thought very highly of Luks. He considered Luks brilliant, while most of his friends were scared stiff of what he would do next. Some people thought Luks' buffoonery a mask, and certainly he was sensitive enough, but mainly he was independent and didn't give a damn. Luks was his own man—he bowed to no one, not even Henri. His stories weren't merely funny, they were epic, and totally his own. In those flashes he had a glimpse of the truth, which nobody sees for long. We treasure droning idiots, and if a man laughs we suspect him; for Luks, the flash of insight was in the laughter, and that is what he made you see. He took pleasure in the world's extravagance not only because it was picturesque, but because through this crazy door we see the other room, the room in which we live. A man like Luks doesn't drink to forget, but to see the light. Luks wasn't fleeing reality, he was finding it. He was looking for life, not running from it. This is the way many drinkers feel: what they find in drinking is more important than what they find in life: it *is* life.

After his newspaper days, which he said never hurt anyone, Luks did nothing except paint; oh, he taught off and on, but he didn't take it seriously and he sometimes showed up drunk. His production wasn't enormous, and it's hard to see how he made a living. The critics always liked him because he was colorful copy, for Luks was a brilliant talker, while many artists don't have anything to say. For Huneker, an afternoon at Luks' studio was an afternoon for the gods, enough to reconcile a man to America. Nobody could say Luks was interested in money; he could have made a fortune by staying with the comics. He had a few patrons: Mrs. Whitney, who comes in and out of this group like some great goddess, backed him as she backed many others, and shy young Edward Root found in him all the color and warmth that were lacking in his own world. But Luks trailed no clouds of glory; he wasn't a man you could patronize and it was dangerous to be fond of him. You never knew how he would jump except that probably it would be the wrong way; none of his friends stayed with him on his drunks, which led him God knows where.

Luks' language was pretty foul—it came straight from the gutter. The stories that are left have been prettied up, but often he was distressing. Like most drunks, he didn't get any better as he got older; drinking doesn't build for the future. After the first wild years he didn't have such a great time.

He was a tremendous boaster, but bragging people are often telling the truth; while Luks was making up tall stories about his fights he came pretty close to telling the truth about his paintings. They were indeed, as he proclaimed, goddamned good. Guy Du Bois, who had a bitter pen, thought him a windbag, a coward, and a fool, and criticized him for accepting criticism from others, but "when he painted a great picture, and they are

surprisingly many in view of his hit or miss way of work, it held the richness and dignity and strength of a full blooded man, an intimate and real achievement." (Guy Pene Du Bois, *Artists Say The Silliest Things:* New York, 1940, p. 182).

Luks was not an analytical painter. No one could say that he ruined his work by reflection. He was a natural and that is his glory. He doesn't paint form, he paints life. There isn't much form to an old befuddled woman bundled up in all her clothes, and even his wrestlers are just two men fighting.

He had his sentimental side. He painted old women with loving care; he painted the Irish before they disappeared from America, and the poor before they became menacing. We consider old people and children problems to be deplored, we don't enjoy them as a spectacle. City streets are now something to be avoided. Luks loved the children playing in an empty lot, old women hobbling along, and people smashed by life, with a raddled gleam within.

Most of the magnificent stories are about the early Luks, before he became a problem and a bore. We think of him as younger than he was. Actually, he was around for years, smelling of whiskey. These colorful characters get pretty hard to take, and mostly people took care not to invite him. It was all part of the act, which continued until October 29, 1933, when he was smashed in a barroom brawl and picked up dead under the El; even Brother Bill couldn't fix him. He was buried in a magnificent eighteenth century vest, just like the vests that he wore in 1893, and Gene Tunney came to his funeral.

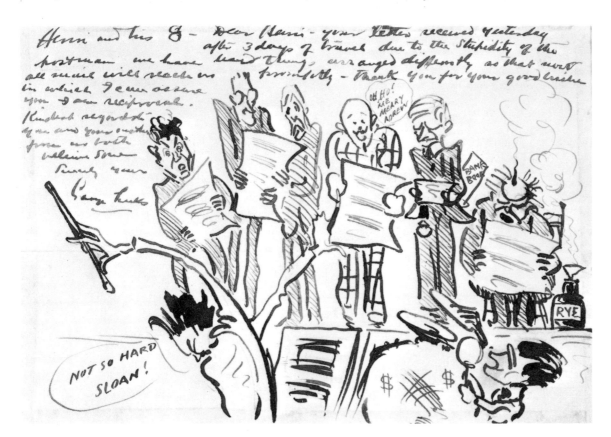

The Eight, *pen and ink, 6" x 8". Collection of Arthur G. Altschul, New York, New York.*

MAURICE PRENDERGAST 1859–1924

An Arcadia of Children

Maurice Brazil Prendergast was the oldest of The Eight, and he was their grand old man when he died at the age of sixty-five. The "Brazil" gave a touch of color to his name, which was typical of the man. He was born in 1859 in St. John's, but he wasn't much of a Newfoundlander, for in 1861 his parents brought him to Boston, his mother's home town, where he lived until the last twelve years of his life. He left school at fourteen and supported himself by lettering showcards, the kind of thing John Sloan did for a living in Philadelphia. But there was no Robert Henri as a source of inspiration in Boston, and Prendergast started out on his own as a Sunday painter. According to Charles, his younger brother who backed him all his life to the detriment of his own career as an artist, Maurice was "hell on cows." When they decided that Maurice should study in Paris, it took them five years to save the necessary thousand dollars, by which time Maurice was over thirty. Up to this point he was a completely self-taught artist, with the direct and naive personality we associate with primitive painters.

In Paris, Prendergast studied at Colarossi's and Julian's, but his real work was done in the parks, the cafes, and the galleries. He learned a great deal from the work of Bonnard and Vuillard, who had recently been at Julian's, and Whistler's small Venetian scenes influenced him very much. According to Perry Rathbone, the Nabis were convinced by Gauguin's contention that "form resides not in nature but in the imagination, and that color exists to be used in its symbolic purity and for its decorative value." (Hedley Rhys, *Maurice Prendergast:* Boston, 1960, p. 13). Prendergast practiced this doctrine all his life, while Maurice Denis, Vuillard, and Bonnard went on to other things. In Paris, he soon began painting distinctive and recognizable Prendergasts.

While it's questionable whether Prendergast knew the Nabis personally, there's no doubt that he was close to Charles Wilson Morrice. This remarkable painter, who affected so many of The Eight, introduced Prendergast to the latest Parisian styles, which fitted Prendergast so wonderfully that he used them all his life. Prendergast was a provincial in Paris, while Morrice knew everybody: They may have been drawn together by the similarity of their names, their painting tastes, and their common Canadian origin, though their personalities could not have been farther apart. Prendergast, a sage and child-like man who behaved like an angel, was always a delight, while Morrice got into everything and could be thoroughly exasperating. Prendergast was delightful to be with,

but it's difficult to imagine a conversation between him and his quiet friend Glackens. They would have said very little to each other, and Prendergast, with his deafness, wouldn't even have heard that. A delightful companion, Prendergast didn't think too highly of talk and he felt that everything important that he had to say was in his pictures.

For many of these men, France was like some great university where learning could take place. The teachers did not interfere, and nothing was done to prevent them from getting an education. France was extremely good to them, and they were eternally grateful.

France allowed Prendergast to become himself. The only man who influenced him was Morrice, who did for the Group of Seven, Canada's leading school, what Henri did for The Eight. When they met, Morrice's style was formed, while Prendergast was a beginner. Prendergast learned his style from Morrice, though later he carried it into great ballooning clouds that Maxfield Parrish would not have denied. As Hedley Rhys says, he and Morrice often painted the same subject at the same place, even though they were not there at the same time. They both put in little figures with red trousers. This cheerful style fitted Prendergast better than it did Morrice, who was a great friend of such uncheerful men as Charles Conder, Walter Sickert, and Aubrey Beardsley.

Morrice had a studio on the Quai des Grands Augustins from 1898 to 1916, with a Conder fan on the wall, drawings by Picasso and Modigliani, and several Prendergasts. He frequented the Chat Blanc with Arnold Bennett, Somerset Maugham, and Roderic O'Conor, who was associated with the Pont-Aven group around Gauguin. Morrice and Prendergast were unlikely friends, but they were both sketchers, and both painted enchanting watercolors of streets full of girls and women, horses and hansom cabs. It's a gentle, blue, white-clouded world, with spots of color put just where they are needed. They painted tiny oils on panels or cardboard, a method Morrice may have invented. Conder went with Morrice and Prendergast to Saint-Malo and Dinard, and what Prendergast painted was an imaginary land that had little in common with granite Brittany. In 1892, Prendergast painted in Dieppe, which was home territory for a long time for both Sickert and Conder.

Prendergast developed so rapidly that his work was soon stolen, which is a remarkable compliment to its charm and acceptability. An Englishman visiting his studio was so impressed with his entrancing Paris sketches that he took a book of them along with him when he left and showed it to Whistler, who was no mean judge: it then turned up in "The Studio" in 1893 as *The Sketchbook in the Street*, ascribed to Michael Dignam. With his unworldly disposition, Prendergast made no complaint, which is less than Whistler would have done.

But Prendergast lived in a world of his own. Several times he wrote down this verse: "Tell me pretty maid, whither are you going? The bark spreads sails and the breeze is blowing." Another favorite came from Kipling: "If a man would be successful in his

Ponte Della Paglia, *1899. Oil on canvas, 28" x 23" (Opposite Page). Prendergast's most famous painting was probably painted in America from a watercolor made in Venice. The catalog of an exhibition at the Carroll Galleries in New York in 1915 states that "he was probably the only Boston painter affected by distinctly European influences." The Phillips Collection, Washington, D.C.*

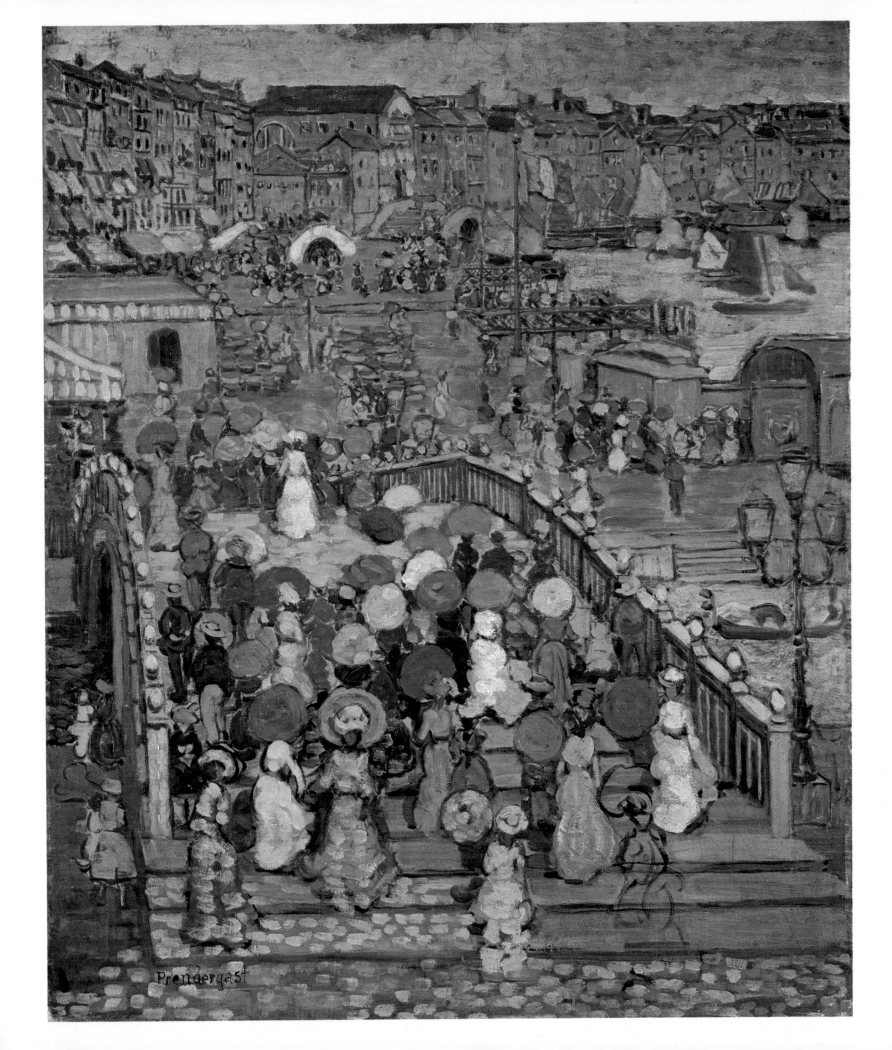

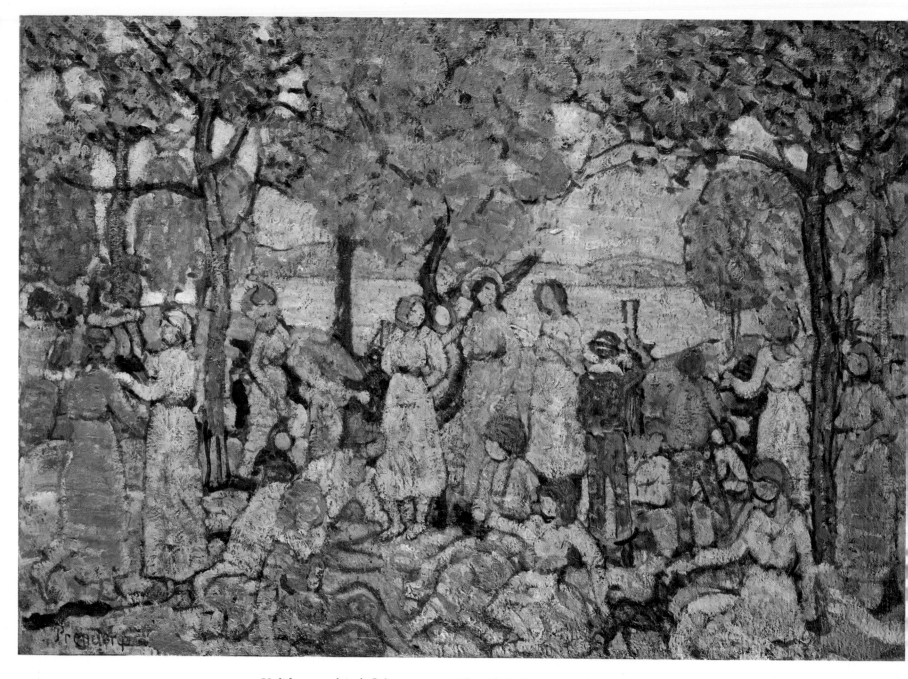

Holidays, *undated. Oil on canvas, 30" x 43¼". Prendergast's contemporaries complained about his figures without faces and his surfaces like old samplers, but as Duncan Phillips said: "He was not consciously or deliberately quaint, capricious and fantastic . . . when he painted a violet horse out of the Noah's art of Toyland it was not as a joke or a challenge, but because he needed it exactly thus for his arabesque." (Phillips, p. 46). The Minneapolis Institute of Arts, Minneapolis, Minnesota. Julia B. Bigelow Fund.*

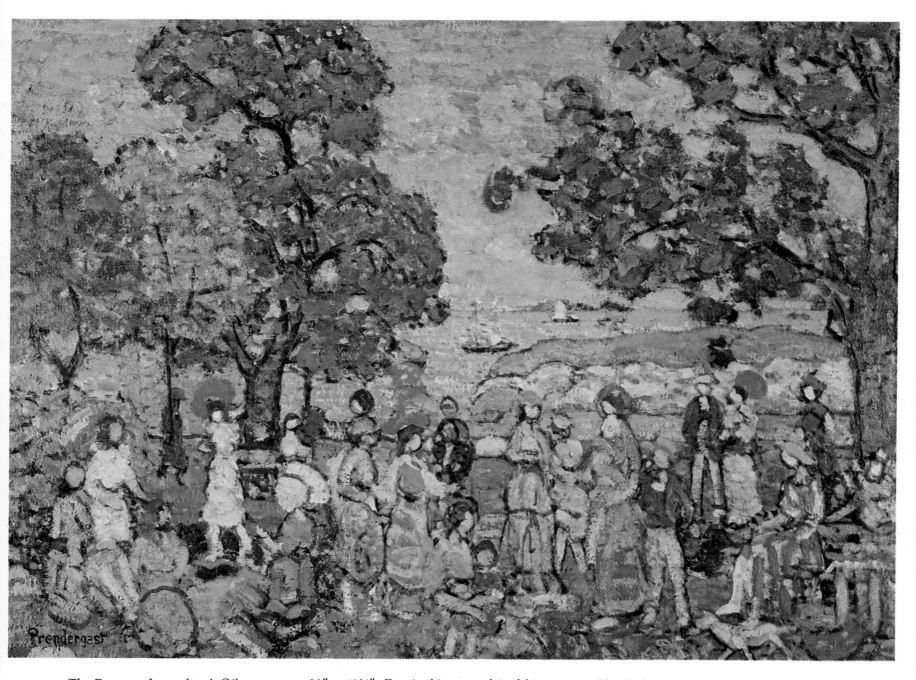

The Promenade, *undated. Oil on canvas, 28" x 40⅛". Despite his warm friendships among The Eight, Prendergast was an isolated figure on this side of the Atlantic, with few stylistic connections with any other artist except for the Canadian painter Charles Wilson Morrice. Critics have tried to establish a connection with Cezanne's concept of space, but it's invisible to the naked eye. This is a very flat picture, with all the action taking place on the frontal plane. The Columbus Gallery of Fine Arts, Columbus, Ohio. Ferdinand Howald Collection.*

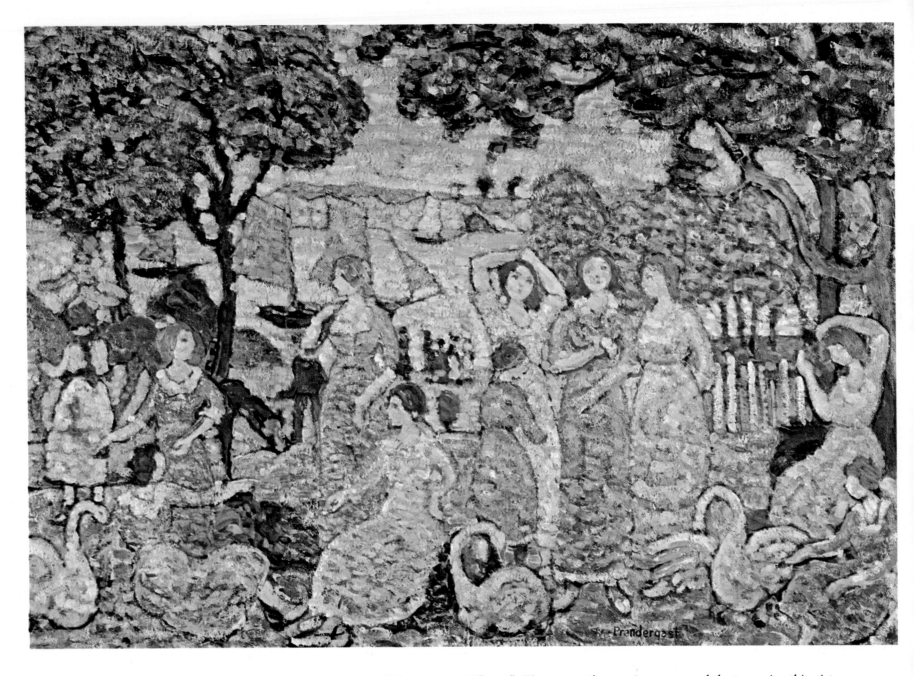

The Swans, *1916–18. Oil on canvas, 30" x 43". The swans, the curving arms, and the trees give this picture a strong rhythm, a dance in dreamland. In the words of Van Wyck Brooks, "nothing amused his eye more than a pretty dress, blue, green, yellow or old rose, as one saw in all his pictures to the end of his life, the beach parties and fairy-tale picnics with their charming wind-blown figures and little girls with parasols and flying skirts." (Brooks, p. 33). The Addison Gallery of American Art, Phillips Academy, Andover, Massachusetts. Bequest of L. P. Bliss.*

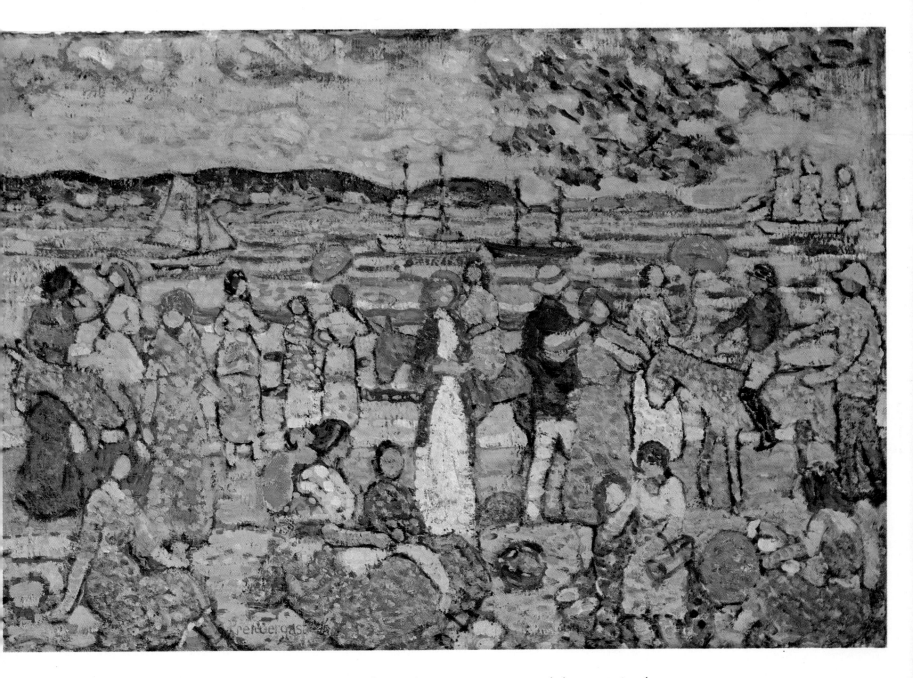

Along The Shore, *1917. Oil on canvas, 23⅛" x 34⅛". Prendergast captures some of the processional qualities of Carpaccio, the Venetian Renaissance painter he so much admired. According to William Milliken, he loved to go to the little dark Scuola of San Giorgio dei Schiavoni to enjoy the masterpieces of the great narrative painter. Venice and Italy were almost as important in his work as his trips to Paris and France, but the vivacity and gaiety are all his own. The Columbus Gallery of Fine Arts, Columbus, Ohio. Ferdinand Howald Collection.*

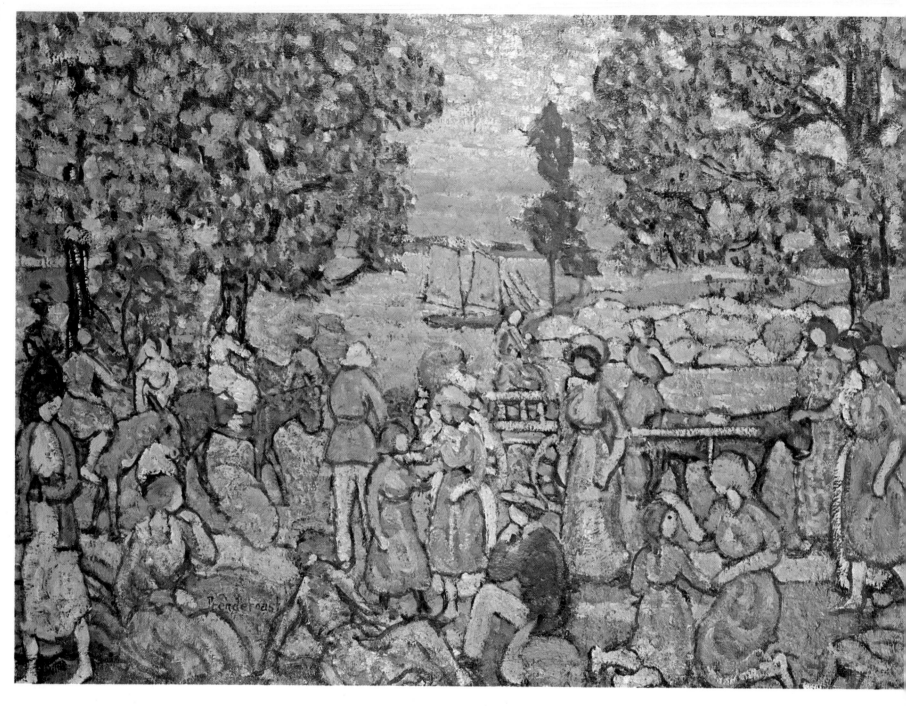

On The Beach No. 3, *1918. Oil on canvas, 26" x 33⅜". William Milliken·relates that Prendergast couldn't afford oil paints until comparatively late in life, and in the early days his oil paints and his money often ran out at the same time. Even after he moved to New York he didn't lose his love of New England, and he made many trips back to Ipswich, Marblehead, and Gloucester. The Cleveland Museum, Cleveland, Ohio. Hinman B. Hurlbut Collection.*

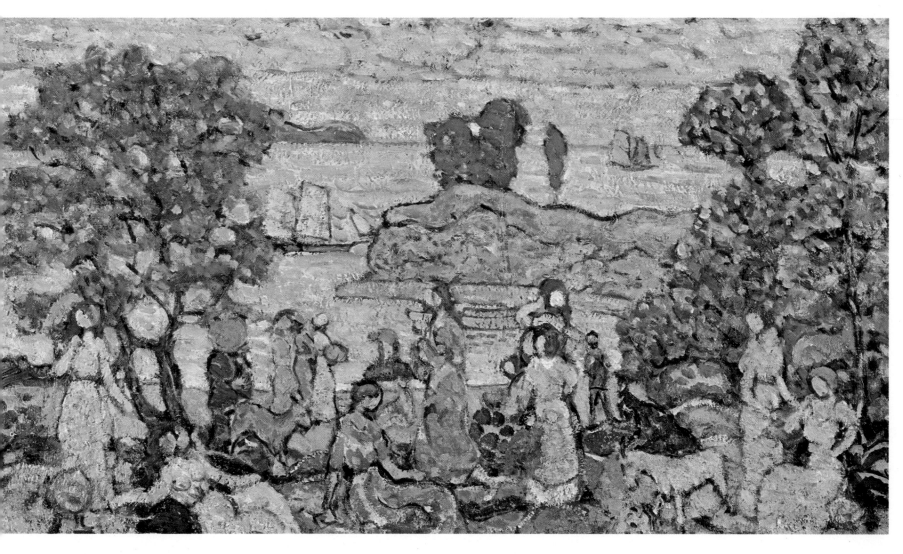

Outer Harbor, *undated. Oil on panel, 18½" x 32¼". This charming painting shows Prendergast's closely woven texture and his jewel-colored mosaic style. Prendergast and Seurat, the inventor of Pointillism, were born the same year; they both used juxtaposed touches of unmixed paint, but Prendergast was moved by the sheer joy of color rather than by rigid theory. The Columbus Gallery of Fine Arts, Columbus, Ohio. Gift of Ferdinand Howald.*

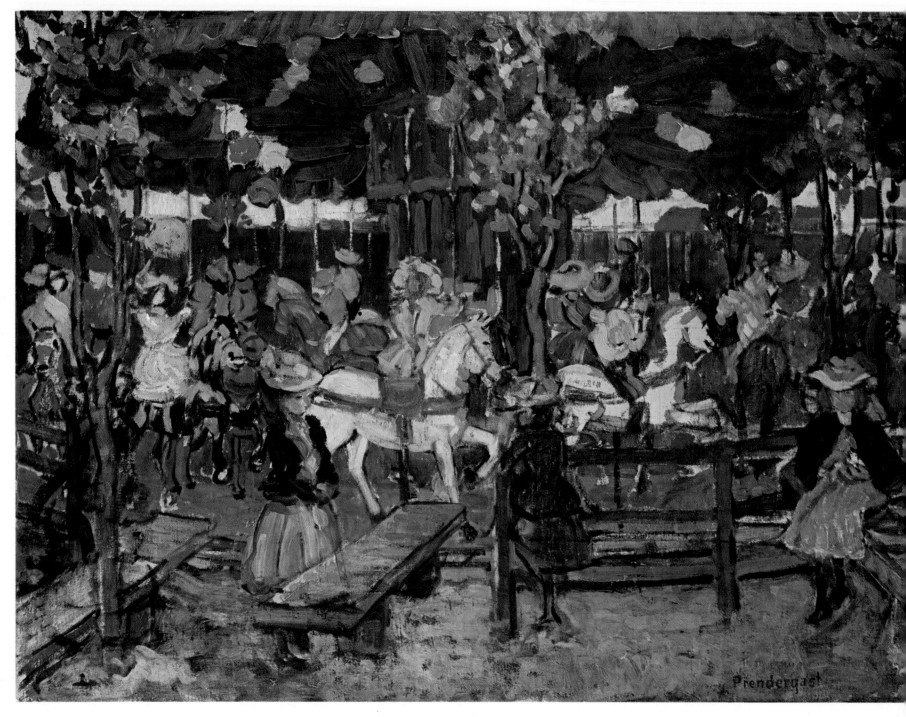

The Flying Horses, *ca.1908. Oil on canvas, 23⅞" x 32⅛". It has been said that Sisley and Monticelli influenced Prendergast's work, but he never mentioned either of them. In Van Wyck Brooks' words, "he liked parks and scenes of holiday making, ponds and flashing fountains and paths chequered with sunlight and flickering leaves." (Brooks, p. 33). He did not regret his deafness too much, for it left him alone with his bright pictures, and he could no longer hear the disagreeable things people had to say. The Toledo Museum of Art, Toledo, Ohio. Gift of Florence Scott Libbey.*

art, art, art / He must keep the girls away from his heart, heart, heart." It was a dream world made up mainly of women and children, seen by a lonely bachelor. Prendergast never married, while his brother Charles waited until Maurice died. It is a world of children's games, of ring around the rosy and catch me if you can; it's always fair weather, and the showers bring flowers. Prendergast's subject matter was fixed as early as the stolen sketches, and though his style developed over the years, building more symphonic masses, he never tired of this lovely toyland where there are no bad things. He actually lived in this world to a surprising extent, and those who do not are fortunate to get a glimpse of it. There must have been rain in Prendergast's three years in Paris, but it rarely rains in his pictures. He never forced the note, but then he didn't have to—this was his real world.

He painted some heads later in life, but it's difficult to believe they were made by so accomplished an artist. He had his own vision, where he was happy, and outside it he was out of place. He believed life was beautiful, which we find hard to believe, but when we look at his pictures, as Henri would say, we see exactly what Prendergast saw. Even his titles have a special touch: *The Pretty Ships, Eight Girls by the Sea, Beach with Blue Tree*—every day was a summer holiday.

When Maurice came back to Boston, his brother Charles, who had worked for an art dealer, started a frame shop, leaving Maurice free to paint the New England beaches that to him were indistinguishable from Saint-Malo and Dieppe. His first Boston exhibition brought him his first patrons, Mr. and Mrs. Montgomery Sears, who were advised by Mary Cassatt on their purchases, though presumably not on these. They put up most of the money for Prendergast to go back to Europe, with Charles, as usual, making up the difference. Maurice was thankful for the help, but he did take things a bit for granted.

Prendergast spent more than half of the year in Venice, which was a great American town in these years. Charles came over on a visit, and Gedney Bunce was still there, as willing a victim of Venice as Joseph Pennell feared he himself would become. The city was a natural for Prendergast; this Byzantine bastion was toyland to him. He did the buildings beautifully, but the people are straight out of Kate Greenaway: they certainly aren't Italian. His Rialto and his San Marco are holiday spots of blue with flags flying: if there wasn't enough red in the scene he added it anyway, tawny and Roman.

If you look long at his pictures the childish note is a little too insistent. The charm, the delicacy, the tenderness, and the sparkling color are always there. They are beautifully orchestrated and composed, but they never go far beyond decoration. They are flat little friezes, a kind of ballet, all on a summer's day. It never snows in the piazza, where he spent his afternoons at the Café Oriental and his evenings with the artists at Florian's. He got sick in Venice, as Chase had before him, and he wrote home to Charles: "It is too bad for your sake that I am sick. It would be so fine to be home in the old studio helping you along with the frames. We together are such a fine team."

People make much of his kinship with Carpaccio, but he could not use the swelling

forms and dusky light of Titian and Tintoretto; it made him ashamed of himself when he saw such glories. Spending his money in tiny calculated amounts, Prendergast visited the other cities dear to the arts and muses, spending two months painting in medieval Sienna. Except in Venice, he did not mix with the American colony. His name appears in no memoirs, for he never knew literary people, and he never looked anybody up. He went his own way. The other artists knew him and admired his work, but he was always on the edge of their circle.

Back in the States he had another exhibition, and in early 1900 he exhibited fifteen watercolors and fifteen monotypes at the Chicago Art Institute, which was his first national recognition. The Italian watercolors are among his masterpieces, "full of balloons, parasols, goats, dogs, hobby-horse steeds and hybrid creatures of uncertain zoological antecedent," as Hedley Rhys says.

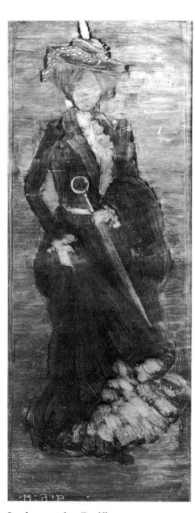

Lady with Ruffles, *monotype, 10" x 3". Collection of Dr. and Mrs. Louis Milstein. Courtesy of the Kraushaar Galleries, New York, New York.*

He made a great many monotypes between 1892 and 1905, perhaps as many as two hundred. This messy and mysterious medium fascinated him. He wrote to his only pupil, Mrs. Oliver Williams, in 1905, "Paint on copper in oils, wiping part to be white. When picture suits you, place on it Japanese paper and either press in a press or rub with a spoon until it pleases you." He made many of these monotypes in Boston, treating the city as though it were Paris. In a sense, these American artists did not live in American cities, for they painted all morning, walked and visited the art galleries in the afternoon, and spent the evening with other artists.

Things went well for Prendergast after his return from Italy in 1899. He sold in Boston, exhibited around the country, and in 1905 Macbeth gave him his first show in New York. He continued to help Charles with frames, and he treated his growing deafness by sunbathing and by swimming off the Massachusetts beaches from March to November. Sometimes he had a room of his own but most of the time he lived with his brother.

He spent quite a bit of time in New York, where he saw Lawson, Glackens, and the rest of the gang. Scientists say that physics is rooted in conversation, and the same may well be true of painting. In New York he could reminisce and lead the old life. In Boston there was no one to reminisce with, and no Mouquin's where, as Charles said, "nobody had as much fun as Morry and me." He loved parties, and the Glackenses adopted him as a member of the family. Through Glackens' influence, Dr. Barnes bought his work in quantity. By 1901 he was painting Central Park, in a series of watercolors which rival Venice. Throughout his career, he kept his meaning clear, which is quite a problem for an artist.

Prendergast began painting seriously in oil around 1903, and the oils gave him work to do in the winter. He often turned a watercolor into an oil, and he repainted continuously. Where Henri liked to finish a head in a day, Prendergast had his pictures hanging around for years and worked on several at the same time. The oils are more solid than the watercolors, more monumental, with a texture reminiscent of tapestry. He had sixteen

Esplanade, Boston, *monotype,*
8" x 4". Collection of Mr. and
Mrs. William Fuller. Courtesy of
the Kraushaar Galleries, New
York, New York.

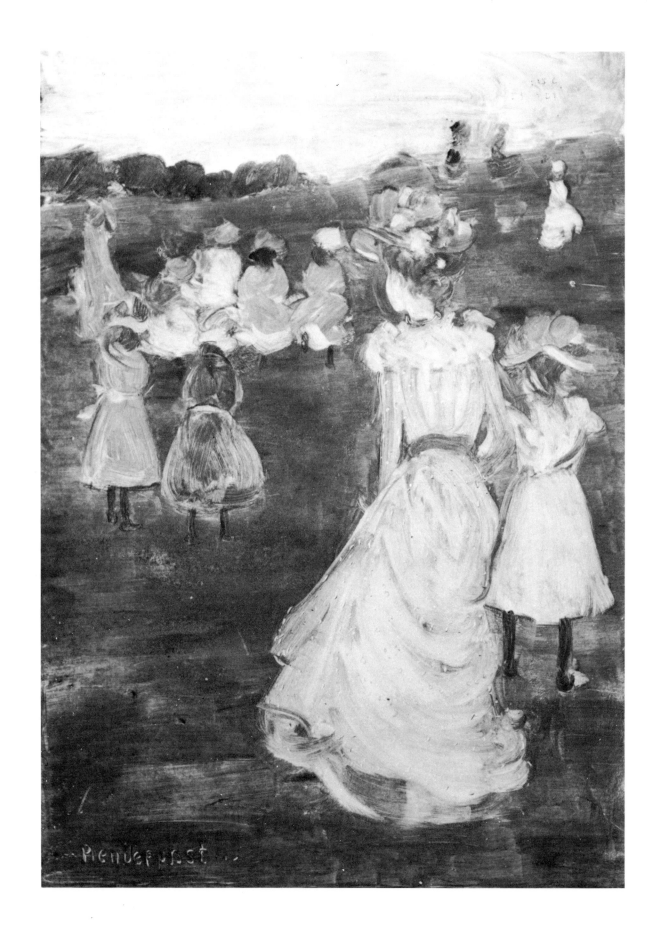

Figures in the Park, *monotype,*
14¾" x 10⅝". Collection of Mr.
and Mrs. James H. Smith, Jr.
Courtesy of the Kraushaar Gal-
leries, New York, New York.

paintings in the great show of The Eight at Macbeth's in 1908, the largest number of any man, including eight scenes from Brittany that were reworkings of early memories. Rather surprisingly, the New York critics lashed out at these imaginary landscapes, calling them artistic twaddle, the product of much cider drunk at Saint-Malo.

There were no spectacular changes in his life or his work. He took another long trip to France in 1909–1910, painting in Paris, at Dinard and Saint-Malo, and a shorter one to Italy in 1911–1912, mostly in Venice. These trips were like his first journeys of discovery, now turned toward the refreshment of memory. In 1912 he moved to New York to be with his friends, and he and Charles had a wonderful studio on Washington Square, on the floor above Glackens. It was full of sunlight, blue bits and pieces, glimpses of heaven. His five watercolors in the Armory Show in 1913 grew out of his previous work, not out of anything new seen in France. It is true that he went through a Pointillist phase when he painted in little patches, but there is no sign of Cubism. Prendergast was as unaffected by what went on in the art world as Lawson or Luks. He kept painting as he always had. Perhaps the best painter of The Eight, his character shows through his pictures; Henri's theory that a man was his art holds perfectly for Prendergast. He could do little nude sketches and rather liked to, but usually his figures are figures in a landscape, full of trees and flowers, where the little girls pick their way over the rocks to the beach. He was painting his best right up to his death in 1924. As Hedley Rhys says: "In his timeless land of horsemen and schooners, goats, swans and dogs, white collared boys on donkeys, half-clothed girls and New England cottages, flowers, fans, wagons, paddle boats, and parasols, all the happy holidays by all the seas and in all the parks can now go on simultaneously forever."

EVERETT SHINN 1873–1958

The Last of The Eight

Though Everett Shinn was the youngest, the cleverest, and the last of The Eight, he did not believe in their legend. Aline Saarinen wrote in the *New York Times* on November 2, 1952 that "when you leave Everett Shinn's studio and walk down the steep brownstone steps of the high stoop, and see the movement of people in Washington Square, hear the rasp of roller skates on the cross walks and watch the flutter of pigeons, you do a double-take." Everything is just the same; the city is just as vivid as it ever was. The people are still there. The young mother, with her child on one arm, being punched in the face by the father, and the drunks on the Bowery stacked like logs in the doorways, with sores all over their feet. The slight, dapper, gray-haired man greeted Miss Saarinen, as he had always greeted women, with a kind of ballroom gallantry. It was a Jimmy Walker, straw-hat world, and Shinn had enjoyed every moment of it. His old friend and dealer Charles T. Henry said that "Shinn loved people; most of them, at any rate. He laughed a lot. He would hold his stomach and bend over a little. This was the way he laughed." Shinn could not understand why people could not draw, and was surprisingly modest about his work.

According to Shinn, the group showed together in 1908 without plan. By that time he was drifting away from the old Philadelphia gang, who felt that his head was turned by his grand new friends. "White arranged it so I could have my first show. Forty pictures, and twenty-two of them were sold to Mrs. Gould and Mrs. Astor and Mrs. Vanderbilt—everybody social. I don't know if they liked them but they'd do anything White—that red-headed wild man—told'em to." (Saarinen, loc.cit.) Of course they liked them, and they liked him, for he was just as charming as his pictures.

According to Shinn, not one of The Eight had a program. They were against the monocle pictures at the Academy, that was all. None of them had a message, and he thought it was funny when people tried to make him a protest painter. He wasn't as interested as the others in people sleeping under bridges, though he painted plenty of mean streets. "It's just that the uptown life with all its glitter was more good looking: the people made pictures. And the clothes then—the movement, the satins, women's skirts and men's coats and the sweep of furs." He was the only one of the group who felt the attraction of pretty actresses, great ladies, and rich men. He was dazzled by the rich just as he was dazzled by women and the theater: they made his heart leap for joy.

He didn't think much of art schools and felt that newspaper illustrating was his most valuable training. "You went out with a menu, or an envelope or a scrap of paper and a pencil and you had to bring back something. You learned to look and understand how things worked and your mind became the plate of the camera, crammed with a million observations." When Aline Saarinen went down those stairs into Washington Square she was as "glamorized and nostalgic as the age itself." (Saarinen, loc.cit.)

For Shinn was the only one of The Eight who *did* glamorize and, like Sloan, he found later in life that what he could do best was to recall the good old days, the way we think of the Twenties and Thirties now. His delicate pastel of *Twenty-Third Street and Fifth Avenue in 1903* was actually made in 1952. In the early days he planned a book on *The Nights of New York*, with text by William Dean Howells, for he found New York "an incredible panorama," and nights in the city he regarded with awe. "The town was full of a thousand girls of perennial magnificence." As Henry says, his stage people live in perpetual hope, his clowns are funny, his comedians humorous, his show girls future stars.

He loved to paint the streets in winter, just the way Gramercy Park looks today, for the snow is the same, though the buildings are taller. He loved Fifth Avenue, the theater, and the women—he found them all intoxicating. His favorite subjects were "the parks and streets of New York and London and Paris, especially at night—old buildings hunched up together, or just a door intriguingly closed to shut you out or make you wonder what lies beyond it. He painted a house that you know was empty and cold, or warm and alive with people; a street that was quiet, or filled with the noise of a changing fire engine. He painted a comedian who just might not be getting a laugh or a ballet girl fearful of losing her balance." (Virginia C. Lewis, *Everett Shinn*, (Foreword) Pittsburgh, 1959, p. 3).

Shinn had more talent and facility than any of The Eight. He could do anything easily. The trouble was that he didn't do his best work all the time. His career has an unexpected shape. The worst sin for an artist is not to advance, and Shinn could not say, with Beethoven, that his work was better than it used to be. He was a light tenor, by no means a heavy. He worked hard, but too easily; by always pleasing, he ceased to please.

Shinn had several styles, some of which aren't very good. His pictures of Paris, London, and New York in snow and slush are dashing and picturesque, with their splotched white highlights. From up front or out back, his comedians, acrobats, and sweet singers are superb—nobody else caught the touching glamour and heart breaking anxiety. His nudes are sweethearts, pocket Venuses. This was no fantasy for Shinn, just the great American reality. He did lots of these nudes and he loved his work. He never needed to take a drink: exhilaration was all around him.

The stage decorations, the glossy figures of harlequins and columbines are pure Belasco and probably should not be considered as serious painting, but they haven't

The Orchestra Pit, *ca.1906. Oil on canvas, 17¼" x 19½" (Opposite Page). The little actress bowing just under the top of the frame represents the world Shinn loved, and you feel that he envied the musician. This was the old Proctor's Fifth Avenue Theater. Collection of Arthur G. Altschul, New York, New York.*

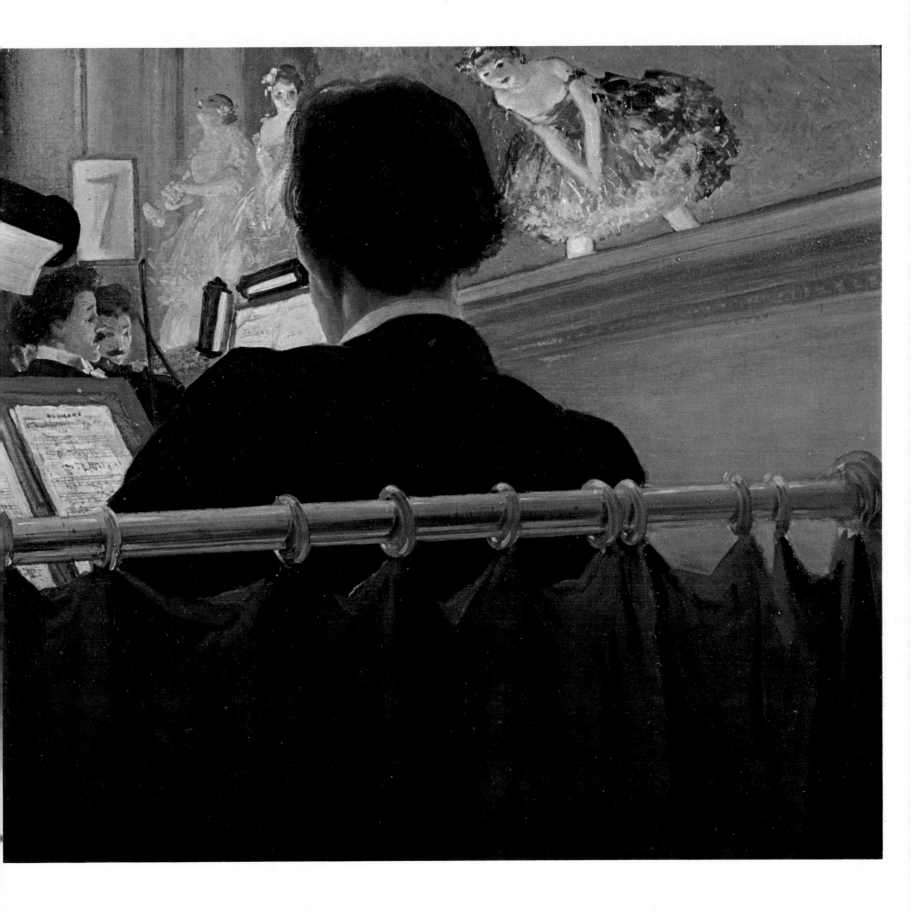

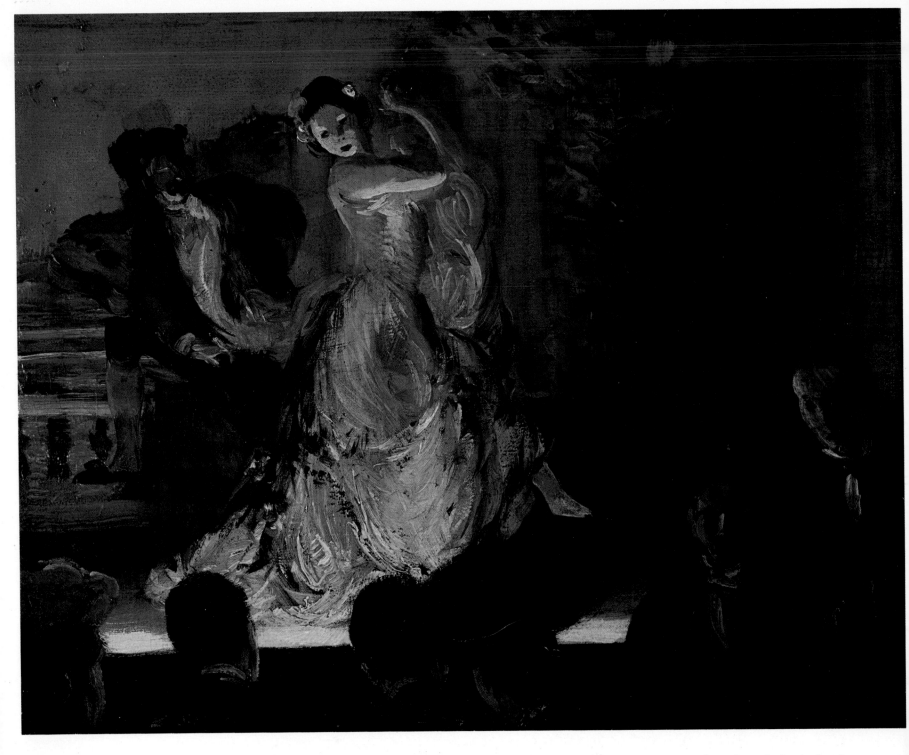

Spanish Music Hall, *undated. Oil on panel, 13½" x 17½". Shinn may never have been in Spain, but he could get a picture out of a music hall anywhere. These theatrical scenes are by far the best of his oils. The Metropolitan Museum of Art, New York, New York. Gift of Adelade Milton de Groot.*

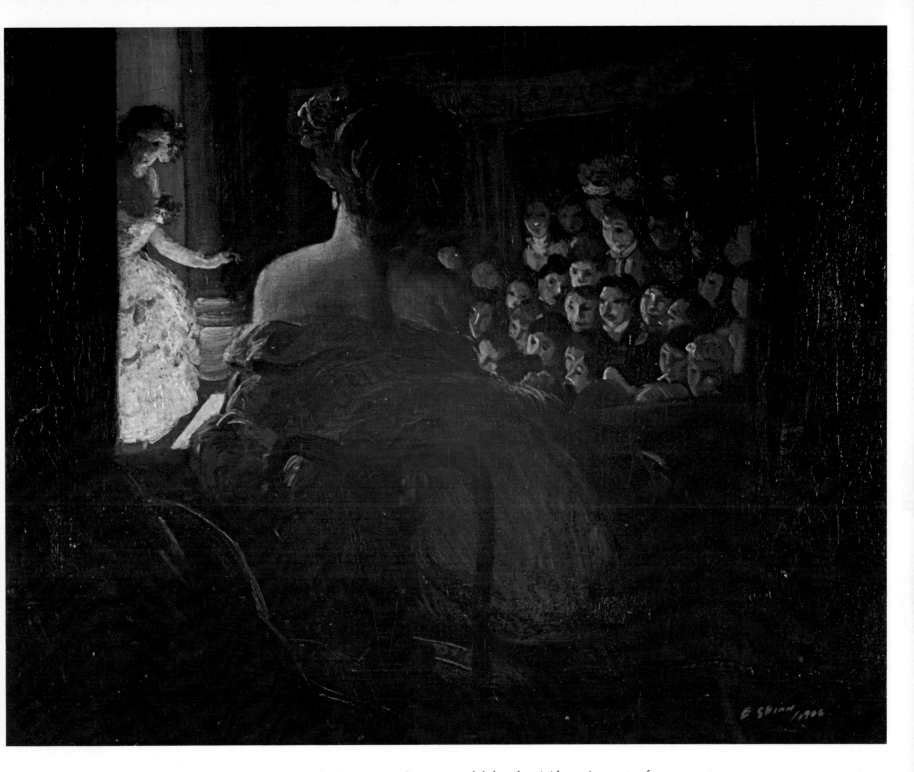

Theater Box, *1906. Oil on canvas, 16" x 20". Shinn was always grateful for the rigid requirements of newspaper pictorial reporting that compelled him to observe, select, and get the job done. He never lost his quick sense of a scene, of a striking angle or gesture. For making notes and sketches, he and his newspaper friends carried envelopes, menu cards, scraps of paper, laundry checks. But Shinn really depended on his marvelous memory, and his sense of the stage. The Albright-Knox Art Gallery, Buffalo, New York. Gift of Edward Hanley.*

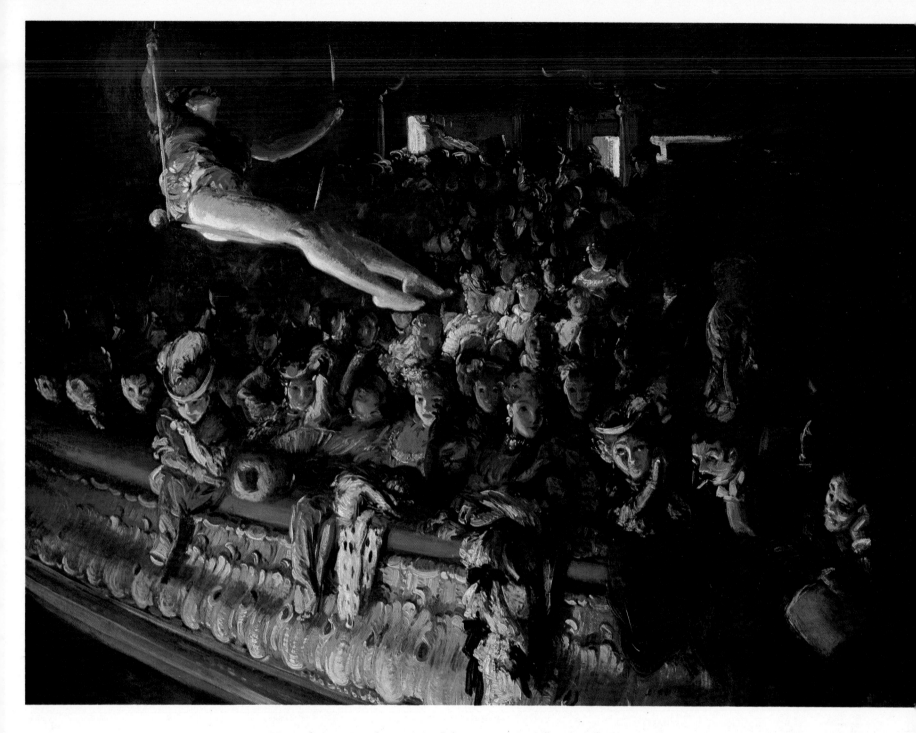

Hippodrome, London, *1902. Oil on panel, 26⅜" x 35¼". The English painter Walter Sickert is never mentioned in connection with Shinn, yet their work has many similarities. Sickert was a devotee of the London music halls, and he would have been entranced by the zip and go of this young lady as she flies through the air with the greatest of ease. Sickert painted the same dark balconies, the same shining faces, with more depth but less bravado. The Art Institute of Chicago, Chicago, Illinois. Friends of American Art Collection.*

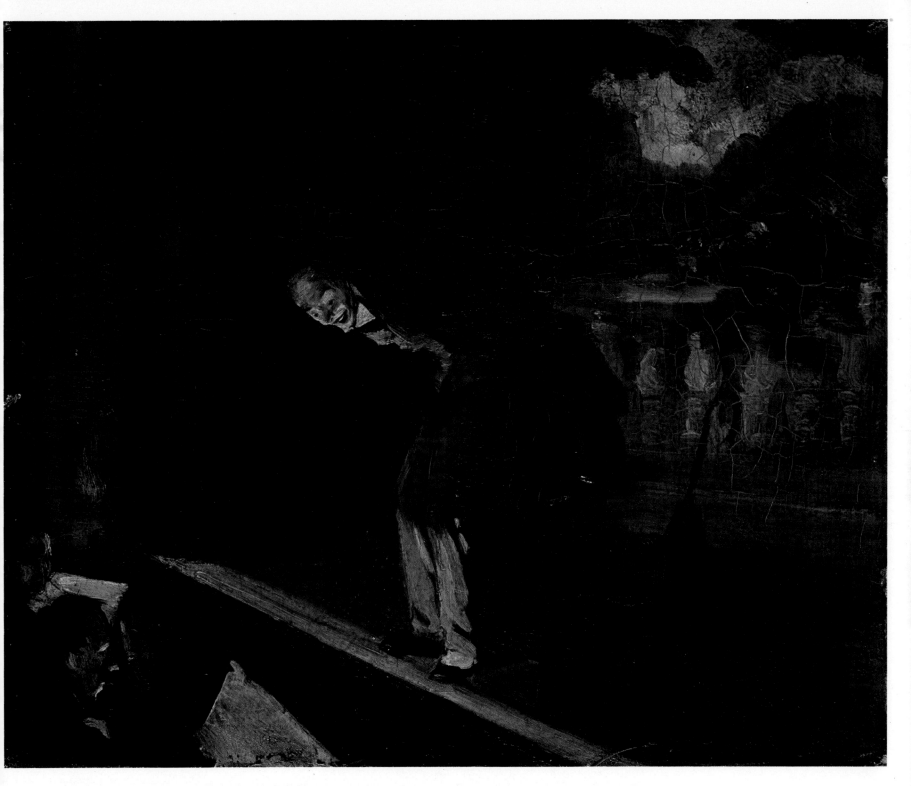

London Music Hall, *1918. Oil on canvas, 10" x 12". Shinn's long love affair with the theater went back to the days when Diamond Jim Brady and Lillian Russell were going strong. While he made his living as an artist, his heart was on the stage. In later life, Shinn did over many of his early pictures, but the first were the best. Henry Geldzahler points out that "the way in which the stage is set at an angle to the picture plane, allowing three of the musicians in the pit, along with their music, to form the lower left hand of the canvas, is a device that Degas used in several of his ballet and theater paintings. (American Painting in the Twentieth Century, p. 32). The Metropolitan Museum of Art, New York, New York. George A. Hearn Fund.*

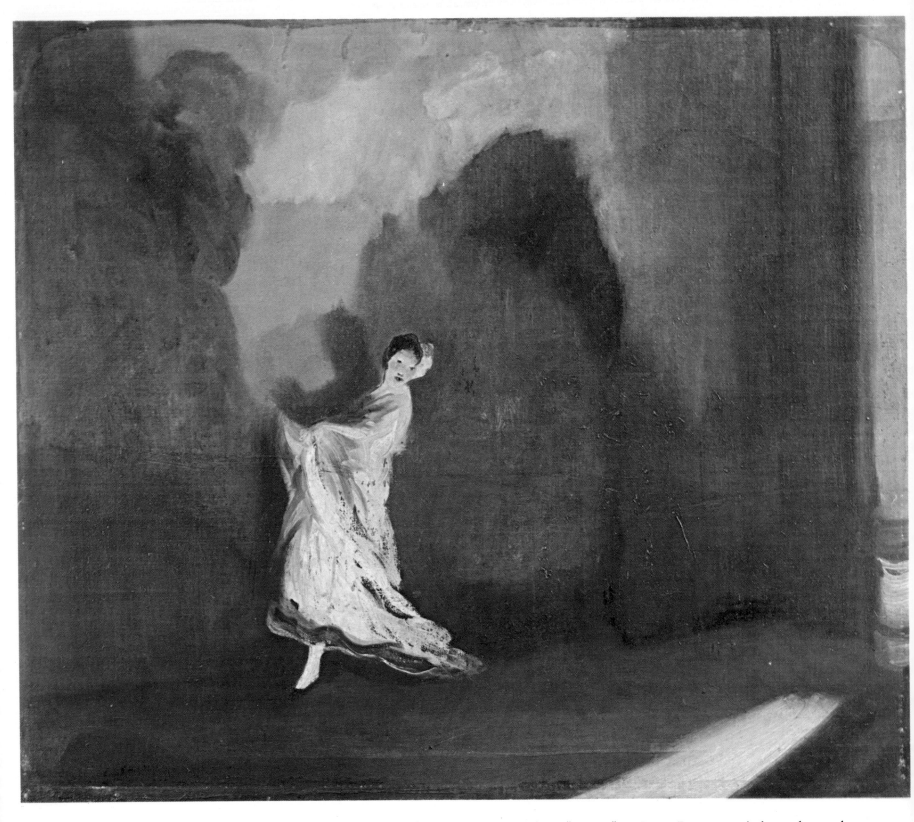

Keith's, Union Square, *ca.1906. Oil on canvas, 19¹³⁄₁₆" x 24⅛". In James Fitzsimmons' phrase, he caught "the richness and glamour of the evening, the theaters and the women of Paris and New York." The Brooklyn Museum, Brooklyn, New York. Dick S. Ramsay Fund.*

done Shinn's reputation any good. His later book illustrations are unbearably quaint, on the road to Disneyland. Newspaper drawing was a wonderful school to graduate from, but Shinn kept going back, and he ended up drawing for *College Humor*.

Shinn was born of Shaker parents in Woodstown, New Jersey, on November 6, 1876, the youngest of eight children. Being a Quaker made little difference in his life, though he blamed his Quaker upbringing for his four divorces: "I told the truth," he said. Actually, each of his marriages lasted a long time; he kept his wives very well, but he found other women exceedingly attractive. With every one of his wives he had a complete set of new friends, but the first ones were the best.

Shinn had a happy childhood, for he had the gift of enjoyment and everything interested him. He did not start out to be an artist. He said that he never meant to be anything he is known to have been. He had a real mechanical bent, and at fifteen he designed his own steam engine and cast it himself; it still works, but it wasted too much steam. His first submarine submerged correctly in the kitchen sink but wasn't so good at rising: the subsequent two-boy model was too wide for the barn door.

He studied mechanical drawing at the Spring Garden Institute in Philadelphia, where a class problem might involve the drawing in three colors of a Maltese cross set back at an angle of sixty-two degrees with the sun throwing a cast shadow on it at ninety degrees. His first job at the Thackery Gas Fixture Works was drawing chandeliers, but the marvelous doodles he drew on the margins got him fired. He floundered a bit, tried Swarthmore College, enrolled at the Pennsylvania Academy, and then, like the rest of the gang, he walked into a job as a newspaper artist at the *Philadelphia Press*. Happy days! Shinn was the fastest of the lot. Their drawings were blown up in the art department of *The Press* with the help of rewrite men who'd never been near the scene of the crime. "Sketches were usually mere markings with numerals. A quick note of some detail of a cornice or architectural peculiarity was drawn in more carefully. More crosses where fire blazed from the windows. Marks indicated fire engines, scaling ladders, hydrants, hose and other apparatus . . ." (Philadelphia Museum of Art, *Artists of the Philadelphia Press:* Philadelphia, 1945, essay by Everett Shinn, p. 12). Now photographers have all the fun, but they don't have to think and work as hard. Covering a coal mine disaster, he made his notes on the white silk lining of somebody else's hat.

Shinn caught on fast in New York, drawing the first color pictures for the center page of *Harper's Weekly*. He had his own theater in the huge studio at Waverly Place that he had built to paint his murals for the State House in Trenton. He could do anything. His stage productions of *Hazel Weston or More Sinned Against than Sinning* and *Myrtle Clayton or Wronged from the Start*, with Glackens and Mrs. Glackens in the cast, have been ranked with the Provincetown Players. Perhaps his importance in the rise of the American theater has been overstressed; he was no Ibsen of the streets.

A stage-door Johnny, he was dazzled by the footlights. Actresses were the most beautiful women, magicians were magical, and the roar of the crowd was the breath of

life. Shinn worked around theaters in New York and did a stint in Hollywood. He would have liked to do more. For years he did practically no painting, yet that was the only thing he could do spectacularly well. He had a compulsion to write plays, more than thirty-five of them, some written in dialect, but his written work is not in the same class as his paintings, drawings, and pastels. He was not an undiscovered genius; he was trying to write commercial plays, and they weren't good enough. His stories are pulp. Shinn was the only one of The Eight whose career as an artist was interrupted. The others all did the best work they could and devoted their lives to painting. Shinn was the only one who continued to turn out illustrations, which did not improve. This highly talented man turned out a great deal of incredibly bad work.

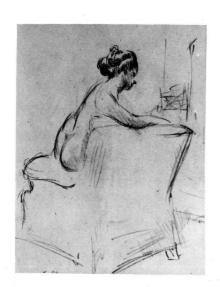

Seated Nude, *1902, pencil on buff paper, 6" x 8". Collection of Benjamin Sonnerbey.*

Like Turgenev's traveler, Shinn felt at ease and happy in a crowd. He enjoyed going where other people went. It amused him to observe people with a kind of joyful and insatiable curiosity. The view is from the outside, the New York City streets, the stage, and the girls as they appeared to the young man from Woodstown, New Jersey. Shinn's last trip to Paris and London was in 1908, and though he painted those cities all his life, they did not have the personal meaning for him that New York did. He appreciated the character and the glitter, but he was not in love with France, and he did not go back whenever he could.

There has been no major exhibition since Shinn's death. He is the only one of The Eight who has not had a retrospective at the Whitney Museum. Yet he was the first to have big shows at fashionable dealers—Boussard and Valadon in 1900 and Knoedler's in 1903. His bad work has stood in the way of his best. He is probably underpraised, for his best work is brilliant. His theaters, his nudes, and his nights in the city were filled with exaltation.

It doesn't help to exaggerate his theatrical prowess or to pretend that his illustrations are excellent. Too much has been made of Shinn's being the model for Dreiser's *The Genius*, particularly by Shinn himself. Dreiser used Shinn's early work and career through his New York success, his trip to Europe, and the halt in the career, but Dreiser's fictional character bears no relation to Shinn. Usually people, hurt and angry, deny that they are models for fiction, but Shinn gloried in it.

Shinn's own recollections are far more vivid than Dreiser's prose. He liked to think that when The Eight came on the scene, art in America was merely an adjunct of the plush interior decoration of the day. For subject matter, he and his friends looked to saloons, to alleys and gutters, train yards, night courts, dives, docks, dance halls, and park benches.

According to Shinn, only Luks' great ability could excuse his weakness: a great painter, a great actor and an outrageous liar, he was a fascinating and picturesque bluff. Davies irritated him. Over the tonal beauty of his pictures Davies smeared a verbal mystery, never content to let them voice themselves. Asked why he painted a bluish white life-sized nude with her eyes closed, Davies replied that if he had painted her eyes

The Ragpicker, *pastel, 20" x 26". Collection of Arthur G. Altschul, New York, New York.*

open, no one could have resisted her. Lawson he remembered as a silent man, Scotch and saving of words, low voiced, scarcely audible, yet many a companion had his legs barked by Lawson's energetic shoe as he drove home his opinions under the table, "at Mouquin's, with its ratty front marked out in swishing snow and swirling steam from the E1."

Shinn is brilliant on himself, all in a daze with the promise of an easy future. "Everything interests Shinn but the presence of his own irksome self." He stresses Sloan's socialism, saying nothing about his painting, early or late, but praising his etchings which "prove his superlative craftsmanship, in which he assembles the groans and laughs of humanity. There he walks alone." He is the source for the story that Prendergast's patternlike design came from the bolts of yard goods which he sold as a dreaming youth in a Boston dry goods store. In Venice, "Prendergast's soul opened in gratitude in the reality of what had always been a hopeful dream." (Brooklyn Museum, *The Eight:* Brooklyn, 1943, p. 20-21). He spoke very highly of Henri, in whose classes there was understandable idolatry.

Shinn understood all these things, but he had a frivolous streak. For him, art was not all that serious. He could do it, but with no high sense of mission. He was a hard worker who got the job out, but it was just a job to him. An exceptional and highly individual painter, Shinn spanned an enormous epoch from the Nineties to the Fifties, but in later years his artist friends thought of him as a lady's man who lived in the theater world. He was the only one who never became a full-time artist.

Shinn has been accused of imitating Degas, with whose work he was certainly familiar, but the direct influence was Forain, who is now as unfashionable as Fortuny. He took the actual cross-hatching and the way he placed a figure from Forain, whose work appeared in all the French magazines which dazzled our fathers, while all he saw of Degas was an occasional pastel at Durand-Ruel. Forain himself had learned from Degas, but in those days Forain was a far greater influence than Toulouse-Lautrec. Shinn transformed the French music hall and the French nude into Broadway and the great American girl.

In New York in the early days, Henri gave Sloan and Shinn a fatherly speech about getting on in the world, but Shinn didn't need it. Gone were the days when his underclothes were unspeakable, when he lived weeks in advance of his salary. Shinn learned the art of getting on only too well. As Sloan wrote with understandable envy in 1906, "Everett is certainly a wonderful man—seems to be still the kid he was years ago on *The Philadelphia Press.* He has a big Watteau-like tapestry painting that he did in two weeks. His speed is terrific." Shinn never got beyond this; the others did.

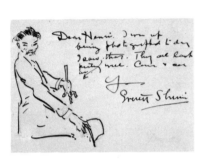

Note to Henri, *1900, pen and ink, 4½" x 6¼". Collection of the Chapellier Galleries, New York, New York.*

Postscript

And now the whole round table is dissolved. Some of these men, like Prendergast, are now treasured, while Henri, the cause of it all, does not have the recognition he deserves. They started out bravely, but nostalgia will not bring them back. They are painters of the past, they did not change the history of art; it was going somewhere else, and the victory went to the abstract painters. But there are never too many interesting painters. We can still get a great deal out of their paintings; Henri was sure that if something was truly seen and well expressed, others would see it, and we do.

Bibliography

Berry-Hill, Henry and Sidney, *Ernest Lawson, N.A.: American Expressionist:* Leigh-on-Sea, England, 1968.

Brooklyn Museum, *The Eight:* Brooklyn, 1943.

Brooks, Van Wyck, *John Sloan: A Painter's Life:* New York, 1955.

Brown, Milton, *American Painting from the Armory Show to the Depression:* Princeton, 1955.

Brown, Milton, *The Story of the Armory Show:* Greenwich, Connecticut, 1963.

Columbus Gallery of Fine Arts, *American Paintings in the Ferdinand Howald Collection:* Columbus, Ohio, 1969.

Cortissoz, Royal, *Arthur B. Davies:* New York, 1931.

Dreiser, *The Genius:* New York, 1915.

Du Bois, Guy Pène, *John Sloan:* New York, 1931.

Du Bois, Guy Pène, *Artists Say the Silliest Things:* New York, 1940.

Gallatin, A. E., *John Sloan:* New York, 1925.

Geldzahler, Henry, *American Painting in the Twentieth Century:* New York, 1965.

Glackens, Ira, *William Glackens and the Ashcan Group:* New York, 1957.

Goodrich, Lloyd, *John Sloan:* New York, 1952.

Henri, Robert, *The Art Spirit:* Philadelphia, 1923.

Homer, William Inness, *Robert Henri and His Circle:* Ithaca and London, 1969.

Huneker, James Gibbons, *Bedouins:* New York, 1920.

Huneker, James Gibbons, *The Paths of Distance:* New York, 1913.

Kuhn, Walt, *The Story of the Armory Show:* New York, ca. 1938.

Larkin, Oliver W., *Art and Life in America:* 1960.

Lewis, Virginia C., *Everett Shinn:* Pittsburgh, 1959.

Mather, Frank Jewett, Jr., *John Sloan:* New York, 1936.

McCausland, Elizabeth, *A. H. Maurer:* New York, 1951.

Morgan, Charles, *George Bellows: Painter of America:* 1965.

Myers, Jerome, *Artist in Manhattan:* New York, ca. 1940.

Pach, Walter, *Modern Art in America:* New York, 1928.

Perlman, Bennard E., *The Immortal Eight: American Painting from Eakins to the Armory Show:* New York, 1962.

Philadelphia Museum of Art, *Artists of the Philadelphia Press:* Philadelphia, 1945.

Phillips, Duncan and others, *Arthur B. Davies; Essays on the Man and His Art:* Cambridge, Massachusetts, ca. 1924.

Phillips, Duncan, *A Collection in the Making:* Washington, D.C., ca. 1926.

Reid, B. L., *The Man from New York: John Quinn and His Friends:* London and New York, 1969.

Rhys, H. H., *Maurice Prendergast:* Cambridge, Massachusetts, 1960.

St. John, Bruce, editor, *John Sloan's New York Scene 1906–1913:* New York, 1965.

St. John, Bruce, *John Sloan,* New York, 1971.

Sandoz, Marie, *Son of the Gamblin' Man: The Youth of an Artist:* New York, 1960.

Sloan, John, *Gist of Art:* New York, 1939.

Index

Edited by Jennifer Place
Designed by James Craig and Robert Fillie
Composed in 12 point Patina by University Graphics, Inc.
Printed and bound in Japan by Toppan Printing Company Ltd.